THE SNAP FASHION SKETCHBOOK

Sketching, Design, and Trend Analysis the Fast Way

Illustration Courtesy StyleLens.com

PO-4798
£25.99

Illustration Courtesy StyleLens.com

THE SNAP FASHION SKETCHBOOK

Sketching, Design, and Trend Analysis the Fast Way

Second Edition

Bill Glazer

PEARSON

Prentice Hall

Upper Saddle River, New Jersey 07458

Library of Congress Cataloging-in-Publication Data

Glazer, Bill.

 The snap fashion sketchbook: sketching, design, and trend analysis the fast way/Bill
Glazer. —2nd ed.

 p. cm.

 Rev. ed. of: The snap fashion sketchbook/Sharon Lee Tate, Bill Glazer. c1995.
 Includes index.
 ISBN 0-13-219423-6
 1. Fashion drawing. 2. Fashion design. I. Tate, Sharon Lee. Snap fashion sketchbook.
 II. Title.
 TT509.T42 2007
 746.9'2—dc22 2006038023

Editor-in-Chief: Vernon R. Anthony
Production Editor: Emily Bush, Carlisle Editorial Services
Production Liaison: Janice Stangel
Managing Editor: Mary Carnis
Manufacturing Manager: Ilene Sanford
Manufacturing Buyer: Cathleen Petersen
Cover Designer: Amy Rosen
Cover Design Coordinator: Miguel Ortiz
Back Cover Image: Courtesy of Bill Glazer
Formatting: Carlisle Publishing Services
Printer/Binder: Command Web

SnapFashun is a registered trademark of SnapFashun Inc./L.A. Stylopedia is a trademark of Bill Glazer. Adobe
Illustrator is a trademark of Adobe Systems.

Pearson Education Ltd.
Pearson Education Singapore, Pte. Ltd.
Pearson Education Canada, Ltd.
Pearson Education—Japan

Pearson Education Australia PTY, Limited
Pearson Education North Asia Ltd.
Pearson Educación de Mexico, S.A. de C.V.
Pearson Education Malaysia, Pte. Ltd.

10 9 8 7 6 5 4
ISBN: 0-13-219423-6

When I peer through the veil of my history through old photos I see my parents very much involved in the fashions of their day. It is from them that I learned that fashion is a necessary component to success and that it can be exciting, beautiful, and deserving of respect. For this, as well as for many other things, I dedicate this book to them.

CONTENTS

PREFACE

This book is designed to give beginners the ability to quickly create a working sketch and design garments. A basic template of a female (Sybil) and male (Sam) fashion figure is provided to give readers a frame of reference to assemble the components of a garment. A great variety of silhouettes and style details, carefully scaled to the basic figures, can be modified by tracing the elements of a garment in an infinite number of variations.

Building garments by tracing details and combining them in a variety of styles builds confidence in drawing and design skills, reinforces the ability to draw details and garments, and allows the reader to build hand skills. Once the ability to draw a working sketch using the details provided is mastered, the student should be encouraged to create and draw from observing actual garments or photographs. The basic figure template can still be used.

The Snap Fashion Sketchbook can be used as a self-teaching manual because the demonstration pages break each lesson down into simple steps. Each step allows the student to create a wide variety of garment styles and to build confidence and ability to draw and design a garment.

Students with a serious interest in fashion design or illustration should progress from this text to the companion textbook *The Complete Book of Fashion Illustration* by Sharon Tate and Mona Edwards (Prentice Hall: 1996). Drawing skills used in all phases of the fashion industry are explored in this text.

FEATURES

The Snap Fashion Sketchbook is organized in units. Unit I provides the background to get the reader started and links the ability to draw a working sketch with designing. Chapter 1 defines the working sketch and introduces the tracing method used throughout the book. Chapter 2 deals with design principles and elements, which govern a successful design. Chapter 3 covers commercial considerations, which drive trends, and the economics of designing and producing apparel.

In Unit II, each chapter covers a particular type of garment and begins with several instructional pages which assist the reader to create the particular type of garment by explaining construction and design guidelines for the category of garment. Basic dresses, jackets, skirts, pants, and garment components for both men and women are covered in Chapters 4 through 11. Students may wish to add tabs to these pages to ease selecting various details as they sketch from Unit II.

The two chapters in Unit III add dimension to the basic working sketch by discussing fabric rendering more sophisticated tools and materials, and presenting the working sketch in a professional manner. Students with prior knowledge of drawing may wish to read these chapters before working on Unit II, and create more sophisticated drawings as they work through the various types of design problems created by each category of garments.

Unit IV contains two new chapters that will assist students in understanding the fundamentals of fashion design as it pertains to researching and using trends. Although these new sections use Adobe Illustrator to reach its ultimate goal, the chapters can be used on their own as they would in the preceding chapters. Printed pages of what is on the disc that accompanies this book can be found at the back of each chapter.

I would like to take this opportunity to thank the ever helpful and constructive Sharon Tate, co-author of *The Complete Book of Fashion Illustration*. Sharon's knowledge of the industry is as vast as her generosity. This book would not have taken place without her. I would like to thank Wendy Bendoni, Director of Educational Sales for SnapFashun® for her editing skills and her always ready support. Also, a thank you to Vanessa Newsome, one of the most extraordinary talents working with Adobe Illustrator in the fashion industry today.

ABOUT THE AUTHOR

Bill Glazer began his career as a textile stylist for Canada's leading fabric converter. He moved to California in the 80s to start BGA, which publishes trend reports for manufacturers and retailers. They include: EyeSpy USA and EyeSpy Europe, the very first digital fashion service that uses digital photography and Adobe Illustrator to forecast trends. He is one of the leading retail trend analysts in the world, covering the U.S. and European markets. Bill has been in business for over 25 years and is the inspiration behind SnapFashun®, the gold standard of software programs for both teaching and creating fashion illustration and design in North America today.

THE SNAP FASHION SKETCHBOOK

Sketching, Design, and Trend Analysis the Fast Way

1

UNIT

The idea for *Snap Fashion* evolved from a professional fashion information service called *Report West* now called EyeSpy. Started in 1980 by innovative fashion expert Bill Glazer, this report shows designers what was selling well in trendy California and European stores. Market research indicated that designers were well informed about expensive European and domestic designer collections, but they often did not have the time to shop all the retail stores in an area to know what was selling. Designers from other countries employed Bill to shop California boutiques, buy samples, and use them as a basis for their lines. He reasoned that a printed report, which sketched garments realistically and provided measurements to guide pattern makers in producing items with the latest details, would be a commercial success. Subscriptions poured in, and soon the report was sold in countries throughout the world. Domestic designers also purchased the report, because Glazer had the uncanny ability to predict what would be the next "hot item," particularly for the fast-changing junior markets.

The drawings for early *Report West* issues were done by fashion illustrators who used a realistic figure as a basis and drew from sketches made in the field or samples purchased for various clients. After a decade of successfully selling *Report West,* Glazer published a "pictionary" of the bodies and details collected. This directory gave him another idea to aid designers. Glazer realized the huge volume of information he had amassed could be computerized. Software was developed which allows a person with limited sketching ability to "snap" fashion details together to form new styles. New details are added monthly, and manufacturers purchase SNAPFASHUN® (the

SNAP FASHION

commercial spelling of the software) updates providing their design staff with a constant flow of information on the hottest details and bodies in the market.

Basic software accompanies this text when sold to an educational institution. Students can learn the procedure to create the styles using software which is found in many manufacturers' design rooms and parallels the tracing skills which form the basis of this text.

The principle of using a basic figure as a guide to create a garment, first sketching the silhouette, and adding the style details, is one that every designer uses. Many designers trace over a basic figure because it is fast, and they have to get as many ideas on paper as possible to evaluate which should be made into sample garments. *Snap Fashion*, the book, translates these professional techniques into an easy-to-use design tool.

Note: Report West is now part of a new service published by SnapFashun® called EyeSpy Europe and EyeSpy USA which comes on a CD. A sample of EyeSpy can be found on the CD that comes with this book.

CHAPTER 1

Drawing: The First Step

WHO CAN DRAW?

Look at the objects that surround you. Every piece of furniture, every building, every household tool, every garment, in fact, every manufactured object began as a designer's sketch. The designer's idea is translated into a picture which is the beginning of a plan from which the object can be constructed. Without the skill of drawing, the idea can not be communicated and translated into a three-dimensional object. That skill, namely, the ability to draw, can be learned.

Most people can develop their graphic ability to the point where drawing can be used to communicate ideas. This kind of drawing is called a *working sketch* or *croquis* (cro-key), the French word for a plan on paper. This ability is especially important in the fashion industry.

This book gives the reader a short-cut method of drawing a working sketch by using *figure templates* (we call our female model Sybil and our male model Sam), tracing paper, carefully scaled basic silhouettes (the shape and outline of a garment), and a great variety of details like sleeves, pockets, collars, and so on. With these tools, drawing skills can be developed which allow the

Illustration Courtesy StyleLens.com

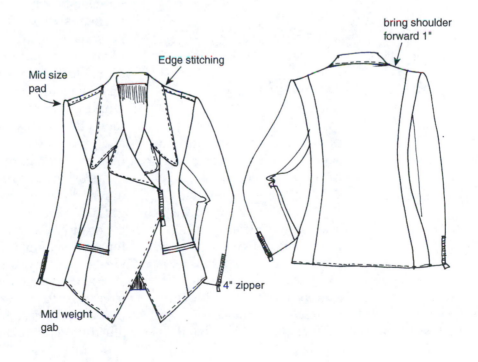

Mid size pad

Edge stitching

bring shoulder forward 1"

Mid weight gab

4" zipper

3

Sample makers use the working sketch as a guide when constructing the garment. The working sketch is used to identify patterns. Pattern makers or assistant designers sketch the garment again for cost sheets, catalogs, sales sheets, and the like.

Buyers who can sketch will often make picture notes of garments they are purchasing. The trend in retailing is to create merchandise for a store. Buyers copy styles from major designer lines which have sold well in their stores and have the garments manufactured in quantity for a lower price than the original. The copied garment is called a *knock-off*.

Today, many buyers must sketch and use photographs or samples to describe garments to the manufacturer who produces the garment. Many retailers have purchased commercial SNAPFASHUN® software systems to aid their buyers when styling special merchandise for a store.

Fashion consultants are specialists in selecting garments which flatter persons who have special wardrobe requirements. They often work with custom designers and must create working sketches to advise their clients on what to wear and guide the dressmaker who sews the garment.

Fashion *illustrators* have a different purpose in drawing a garment. They want to enhance the original design concept. Illustrators emphasize current ideals of beauty to create a stylized, exaggerated version of reality which is designed to sell the garment. Fashion illustration requires a high

reader to modify basic silhouettes and combine details to create a wide range of garments.

FASHION CAREERS THAT REQUIRE SKETCHING

Many careers in fashion require drawing skills. Designers sketch their ideas so they can be interpreted by pattern makers. The working sketch, also known as a "flat," must accurately show the silhouette and style details. The sketch should be drawn to scale so technicians can accurately gauge the size and placement of the details. *Designers* often write specifications alongside the sketch to describe the garments in greater detail.

degree of artistic achievement. Rendering the fabric, selecting the appropriate model pose, makeup, hair style, and attitude require a great deal of drawing ability.

THE BASIC FASHION FIGURE

Each era has an ideal of beauty. Today's female fashion figure is tall, slender, and athletic. She has broad shoulders and a small bosom so clothes drape easily over her body. The modern male fashion figure is also tall and slender, with broad shoulders and slim hips.

The *proportion* of fashion figures is measured by the number of head lengths that comprise the body. A realistic fashion figure is seven-and-one-half heads. This length is further extended by drawing the foot with an exaggerated perspective to create a visual base for the figure. This figure is called an *eight-head figure*. Study the diagrams of the *Snap Fashion* template you will use. The basic blocks which comprise the body and actual templates have been compared to head heights; body landmarks are clearly designated.

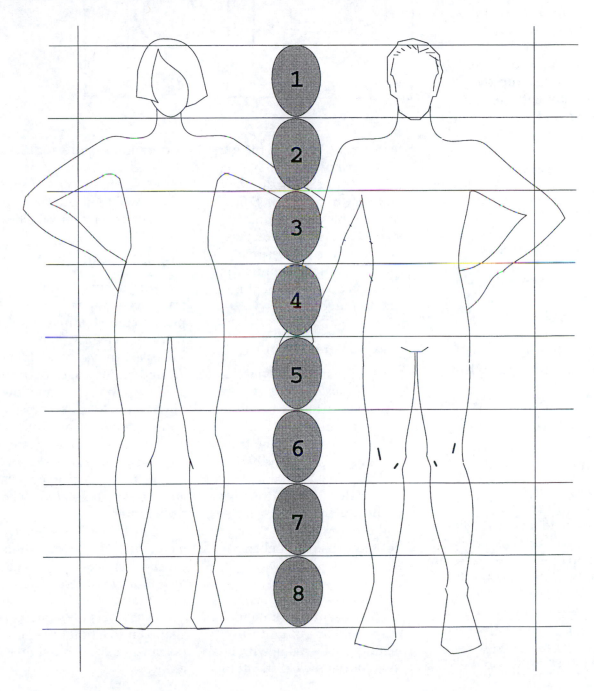

Fashion illustrators often exaggerate the body by elongating drawings to nine- or ten-head lengths. Length is usually added to the neck and legs. Drawing skill is necessary to successfully draw an exaggerated fashion figure. Expensive apparel is often illustrated on exaggerated models.

Snap Fashion templates have realistic proportions because most working sketches reflect reality. Placement and size of details are easier to read. As your drawing skills improve, experiment with freehand drawing and a high fashion, nine- or ten-head figure.

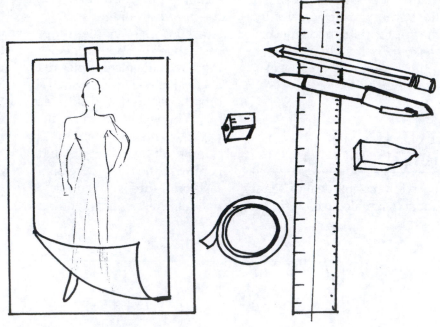

BEGINNING DRAWING SUPPLIES

To begin using *Snap Fashion*, you will need basic art supplies. Start with the simplest tools to begin developing your sketching skills. More sophisticated equipment is listed in Chapter 12. Skip ahead to this chapter when you want to begin experimenting with color and fabric rendering.

Papers

Overlay, tracing, or *vellum transparent papers* are necessary tools when using this book. *Overlay paper* is the most opaque, but is also quite durable. Details are more difficult to see, but overlay paper is quite inexpensive. *Tracing paper* is inexpensive and easy to use because it is very transparent, but it also tears easily. *Vellum* is the most expensive paper, and has the advantage of being durable and very transparent. Start with a tablet approximately 9" by 12". As your sketches become more professional, you may wish to mount your work on opaque paper or illustration board.

Markers and Pencils

Start with a dozen *number 2 soft lead pencils* and sharpen all twelve. Change pencils as the points become blunt. Most people find pencils to be the most "user-friendly" marking tool available. You can shade, alter the thickness of the line by pressing harder, and erase mistakes. Most designers use a number 2 pencil for all their preliminary sketches.

A *fine-line, black marker* is another useful marking tool. A crisp, bold line of uniform texture can be made with this tool. Markers are difficult to correct and require additional skill to draw a single line to depict an object. A *fine-line, red marker* will help you make corrections on your sketches.

Other Equipment

Use *masking tape* to hold the translucent paper on the plastic figure template while you are sketching. Then you can easily move the template around on the pages of details to line up the figure and the illustration. Masking tape is easily removed from both tracing paper and template.

A *portable pencil sharpener* is a must for keeping pencils sharp so small details can be drawn precisely.

An *18" by 2" see-through plastic ruler* is an excellent tool for checking your drawings and adding borders to a presentation.

Kneaded erasers can be shaped into a point to erase portions of your drawing easily.

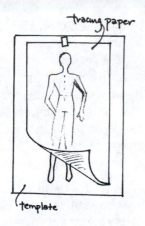

tracing paper

template

GETTING STARTED: THE SNAP FASHION TRACING METHOD

Each chapter in Unit II deals with a different type of garment. Construction methods and design guidelines for each type of garment will introduce the chapter. Using the figure template is the same for all types of apparel.

1. Tape a fresh piece of transparent paper to your template.
2. Select the garment silhouette first. This silhouette should most

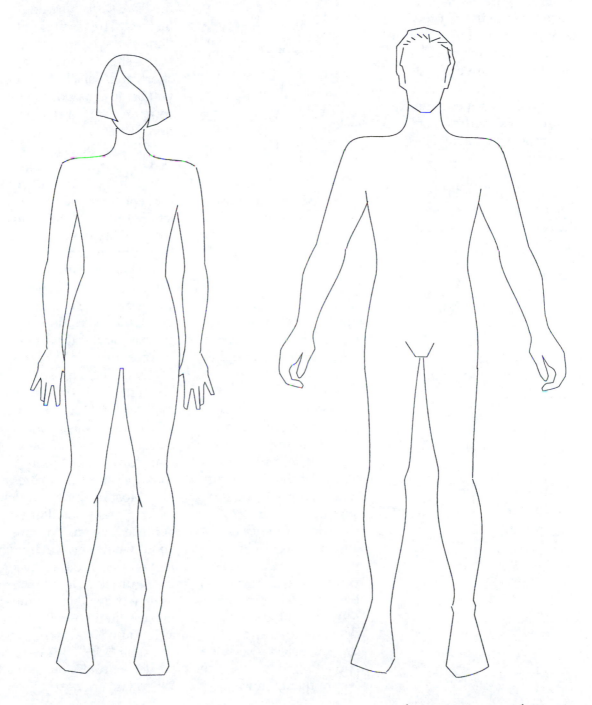

closely match your idea for a garment.

3. Decide how long the garment should be. Each of the basic bodies is designed for a typical length. For example, the dress silhouettes typically have hems that fall at mid-knee. Shirts for both men and women usually hit mid-thigh. Line the hem line of the basic garment with the figure template at the desired length and sketch the hem line and lower third of the garment first.

4. Move the template to the waist if you are drawing a skirt or pant, or to the underarm if drawing a shirt, jacket, or dress. Be sure to place the middle line on the template over the center of the garment so your sketch is

balanced. Measure the illustration if you have trouble finding the center. Sketch the shoulder or waist line. Sketch the portions of the garment that you will modify later very lightly. Blend the top third of the garment with the details and the hem of the rest of the sketch.

5. Add sleeves to the garment by lining up the torso drawing with the sleeve styles provided. Draw the shoulder seam when designing a set-in sleeve at this time. You can add or modify the length of sleeves just as you did the hem line of your garment. Add waist details to skirts and pants.

6. Move on to the neckline detail for tops and dresses. Select a neckline and add it to your sketch. Notice that men wear

buttons left over right. Women wear buttons right over left.

7. Add the pocket and trim details. Guidelines for placing these details are found at the front of each chapter on specific garment types.

Now let's practice actually drawing some garments so you can perfect the *Snap Fashion* tracing method. The six projects demonstrated are a dress, a man's shirt, and two pants, a short, and a slack. Each detail will be designated, so you can compare your drawing to a final sketch.

Before we begin, practice making a strong, firm line with your number 2 pencil. Pretend that you are making a large letter "O." Hold the pencil comfortably in your hand, firmly, but without tension. Draw without lifting the pencil from the surface of the paper. Circle the pencil many times, in a spiraling motion and practice applying several kinds of pressure. Pressing firmly on the paper makes a bold line. Little or no pressure makes a light, delicate line which can be easily erased or changed. The variation in line makes the pencil "user-friendly" and very expressive.

Most beginners sketch by making many small lines because they are insecure about what they are drawing. As you begin to trace using the figure templates, resist the urge to draw "hairy" lines but make a single pencil line, just as if you were drawing your freehand "Os." This technique creates a professional sketch. When you are nearing a

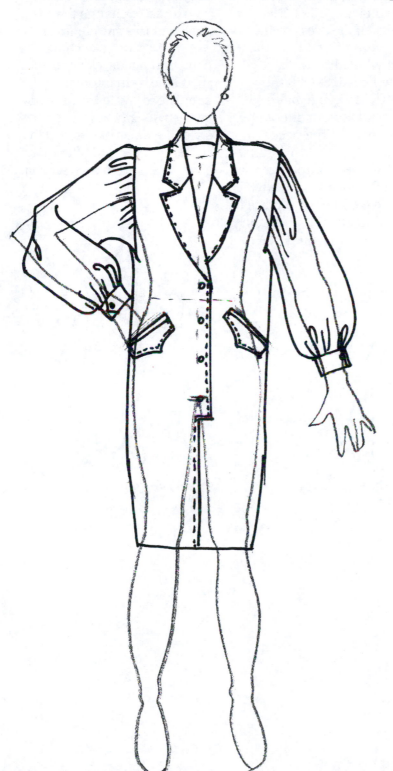

practice making smooth ovals

portion of the drawing that will require modification, lighten the pressure on your pencil. Use firm pressure and a bold line for the silhouette of the garment, because that is the most definitive part of the drawing. Lighter, more precise lines are best to draw crisp collar, pocket, pleats, and other details.

The Dress

Tape a fresh piece of paper to the Sybil template. Use the *tent basic dress body* pictured on page 138. Place the hem line at mid-calf and draw the flared edge and bottom third of the

garment. Use a crisp line on the hem but lighten the side lines near the top because you will be blending these later on in the sketch. Align the template with the shoulders and draw in the top of the shoulders and the dress from the underarm to the waist. Blend the side silhouette lines of the dress. This garment has no internal fit lines and is very simple to draw.

Select the *bishop sleeves* on page 91. Sketch a sleeve on each arm. If you wanted to modify the cuff or shorten or lengthen the sleeve, you would do it now. Add the line which defines the armseye.

Move your template to the *cowl, basic* pictured on page 115.

Line the template up with the center of the collar and sketch in the details. Erase a part of the shoulder seam near the cowl if it interferes with the drape.

Select the *slanted slash pockets* to add to the dress pictured on page 172. Place at the sides of the dress so the hand fits comfortably in the pocket when the arm is slightly flexed. Sketch the pockets with a line that is not as bold as your silhouette line but defines the pocket crisply.

You have completed a sketch! Remove your drawing from the template and place it over the completed design in the exercise. Use a red pen to

draw the lines that do not correspond with the sketch in the book on your paper. Notice how you could improve your drawing. Think about the hundreds of different details you could have used to change the design of this simple dress.

Note: When sketching pants and hoods, elongate the silhouette by manipulating the template to create the desired garment length. Several of these styles have been shortened to conserve space and offer more style variations in each section.

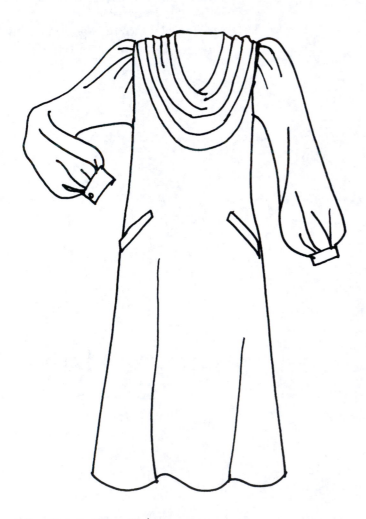

The Man's Shirt

On the Sam template, tape a fresh piece of paper that covers his figure from the knees up. Turn to the shirt bodies and use the *basic block long sleeve* on page 81. Sketch the hem line and draw the side silhouette of the shirt to the shoulder line.

Add a shoulder line that connects with the top quarter of the sleeve. Yoke details add structure and shape to a shirt and may control pleats, gathers, tucks, etc.

Now draw the shirt sleeves and add the *basic French cuffs #01* on page 98 to the sleeves.

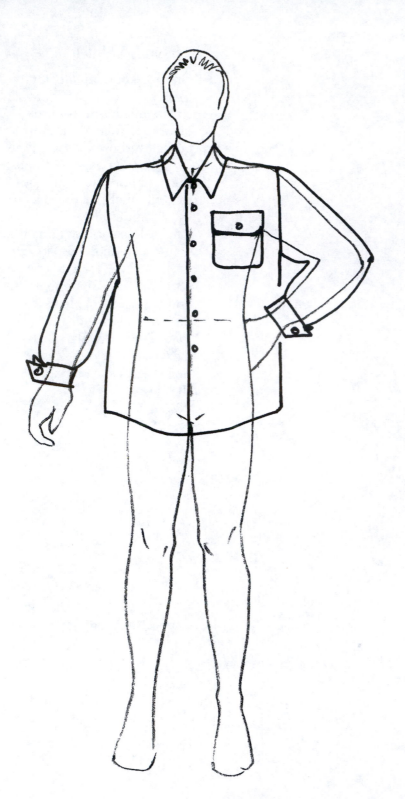

Draw the front placket. Notice that men's shirts button the opposite direction from women's garments. Draw the basic shirt collar.

Line up your Sam template with the *patch-button flap pocket* on page 172 and sketch one breast pocket on the left side of the garment. Place the pocket over the breast and in the center of the left side of the torso. Remember that the pocket is actually drawn on the right side of the garment as you look at your sketch. To understand this concept better, place your sketch over your chest as if you were Sam, and you can see that the pocket falls on the left side of the actual figure. Traditional, one pocket men's shirts have a single pocket on the left side so a person can reach with his right hand to easily remove a pencil or other object.

Again, remove your sketch from the plastic template and place it over the finished drawing of this shirt. Correct your drawing with a red pen.

Styled Pants and Shorts

Tape a piece of paper to the Sybil template. Turn to page 143 and sketch the *tailored-basic pleated pant*. Do not draw the belt or back pocket detail.

Turn to page 173 and line the Sybil template up with the *high-pleats and tab waist*. Sketch in these details.

Move your paper over so you have a fresh area over the Sybil figure. Turn back to the *tailored-basic pleated pant* and draw the pant to Bermuda length, approximately five inches above the knee. You may wish to taper the side of the pant so the Bermuda shorts are not as full as the trouser. Sketch in the body of the pant as you did with the basic trouser.

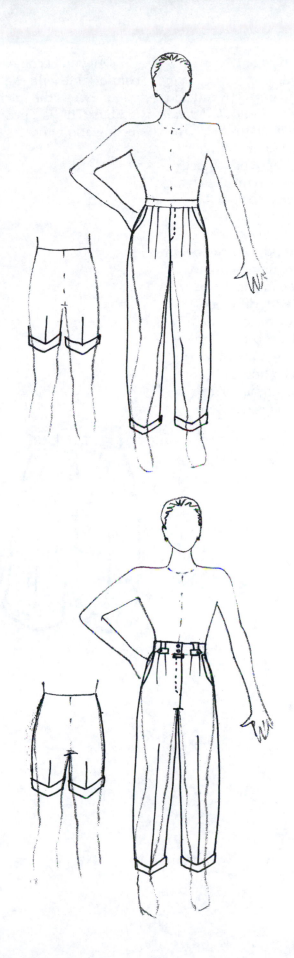

Turn to page 174 and sketch in the *three-pocket jean fly*. Then skip to page 166 and add the *western buckle and belt* detail.

If you wish to sketch the back pocket detail on your pants, you can work directly from the basic pant sketch and add a novelty pocket.

Now that you have practiced the *Snap Fashion* sketch method, you can begin to innovate. Remember to leave out details that you wish to replace with different treatments, or sketch them in very lightly, and then draw the new design over them with a bolder line. There are an infinite number of garments you can design.

As you become more comfortable with sketching, you may feel the tracing is tedious. This is a positive feeling and indicates that you are ready to begin drawing details freehand and become more independent and inventive.

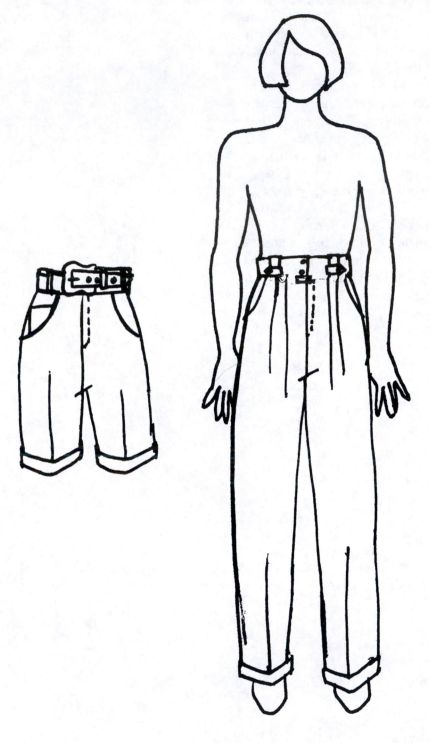

REVIEW

Word Finders

Define the following words from the chapter you have just read:

1. Bermuda shorts
2. croquis
3. eight-head figure
4. fashion consultants
5. fashion illustrators
6. hem line
7. kneaded eraser
8. knock-off
9. masking tape
10. overlay paper
11. soft lead #2 pencil
12. silhouettes
13. template
14. tent dress
15. tracing paper
16. transparent
17. vellum
18. working sketch
19. yoke

DISCUSSION QUESTIONS

1. What are the differences between a working sketch and a fashion illustration?

2. What fashion careers require the ability to draw a basic working sketch?

3. What order should a designer use when sketching a garment?

4. Discuss the best papers to use when tracing a working sketch.

Basic Design Principles

Illustration Courtesy StyleLens.com

The *esthetics* (appearance) of a garment is a combination of the color, fabric, shape (also called silhouette), and details. A garment is made from flat fabric that covers the human body, a three-dimensional moving form, which must be constructed to allow a person to move. The esthetic value of a garment is measured by the fashion standards of the period.

Designers learn how to construct garments by draping fabric around a standard size garment form and making a pattern which fits the body. This trains the designer to think of how a garment should be made while at the same time evaluating the fabric determining how to shape it to the human form.

Flat sketches are shorthand methods of communicating design. They are two dimensional, that is, they have height and width, but in the designer's mind, a flat sketch represents a three-dimensional garment. Designers may sketch the back of a garment to indicate how it is styled, but usually details are on the front of a garment.

Observation is an important design skill. Observing how garments are constructed, learning to sew, investigating the inside of garments to see how they have been made are steps on the path to becoming a designer. The habit of touching fabric to evaluate the *hand* (the texture, density, and flexibility of the cloth) should be almost instinctive for a designer. Early in their careers, designers learn that flexible fabric requires fewer construction details to shape the cloth into a garment. For instance, knit fabrics, the most flexible textiles, often have enough stretch to be shaped with side seams only.

Four elements are the basic ingredients of a garment:

1. *Silhouette*—the shape and outline.
2. *Line*—the internal structure.
3. *Color/Value/Texture*—the combination of colors and the density and hand of the fabric.
4. *Details*—the accents, trim, and subordinate parts.

SILHOUETTE

The silhouette is the starting point for most flat sketches. The designer evaluates a fabric and imagines how it will cover the body and selects a silhouette which is compatible with the fabric hand. Fashion dictates the silhouette. The shape of clothing changes often, reflecting lifestyle, how the garment will be used, and the ideal of beauty for the period. The length of a garment radically alters the proportion of a silhouette. Modern lifestyles are so diverse that many silhouettes are acceptable.

The *natural silhouette* conforms to the body shape exactly. Bathing suits, fitted sweaters, leotards, and other active wear are typical natural silhouette garments. Often these categories of clothing are made of stretch fabrics. Color, pattern, and line are important styling devices for the natural silhouette. Darker colors reduce the visual size of a body, bright colors command the viewer's attention, and light bright colors make the area covered seem larger.

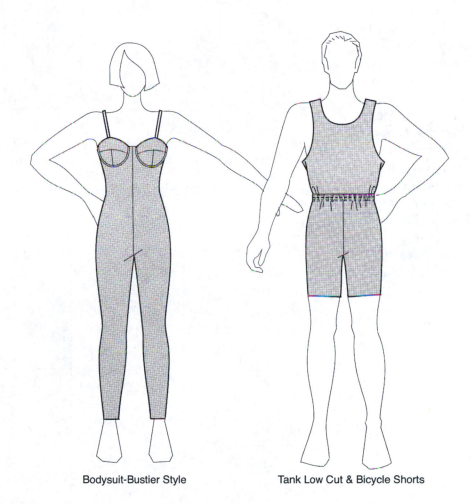

Bodysuit-Bustier Style Tank Low Cut & Bicycle Shorts

Slim silhouettes follow the line of the body closely but have enough ease to allow the body to move when made from fabrics which do not stretch. Ease is the difference between the actual body measurement and the size of the garment. Minimum ease for women's wear allows a conventional garment to move. Four inches at the bust, two at the waist line, and two at the hip line are typical allowances. In fact, most garments made from rigid fabrics have more than minimum ease requirements, and the looser fit becomes part of the garment's style, called *style ease.*

A slim silhouette with no waist emphasis becomes a *rectangle.* Casual apparel for both sexes is often this shape. The style lines dividing this silhouette into various color and texture areas must be carefully used or a person will look short and wide. This silhouette is useful for camouflaging a thick waist. When extremely full clothing is worn, the rectangular shape of the body is emphasized. Cold weather clothing like bulky sweaters and coats typify the rectangular

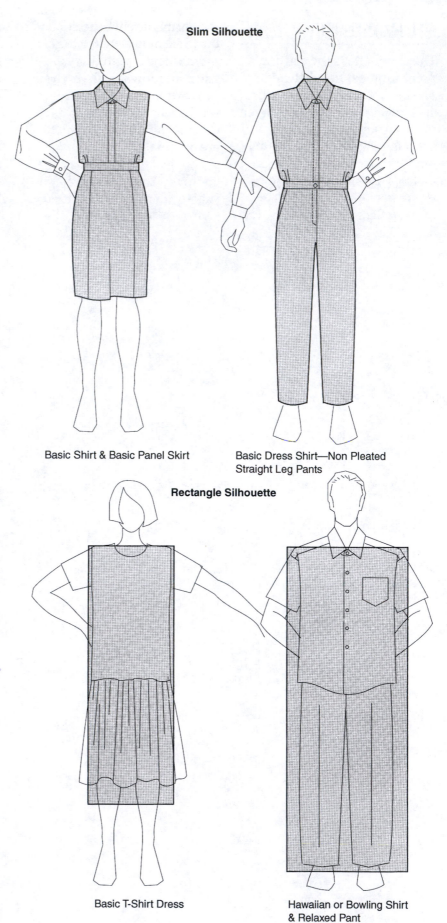

Slim Silhouette

Basic Shirt & Basic Panel Skirt

Basic Dress Shirt—Non Pleated Straight Leg Pants

Rectangle Silhouette

Basic T-Shirt Dress

Hawaiian or Bowling Shirt & Relaxed Pant

silhouette. When worn with snugly fitted garments below the waist, such as stretch ski pants, the bulky garment contrasts with the slim part of the body and does not make the wearer look as large. Rectangular silhouettes made with transparent fabrics hint at the slim body underneath, and make the wearer seem more slender.

When the slim silhouette has padding, fabric volume, and/or horizontal style details added to the shoulder area, it is called a *wedge* or *V shape*. This silhouette is typical of a young, athletic man and is a classic men's wear shape. When wedge-shaped silhouettes are fashionable for women, wider shoulders are achieved by adding shoulder

Wedge Silhouette

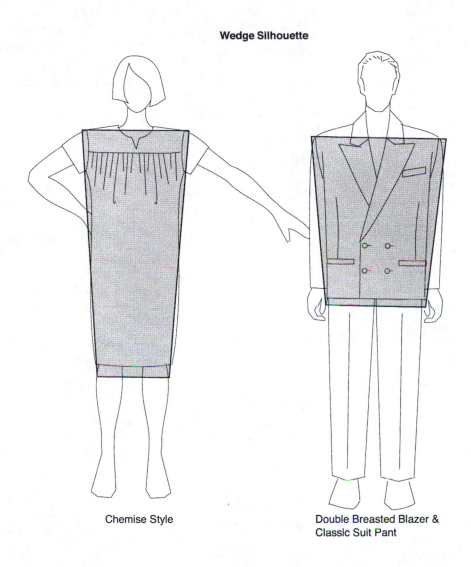

Chemise Style

Double Breasted Blazer &
Classic Suit Pant

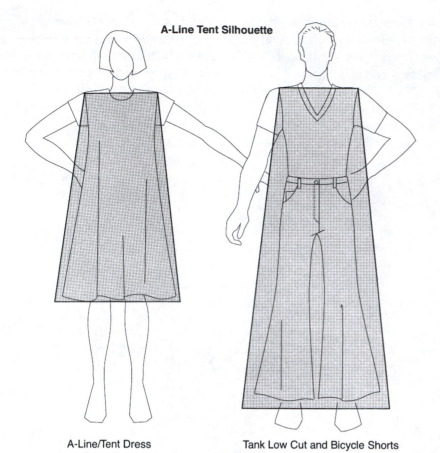

A-Line Tent Silhouette

A-Line/Tent Dress Tank Low Cut and Bicycle Shorts

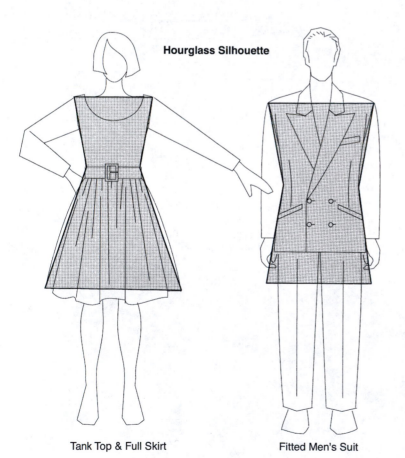

Hourglass Silhouette

Tank Top & Full Skirt Fitted Men's Suit

pads and horizontal design lines at the shoulder. Wedge silhouettes emphasize a person's height and make the hip line seem smaller. Sleeves cut in one with the bodice (like a raglan, kimono, or dolman sleeve) are popular styles when wedge silhouettes are fashionable.

The *tent*, *flare*, or *A line silhouette* is the opposite of the wedge. A narrow shoulder line is emphasized by a flared skirt or pant. Almost never used in men's wear, this silhouette is a classic maternity and little girl's dress silhouette and goes in and out of fashion in women's wear.

When the waist line of a wedge or "A" tent shape is fitted or belted, the *hourglass silhouette* results. Fitted men's wear is a less extreme version of this silhouette. The hourglass silhouette is a classic feminine shape. Evening wear often has an hourglass silhouette.

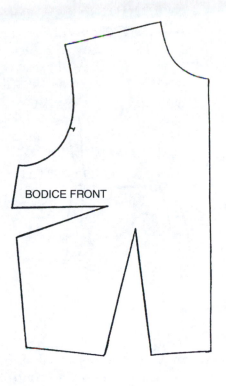

BODICE FRONT

LINE

Line refers to the seams, darts, yokes, and gores which divide the garment into sections. This design device shapes fabric to the body. A *seam* joins two pieces of cloth together. Most garments have side seams which do not impact the style of the garment greatly. Seam lines used in the front and back of garments require careful placement because they divide the space into parts which must be proportioned well to create a pleasing and flattering design.

Darts shape fabric to the body by removing excess fabric in a wedge shape. The basic block for women's dresses illustrates how darts shape rigid fabric to fit a small waist and release it at the bust and hip line where the body is fuller. Darts are also used to shape fitted men's wear styles.

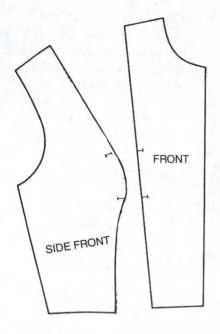

SIDE FRONT

FRONT

Gores and yokes are pieces of shaped fabric which are seamed together to contour the garment to the body's curves. *Gores* are vertical pieces of fabric, typified by the princess line for women and the side seam gores used in men's suit jackets. *Yokes* are horizontal pieces of fabric typically used at the shoulder or hip to shape fabric and control ease or fullness.

Some universal design principles govern the use of line in apparel design:

1. Vertical lines tend to make a garment look slimmer and the person taller.

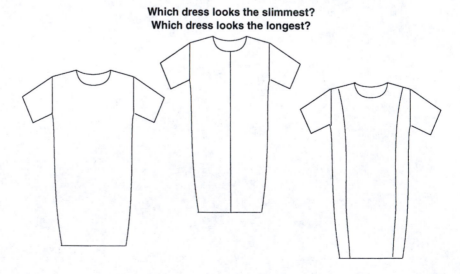

Which dress looks the slimmest?
Which dress looks the longest?

Which dress looks the slimmest?

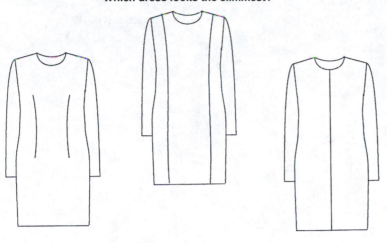

2. Vertical lines which extend from the hem to the torso are more slimming than interrupted vertical lines.

Which dress looks the longest?

3. The more unequal a horizontal division in a garment is, the taller and slimmer a garment will look. The more equally a rectangle is divided, the squarer the total area will look.

Which dress looks the slimmest?

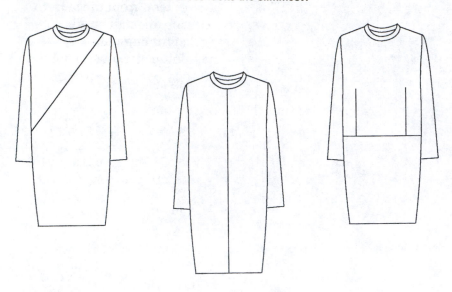

4. Diagonal style lines are slenderizing.

Which dress looks the slimmest?
Which dress looks the tallest?

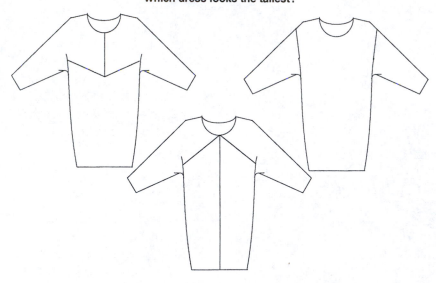

5. Diagonal style lines which form an arrowhead are more slimming than those which form a V because they draw the viewer's eye upward.

Which garment looks the longest?

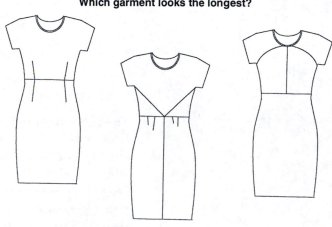

COLOR/VALUE/ TEXTURE

Color

Color selection is governed by personal preference, the season a garment is designed for, and commercial color trends. The American consumer is fascinated by color. Many people have their complexion, hair, and eye colors analyzed by professionals who then recommend the most flattering colors to wear. Most color systems divide human complexion pallets into warm toned skin colors which have yellow undertones, and cool, for blue undertone skin colors. Complimentary colors flatter the complexion of warm and cool color types. For example, red can be worn by both color palettes, but warm-toned complexions look best in a red with yellow in it, and blue-toned complexions are most flattered by a red toned with blue. To read more about color types, investigate the Ameritone Color Key System, or one of the many personal color analysis books on the market. The commercial designer should be aware of color selection driven by personal consumer preferences and offer a wide range of color selection in a specific line.

Seasonal colors are selected by analyzing traditional favorites in the context of commercial color predictions. Again, variety is the key to successful color selection. Neutral colors such as black, white and off white, navy, beige, taupe, and the gray family are included in almost every line. Fashion colors are used more sparingly to update the basics. Warm colors such as red, yellow, and orange should be balanced with cool blues, greens, and purples.

Color predictions are made by fiber and textile companies to guide designers to select the latest shades. Fashion publications and designer lines experiment with new colors first. Colors which are successful in expensive apparel are often incorporated into volume lines later on in the year.

Geography makes a difference in color selection. Tropical climates favor bright colors, often accented with white which reflects the sun. Urban dwellers prefer neutral, dark, and muted colors typically worn for business. Rich, deep jewel tones and dark neutrals are popular colors for colder climates.

The fashion designer has to be aware of how illusions are created when colors are combined and used as accents on various parts of the body. Some basic rules for using colors are the following:

Light Colors:

1. Make the area covered seem larger.
2. Direct the viewer's eye to the light area when contrasted with a large area of dark color.
3. When worn at the neck, they emphasize and call attention to the face.

Dark colors make the part of the body covered look smaller than light colors do.

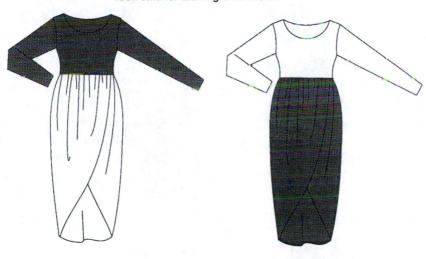

The eye is directed to the light areas of the garment.

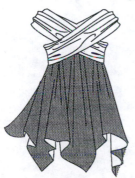

Bright colors contrast areas of a garment and focus attention on the area.

Bright Colors:

1. Stand out or "pop." When combined with a large area of dark or neutral color, the bright accent will attract the viewer's eye and emphasize the part of the body it covers.
2. Reflect on the face. Warm colors like red and pink make the complexion seem rosy.
3. Large areas of bright colors can cause eye fatigue.

Color shaded areas with a red pen or pencil. Notice how prominent the accents appear. Notice how awkward contrasting areas at bust and crotch look. Avoid accenting these areas.

Dark colors deemphasize the size of the body.

Dark Colors:

1. Recede visually and make the part of the body they cover seem smaller.
2. Worn near the face make a sallow complexion seem unhealthy or tired.

Value

Value is the contrast between light and dark. The designer balances the use and strength of color to create subtle illusions and is often called upon to match and blend colors so various components of an outfit are compatible. Dyed to match colors in different fabrics are usually blended and there is no attempt to match them exactly.

Printed fabric gives added dimension to a garment. Designers who have the commercial ability to select patterns which appeal to a specific market segment develop their skill by studying what sells at retail. When matching a style with a print, an excellent rule of thumb is to cut a simple style in a bold print, and a more complicated style in a small, simple print.

Directional prints, like stripes and geometric patterns, can be engineered to emphasize style details. Observe and experiment with geometric patterns to see how they change a design. Remember, horizontal patterns emphasize width, and vertical lines lengthen the figure.

Texture

Texture, a visual characteristic that affects the hand of the fabric, is a result of the way the textile is constructed, the fiber and yarn used, and the way the fabric is finished. Draping fabric on the dress form and sewing fabric to create garments teach a person how textiles react in various silhouettes. Converting textiles, flat two-dimensional material, into apparel provides essential training for the commercial designer exactly as working with clay and molding it into plates, bowls, and other items teaches the potter his craft.

Shiny fabric reflects light and visually enlarges the area it covers, especially when a garment fits snugly. Fabric with a low luster reflects the light to a lesser degree than a shiny fabric and subtly enhances the wearer's face. Silk crepe is a typical low-luster fabric. Matte fabric has no luster, does not highlight the area it covers, and is a camouflage especially when dyed a neutral or dark color.

Crisp, absorbent fabrics, like cotton and linen, are appropriate for summer clothing because they absorb perspiration and allow the

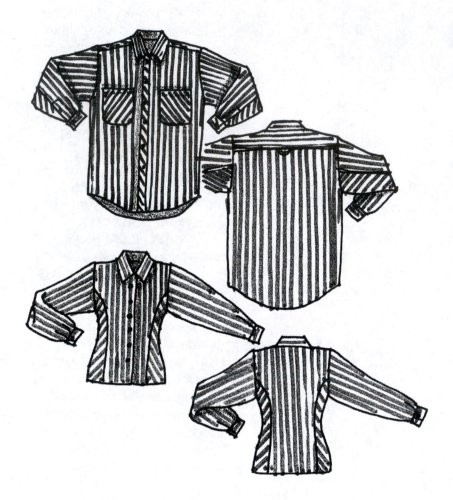

body to breath. Spongy fabrics with a soft and lofty hand feel warm because the thickness of the fabric retains the body's heat. Thick coating weight woolens and quilted fabrics are appropriate for cold weather outerwear because they insulate by keeping the body's heat from escaping.

Observe and experiment with fabric to learn how the intrinsic characteristics of textiles translate into garments which are appropriate for various practical end uses and styles.

DETAILS

The final ingredients in designing a garment are the *details*. Collars, sleeves, cuffs, pockets, and trims like buttons and ornamentation are added to the basic silhouette and structure of a garment to provide accents and interest. Details should complement the other components of a garment, and often the style will sell because of unique details. A basic shirt, for example, may appeal to an upscale customer if it has a novelty pocket, unique embroidered motif, or unusual buttons.

Details can be combined in many ways. Fashion designers track "hot" details and interpret them in different ways when it is clear they appeal to the customer. "Versions" are variations of a garment which have similar details to styles which have sold or "checked" at retail.

An infinite variety of styles can be created by varying the details, silhouette,

line, and fabrics that comprise a garment. The way these elements, the ingredients of a garment, are combined are governed by the principles of design.

DESIGN PRINCIPLES

The *principles of design* are the rules or directions for combining the elements (silhouette, line, color/value/texture, and details) into a successful style. Fashion is often defined as what is acceptable in a given time period for a specific group of people. In other words, change is a constant when defining fashion. Commercially, change is desirable, because it drives the sale of apparel. A vastly greater quantity of apparel is discarded because it goes out of fashion than because it has worn out.

If change is the nature of fashion, then it stands to reason that the principles of design change also. The designer must know what the principles are so they can be manipulated consciously to create something that is new enough to interest customers, yet familiar enough not to scare them away! Knowing what the principles are helps the designer to analyze fashion trends and apply them to the development of a specific garment. Design principles follow:

Proportion—the size of the parts of a garment in relation to each other.
Balance—informal or asymmetrical balance

and formal or symmetrical balance refer to the relationship of the divisions of a garment.
Unity—refers to how the parts of a garment work together to form a successful visual effect.
Rhythm—the way repeated lines and shapes are used in the design.
Emphasis—reinforcing a design element with contrasting trim or an additional detail.

Proportion

Proportion, or scale, is the relationship of various spaces within the garment to the whole shape. Designers modify proportion to achieve the ideal of beauty most acceptable in a specific time period.

A standard body form is used as the norm for establishing typical waist lines; shoulder, bust, and hip width; and lengths. The Sybil and Sam templates are examples of standard, two-dimensional body formats. Commercial dress forms and men's wear body forms provide standard three-dimensional shapes for developing garment fit. Garments which follow the natural body divisions tend to be fashionable for long periods of time. For example, defining a woman's natural waist line is a style classic.

A woman's garment with a fitted natural waist line and a hem which ends slightly below the knee conforms to a proportion known as the *Golden Mean*. This is a ratio of space divided 3:5:8. It is a

proportion developed by Greek artists and mathematicians who analyzed buildings and the art of earlier civilizations looking for the most pleasing visual art forms. The Golden Mean has been used in Western art for many centuries and is a classic.

Exaggerated proportions ignore the natural divisions of the body and create illusions which must be evaluated by the ideal of beauty or the fashion of the time. For example, during the 1920s, it was not fashionable to wear belted dresses. The ideal of beauty was a tall, slender, slightly masculine woman with no curves. Dresses emphasized vertical style lines and had few horizontal divisions. Bosoms were bound and short hair styles with little volume made a woman seem even taller. This fashion contrasted dramatically with the feminine hourglass silhouette, long skirts, and hair of the previous period.

During the 1960s the ideal of beauty was a young and innocent girl. Popular fashion models like Twiggie and Jean Shimpton had slender, adolescent bodies. The proportion of apparel reinforced the ideal of beauty. Very short, tent-shaped dresses, and a typical little girl silhouette were popular. Women's garments were designed with small collars, snug shoulder details, and small bust lines. Teased hair gave the illusion of a large head, making the body seem even smaller by emulating a child's proportion.

These two examples show how the image of beauty

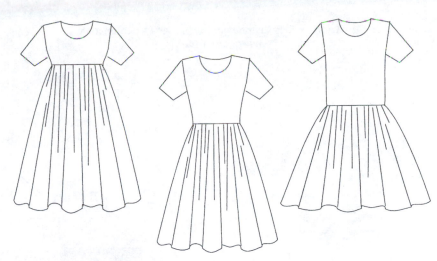

changes the proportions of a fashion period. A designer must learn what illusions are created by using different proportions and match the ideal of beauty to the taste of the time.

Design rules governing proportion follow:

The greater the difference between the size of the parts of a garment, the taller the wearer will look. The empire dress has a style line right under the bust. It makes the figure look longer than a dress belted at a natural waist. Drop the hem line to the floor, and an even taller illusion is created. This is a favorite silhouette for wedding dresses and negligees.

A drop torso dress reverses the proportion, putting the smaller portion at the hem line, contrasted with a long, usually straight top. This proportion also creates the illusion of height.

Apply this rule to a very short skirt. When colored stockings are worn, the illusion becomes very clear. Short skirts contrast the length of the leg to the size of the garment and make the legs look longer. When contrasting garments are worn, the emphasis between the two parts of the ensemble are exaggerated.

When a garment is divided into equal horizontal spaces, the body looks short and wide. This rule is especially important when designing maternity wear. The top must be

Hose and skirts the same color visually extend a person's height.

Equal horizontally divided garments make a person look shorter and wider.

Garments with design elements emphasizing width make other parts of the body seem smaller.

long enough to cover the protruding stomach, and often it divides the figure visually in half. The wider girth of the midsection is emphasized. To avoid this proportion problem, design maternity tops long enough to reach the thighs or below, or use the tent shape to camouflage the stomach and emphasize vertical style lines. The same design rule applies to men with a large stomach. Long shirts are not necessarily the answer. Camouflage a prominent stomach with an appropriately fitting jacket and the same color pant and jacket to make the person seem taller and slimmer.

Width makes smaller parts of the body seem even smaller. Garments which emphasize the width of the shoulder make the hip and waist lines seem smaller. Men's business suits use this principle to make the wearer seem taller by padding the shoulder line. Women's wear designers use flared skirts to emphasize a slim waist line and to make legs seem slimmer.

Balance

Balance refers to the visual weight of various parts of the garment, and how they relate to each other. There are two kinds of balance:

1. *formal* or *symmetrical balance*; and
2. *informal* or *asymmetrical balance*.

Formal balance is achieved when a design is divided into two equal parts; in other words, the parts are symmetrical. *Informal balance* has differing elements and spaces which are asymmetrical and usually have a more casual appearance.

Vertical Balance

The human body is *vertically balanced*, which means the figure appears to be the same on each side of a central vertical line. Two eyes, two legs, two arms, and two breasts are balanced opposite each other. Actually, there are slight discrepancies in a normal human figure, so if one half of a face or figure were duplicated exactly and reversed to produce a picture of a whole face, the picture would look quite different from the actual person. The human eye ignores minor discrepancies because of the dominant symmetry of the body. Clothing is often adjusted to compensate for minor discrepancies, like padding a low shoulder to match its counterpart.

Symmetrical or formal vertical balance is the more usual design solution for most garments. Asymmetrical divisions of a garment require greater sensitivity so they relate to the dominant symmetry of the human form.

Although not truly symmetrical because of the placket, the balanced trims dominate this design.

Informal asymmetrical balance

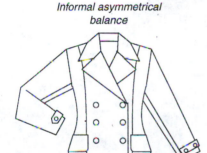

Formal asymmetrical balance

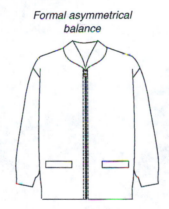

Horizontal Balance

Horizontal balance of the human figure is asymmetrical. The current ideal of beauty idealizes long legs for both men and women compared to their torso. Clothing is designed to enhance this illusion.

Horizontal balance becomes extremely important when visually correcting figure problems. The "balanced" woman's figure has a bust and hips of about equal size. When a woman has an exceptionally wide hip line (called a *pear-shaped figure*), the condition can be minimized visually by emphasizing shoulder width and camouflaging the size of the hips. Conversely, a woman with a large bust can minimize the torso by focusing on the fuller hip line created by a flared or pleated skirt. The principle of padding the shoulder to balance a wide stomach or hip girth can be equally applied to men's wear.

The way an outfit is colored visually balances a figure with irregular proportions. Apply the principles of accenting or camouflaging an area with color described on pages 25–27 to emphasize the small areas of the figure and neutralize the larger parts of the body.

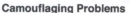

Camouflaging Problems

A round collar and pockets are compatible with the curved princess lines.

Details focus attention on the part of the body they are applied to. When they are the same color as the rest of the garment, the illusion is subtle. Contrasting details command the viewer's attention. Pockets, for example, placed at the bust line make it seem larger.

Pockets at the hip place the emphasis there. Contrasting pockets call immediate attention to the area they cover. Add details to balance the composition of an outfit and correct figure problems.

Contrast details emphasize the area they cover.

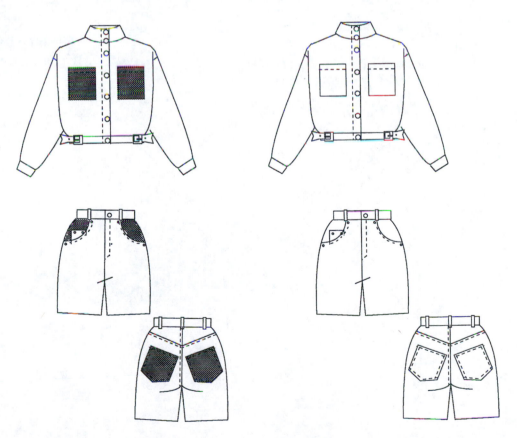

Darts do not complement angles of domain sleeves.

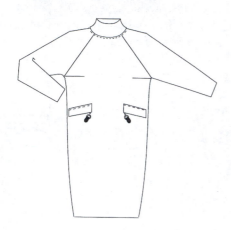

Connecting darts to ease is more consistent with the curved domain sleeves.

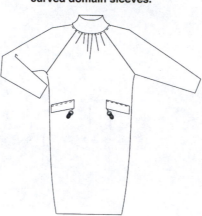

Unity

Unity means all the parts of a design work together to create a successful visual effect. Details, fabric use, and style lines should complement each other. Some specific guidelines include the following:

1. Style lines should have compatible angles which complement each other.
2. The shapes of details within a garment should be compatible (see illustration at top of page 45). Avoid combining curved and straight design details within a single garment.
3. Geometric patterns, like stripes and plaids, when used on the straight grain, should match. Bias or diagonal patterns can be contrasted with straight patterns but should match each other.
4. Avoid small "jogs" in style lines. Blend the fitting lines used in bodices and bottoms so they have a continuous flow.

Line up stripes on sleeve and body of the garment.

Align style lines in the bodice and skirt, avoiding small jags in design.

Uniform Rhythm

Rhythm

Rhythm is the repeated use of design motifs to create a pattern. The repeated use of lines of similar shapes leads the viewer's eye through a design with a flowing movement. Uniform rhythm is repeated use of the same design element. Color is often used to reinforce the shape and make the design more interesting.

Progressive or *graduated rhythm* is the repetition of a shape in increasingly larger sizes. Unequal rhythm is the use of small and large spaces to create a dynamic design. For example, a small collar on a very full blouse will make the garment seem larger than it is. Beware of using very small details on garments for large size people.

exaggerated so that it becomes the most prominent element of a garment. A classic example is the Chanel suit jacket with braid trim emphasizing the front opening, neckline, and cuffs. Emphasis should be used carefully, so that too many conflicting themes do not create a disjointed design.

Several areas of the human body are usually deemphasized. Women's street wear should avoid overemphasizing the bust line, crotch, stomach, and hips unless there is a specific purpose to the design. For example, a costume created for a Las Vegas extravaganza would appropriately emphasize the bust. Men's wear usually avoids emphasis on the crotch.

Graduated Rhythm

Emphasis

Emphasis is the center of interest created when detail or style is outlined or

Chanel Style

REVIEW

Word Finders

Define the following words from the chapter you have just read:

1. asymmetrical balance
2. darts
3. balance
4. ease
5. emphasis
6. esthetics
7. Golden Mean
8. gores
9. fashion
10. hand
11. hourglass
12. line
13. matte fabric
14. neutral colors
15. proportion
16. rhythm
17. seams
18. symmetrical balance
19. value
20. wedge silhouette

DISCUSSION QUESTIONS AND EXERCISES

1. Discuss the elements which contribute to the esthetics of a garment. Do these change?

2. Compare and contrast the fashion image of two or more fashion periods and how the design principles of the period contributed to the ideal of beauty.

3. Design a variety of outfits which correct the following figure problems and explain how your design addresses the problem:

 (a) Make a petite woman with a large hip line seem taller.

 (b) Design a casual men's wear outfit that camouflages a large stomach.

 (c) Design a maternity outfit for an average size woman who has to go to an afternoon wedding.

Commercial Fashion Design

Defining the job of a commercial fashion designer is difficult because no two designers have exactly the same responsibilities. The average apparel firm is divided into three major departments: design, production, and sales. In many manufacturing firms, the designer may contribute to sales and production departments, as well as create the product. Mid to large size firms hire specialists to market and produce the garments, leaving the designer to develop the product and supervise the management of the design room. Usually the designer is responsible to the owner of the company or the head merchandiser of the division. Merchandisers work for large manufacturers and are responsible for store liaison, product development coordination, and sales to larger accounts.

Understanding the esthetics of how a garment is designed is only one part of a designer's job. Many other factors influence the success of a commercial garment. Following the steps required to produce a line is a good way to understand a designer's job.

TIMING

A designer must have a sense of the general fashion climate and the customer who will wear the clothes. Climate is a combination of the general economic condition of the country, current retail trends, technological developments, and new trends in fashion. A knowledge of the current events of fashion and an eye for what is to come are essential talents for a commercial designer.

Knowledge of the customer is a critical factor in designing successful garments. As noted in Chapter 1, a garment must be new enough to make the customer want to wear it, but familiar enough not to scare him/her away.

Illustration Courtesy StyleLens.com

Designers mentally place their customers on the fashion cycle. Understanding the fashion cycle is an important design skill.

The Evolution of a Fashion

A new fashion is first worn by an *innovator* who wants to distinguish himself/herself from the accepted fashion norm. Usually, but not always, distinctive fashions are high-priced designer garments, often originating in Europe. The failure rate for experimental styles is high. Some fashion starts "in the streets," created and worn by individualists who synthesize or design special outfits.

Fashion professionals are constantly looking for new trends. As a new style begins "checking" or selling to trend setters, copying the style begins in earnest.

During the second phase, the *trend setter stage*, versions of the original style are made in different fabrics. Trend setters are often fashionable society

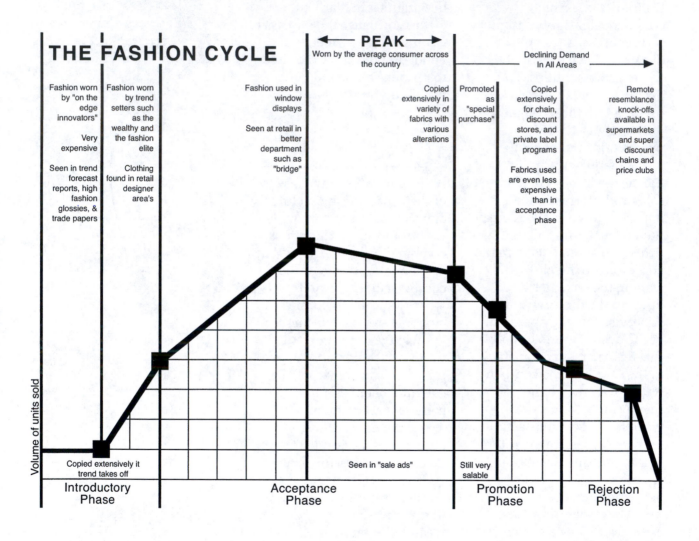

THE FASHION CYCLE

◄— **PEAK** —►
Worn by the average consumer across the country

Declining Demand In All Areas ——►

Fashion worn by "on the edge innovators"

Very expensive

Seen in trend forecast reports, high fashion glossies, & trade papers

Fashion worn by trend setters such as the wealthy and the fashion elite

Clothing found in retail designer area's

Fashion used in window displays

Seen at retail in better department such as "bridge"

Copied extensively in variety of fabrics with various alterations

Promoted as "special purchase"

Copied extensively for chain, discount stores, and private label programs

Fabrics used are even less expensive than in acceptance phase

Remote resemblance knock-offs available in supermarkets and super discount chains and price clubs

Volume of units sold

Copied extensively it trend takes off

Seen in "sale ads"

Still very salable

| Introductory Phase | Acceptance Phase | Promotion Phase | Rejection Phase |

personalities, movie stars, and other people who receive coverage in the press. Advertisements in glossy fashion magazines are common during this phase of the cycle.

The style next moves into the *acceptance phase*. The new trend is featured in window displays and image advertisements of better department and specialty stores. Buyers from volume retailers and manufacturers begin to copy the style at less expensive prices. At the peak of the acceptance phase, the style is widely copied, offered in many fabrics and colors, and often featured in high style mail order catalogs.

Classics evolve during the acceptance phase from basic garments which are worn by a wide variety of customers. Often, classics readily combine with other more novel items which greatly extend their acceptance. Classics are available at many price ranges, in a variety of fabrics, and have a wide appeal. The pleated trouser is an example of a classic which is modified slightly to reflect the style of a period. For example, the trouser leg may be tapered or widened, cuffed or uncuffed, but the trouser itself has remained popular for many years.

The style enters the *promotional phase* as more and more copies (knock-offs) are made, often with the store's own label. Budget "resources" (manufacturers) cut the style in inexpensive fabrics to minimize costs. Popularity decreases as less expensive fabrications are sold to mass merchandisers and discounters. The style is often found on sale racks and at jobbers.

The final demise of the fashion is the *rejection phase* of the fashion cycle. Now the style is so widely available in inexpensive copies that the mass of customers rejects it as an item too old to generate sales.

But wait, almost every trend comes full cycle and is freshly interpreted by a new generation. Often fashion innovators create new looks by combining period pieces with a fresh eye and starting a trend anew several decades after it has saturated the market.

Commercial designers analyze their customers, mentally placing them in a "niche," somewhere on the fashion curve. The designer looks at the fashion cycle as a whole, analyzing new trends and selecting the items, colors, and silhouettes that fit the lifestyle and fashion cycle of the customer.

Seasonal Timing

The commercial designer works from six to eighteen months prior to the retail selling period of the garment. Called *lead time*, this period allows a manufacturer to sell the garment, order fabric and trims, manufacture, and ship to the stores. Trendy items like junior dresses and sportswear are "fast turn" items and are produced closest to the time they are sold because the customer demands newness.

Imported garments (also called *offshore*) have the longest lead time, making them a prime way to manufacture classic styles. Quality fabrics and construction details are available from, for example, Hong Kong and Korea, where a sophisticated workforce can construct a high quality garment for a lower price than is possible domestically. Mass merchandisers and discounters import inexpensive garments, but their lead time is longer than domestically produced apparel which increases the risk that the fashion cycle will have passed the item by before it is shipped to the retail store.

The commercial designer has to anticipate the weather during the selling period of the garments in the store. For example, fall merchandise is shipped to stores in August and September. Often unseasonably warm or cold weather can delay the sales of an otherwise desirable garment.

VALUE AND PRICE

The price of a garment is determined by the *fabric + the make + the overhead/mark up*. For the purposes of this discussion, *fabric* includes all the textiles used in the outer and inner construction of the garment, thread, and trimmings. The *make* refers to the direct labor which includes cutting, sewing, and finishing. Overhead/mark up includes sales commissions and expenses, support services, financing, advertising, shipping, discounts and anticipation, and general overhead to run the manufacturing business.

An official cost sheet is usually begun by the designer, who accounts for all the components used to construct the garment. The production department calculates labor costs and adds them to the sheet. Usually, the sales department completes the cost sheet, adding the appropriate sales and overhead costs to determine the final wholesale price. The typical retail store approximately doubles the wholesale cost to determine the final price of the garment. A detailed

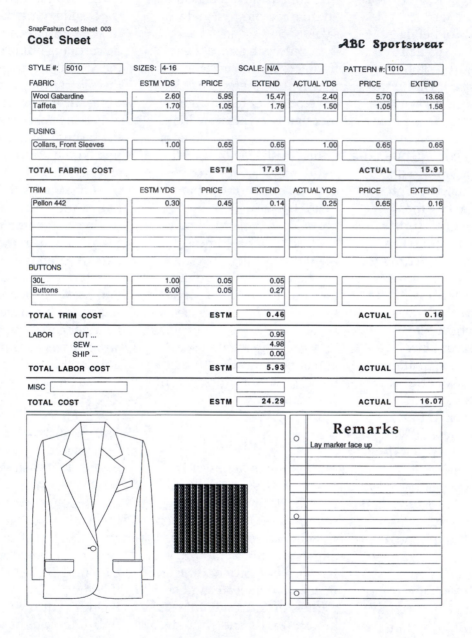

SnapFashun Cost Sheet 003

Cost Sheet

ABC Sportswear

STYLE #: 5010 SIZES: 4-16 SCALE: N/A PATTERN #: 1010

FABRIC	ESTM YDS	PRICE	EXTEND	ACTUAL YDS	PRICE	EXTEND
Wool Gabardine	2.60	5.95	15.47	2.40	5.70	13.68
Taffeta	1.70	1.05	1.79	1.50	1.05	1.58

FUSING						
Collars, Front Sleeves	1.00	0.65	0.65	1.00	0.65	0.65

TOTAL FABRIC COST ESTM 17.91 ACTUAL 15.91

TRIM	ESTM YDS	PRICE	EXTEND	ACTUAL YDS	PRICE	EXTEND
Pellon 442	0.30	0.45	0.14	0.25	0.65	0.16

BUTTONS						
30L	1.00	0.05	0.05			
Buttons	6.00	0.05	0.27			

TOTAL TRIM COST ESTM 0.46 ACTUAL 0.16

LABOR	CUT ...	0.95	
	SEW ...	4.98	
	SHIP ...	0.00	

TOTAL LABOR COST ESTM 5.93 ACTUAL

MISC

TOTAL COST ESTM 24.29 ACTUAL 16.07

Remarks

Lay marker face up

discussion of costing a garment is found in *Inside Fashion Design*, written by Sharon Lee Tate and published by Harper Collins, 1989.

The garment should be a good value for the price. If the price is too high, the customer will shop for a better value, comparing products and usually purchasing the superior garment. Because there is less competition, innovative styling tends to cost more. Manufacturers of high-priced garments build in advertising allowances to promote a new trend, and mark down allowances to cover the many styles which will not sell in volume. A classic garment is often evaluated by the fabric and make, with durability and quality being more important than innovative design.

Designers have to be aware of their customer and the retailer who sells their apparel. Shopping the stores to constantly fine-tune a sense of the value of a garment is an important part of being a designer. Overpriced garments do not fit into the established value of a category of merchandise and do not sell well.

Merchandise is divided into categories which designate large groups of customers by age and size. In women's wear, the two main size designations are junior and missy. *Junior apparel* is styled for the youthful customer, depends greatly on fast changing trends and fads, and is sized with odd numbers (3, 5, 7, etc.).

Missy styling fits a mature woman's figure and has a wide range of styling characteristics from classic to high fashion. Missy sizes are even numbered (4, 6, 8, 10, etc.) and have several

Typical Junior Styles

A Classic Missy Jacket

subcategories such as contemporary (most current styling), designer, and conservative. Bridge merchandise is designed for a stylish customer who will not pay designer prices and is more conservative than a contemporary customer. Large size, half size, tall and petite sizing are all specialty categories which offer merchandise to women who have alternate figure types.

Men's wear has similar customer distinctions, but tends to size them with greater uniformity than women's wear. Degrees of fashionability separate categories which are designated as *innovative* (very trendy, youthful styles) *directional* (merchandise for the man who wants a current image), and *conservative* (for the man resisting change). Fitted men's wear, including suits, woven shirts, underwear, jeans, and pants is sized according to waist, chest, and neck measurements. Special merchandise is made for both short and tall men.

Some categories of merchandise are sized P, S, M, L for women, and S, M, L, XL, XXL, etc. for men. This system works best for informal apparel which is loosely fitted, like sweaters and sportswear. Using these sizing systems allows the manufacturer and retailer to offer fewer units per style to cover a size range, thus lowering the cost of stocking a style.

Both men's and women's wear also divide apparel categories by how and where clothes will be worn (evening wear, daytime dresses, business suits, etc.) and by price. Manufacturers usually specialize in a specific size, category, garment end use, and price of merchandise. The designer focuses on the specific needs of these customers and researches the stores which cater to them.

the BUZZ | **EyeSpy Europe**
Fall 2006 Vol.82

COLOR

Black is the color of the moment. Black is black is back. Unfortunately black is the hardest color to photograph but the details sometimes get lost. We've manipulated those photos in order for you not to miss out on anything so please excuse some pixelation on these particular ones. They're not the prettiest but they do inform.

As we reported in our Saint Tropez issue black is no longer an evening color as we saw plenty of it during the daytime (even on the beach). Fall looks no different as black was chief among the colors offered.

Color took a very luxurious turn as the textiles had shine and sheen like satin or shiny jersey. These colors also look fantastic on many of the new cropped sweaters. Mustard and red were the # 1 pop colors while purple, inky blue, green, and gray along with black are the standard bearers. Some very good examples are provided in the TrendFile section.

Of course with all these rich autumn shades the white top has become an even stronger partner bringing any of these shades, especially black, into to the forefront. In prints add a touch of red to this dynamic partnership and you have something very saleable.

FABRIC

On the frontlines of fabric we have the usual suspects infiltrated with some newer ones.

We have the tartans, checks, enlarged windowpane, and plaids (include houndstooth and Prince of Wales) that were touched upon last year and this year has blossomed into the chief contender for shopper's focus. These patterns are a big competitor to the print market. Even some of the majors were doing print renditions of houndstooth.

A returning classic has returned in newer colorings and that is the prep motif the argyle. Like jersey! is always there to some degree but because of the checks and plaids it has been dragged out of the fashion retirement bins.

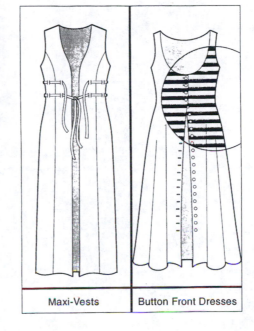

Maxi-Vests | Button Front Dresses

SOURCES OF INSPIRATION

Research is essential for a fashion designer. Fashion students should begin their education by developing good work habits. Designers read trade newspapers like *Women's Wear Daily (WWD)* as well as the category newspapers like the *Daily News Record* (men's wear). Local newspapers, glossy consumer magazines (both foreign and domestic), and store catalogs are also important. Many manufacturers subscribe to design and retail reports which inform designers about the latest trends in Europe and the United States. Examples are *SnapFashun, EyeSpy, Promostyl,* and *Tobè.*

Historic research of both photographs and actual garments offers a wealth of inspiration. Designers often have to style prints and should constantly be looking at period art and fabrics for inspiration. Designers collect trims, buttons, and ribbons.

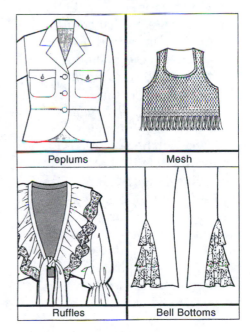

Peplums | Mesh
Ruffles | Bell Bottoms

Museums and art galleries are a rich source of inspiration. Designers study ethnic costume and how new ensembles are created by innovative people on the streets.

Designers clip ideas from newspapers and magazines. General consumer fashion magazines like *Harper's Bazaar*, *Vogue*, *Mirabella*, and *Elle* are necessary reading. Magazines devoted to a specific consumer or activity are important research for designers in specialty markets. Examples are the *Sports Illustrated* swimwear issue, *Brides*, and magazines covering specific sports. Reading foreign fashion magazines provides a wealth of new ideas which have not been edited by the American press and, therefore, have a different perspective from the *domestic glossie* (term refers to the coated paper consumer magazines are published on). Examples of important foreign fashion magazines include *Belezza, British,* and *French Vogue, French Elle, Harper's Bazaar* (Italia), *Linia Italiana,* and *Officiel,* to name a few.

A sketch book to record interesting details observed while shopping the stores is an invaluable tool. Designers keep tabs on the European and domestic designers, evaluating their lines firsthand when possible. It is also important to research volume merchandise to evaluate what is available at lower price points.

Current movies and popular television shows are good indicators of what the American public is wearing. Designers visit trend setting locals and take notes on the

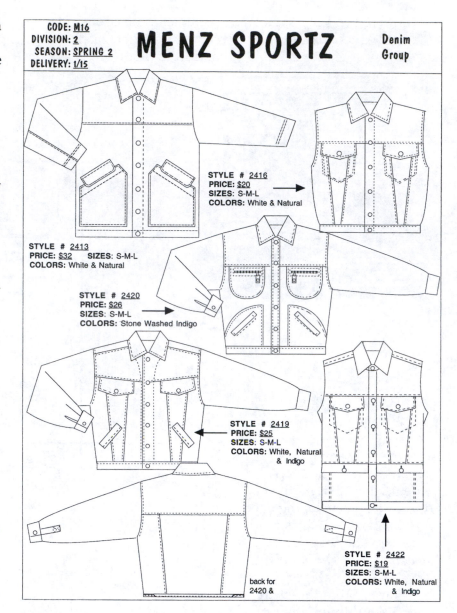

MENZ SPORTZ

Denim Group

STYLE # 2416
PRICE: $20
SIZES: S-M-L
COLORS: White & Natural

STYLE # 2413
PRICE: $32 SIZES: S-M-L
COLORS: White & Natural

STYLE # 2420
PRICE: $26
SIZES: S-M-L
COLORS: Stone Washed Indigo

STYLE # 2419
PRICE: $25
SIZES: S-M-L
COLORS: White, Natural & Indigo

STYLE # 2422
PRICE: $19
SIZES: S-M-L
COLORS: White, Natural & Indigo

back for 2420 &

people seen on the streets. Home furnishing trends also affect apparel fashions so designers read shelter magazines to study lifestyle trends.

DEVELOPING A LINE

Item and group lines are two main ways of organizing a line of apparel. *Item lines* offer retailers single styles, often interpretations of more expensive styles cut in

different fabrications and manufactured less expensively than the originals. Item lines may be manufactured for stores as private label merchandise and are not innovative. A designer for this type of merchandise researches the market carefully, searching for styles which are checking at higher prices, and interprets them for a specific market.

Item lines are also typical of high-priced designer lines which feature "wearable art"

or import high-priced apparel with limited production capabilities. Also, cottage industries (run by people who work from their homes to craft specialty items) are typical producers of item lines. The designers for this type of apparel stress creativity and are constantly innovating to cater to an innovative and trend setting customer.

Group lines are more typical of coordinated sportswear and category manufacturers. Usually, the groups are organized around fabrics and allow a manufacturer to develop a theme or story within a group. Designers must carefully coordinate the styles offered so the line has a range of items which encourage the customer to make multiple purchases. Often, sportswear groups from major manufacturers are very large so that competing stores can select diverse merchandise or color combinations. Advantages of group organization include the following:

1. Several styles are shown, but only the most successful are cut. Thus, a manufacturer has a greater chance of selling enough garments to justify ordering a minimum fabric run (for example, 3,000 yards of a print is a typical production run). A large

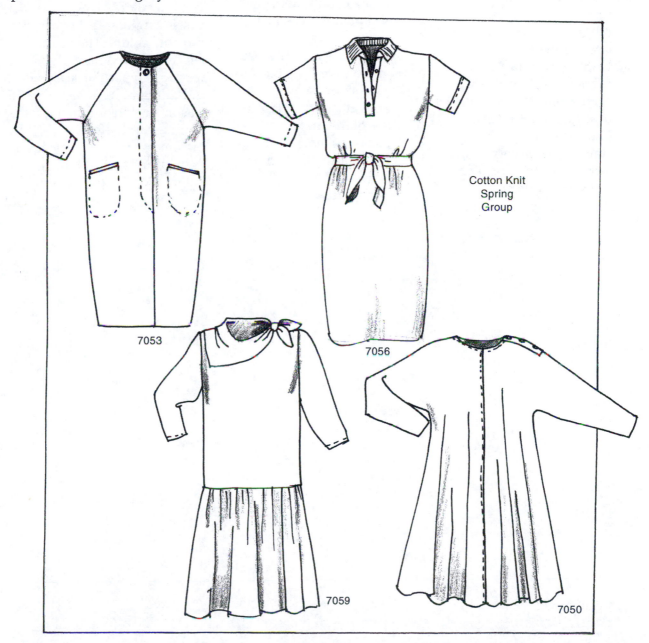

7053

Cotton Knit
Spring
Group

7056

7059

7050

fabric purchase usually is sold at a substantial discount.

2. The garments have a theme or story which creates visual impact when displayed and advertised. Sufficient stock can be purchased to allow the customer to coordinate several pieces into an ensemble which stimulates multiple sales.

3. Hot items can be repeated in several fabrics to capitalize on development costs.

4. Different colors and fabrics are selected for each group to stimulate multiple retail sales. Groups usually have staggered delivery dates which span a season and keep a flow of fresh merchandise coming into the store.

5. Fabrics can be varied to offer customers a range of prices and types of fabric. Less expensive fabrics can be styled into garments with more details.

The styles in both item and group lines should have a consistent visual image or theme. A theme is developed by repeating a trim, detail, color story, or silhouette. Colors should be seasonal, fashion right, and have sufficient variety to stimulate as many sales as possible. No piece should be so similar to another that it detracts from the sales of the first piece. Groups often have price leaders, a garment which is slightly less expensive than the others. Often, this is a garment which has become a proven seller in past seasons, and production costs have already been realized. The price leader may require less fabric or labor. This item often drives the sales of other coordinates in the group.

PLANNING THE FABRIC STORY

The color story should include fashion colors, staples (neutral colors, darks, and classic brights), and warm and cool colors. The colors selected should be appropriate for the season, and different from last season's colors, fit the type of clothing, and offer the customers sufficient selection. Each group should have a different color story.

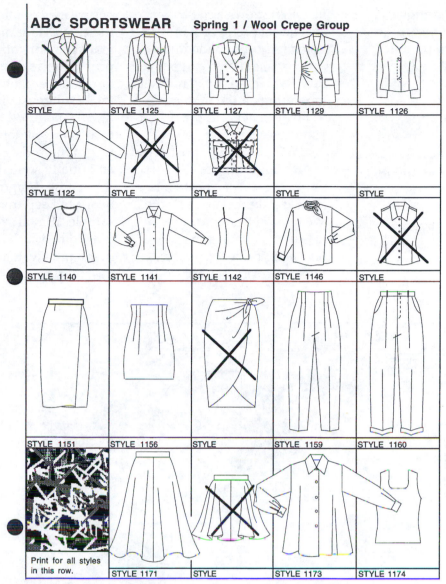

ABC SPORTSWEAR Spring 1 / Wool Crepe Group

STYLE	STYLE 1125	STYLE 1127	STYLE 1129	STYLE 1126
STYLE 1122	STYLE	STYLE	STYLE	STYLE
STYLE 1140	STYLE 1141	STYLE 1142	STYLE 1146	STYLE
STYLE 1151	STYLE 1156	STYLE	STYLE 1159	STYLE 1160
Print for all styles in this row.	STYLE 1171	STYLE	STYLE 1173	STYLE 1174

SnapFashun Line Sheet-**SPORTSWEAR**-001

The designer should organize all the fabrics selected for a line on a fabric board (illustration board or Foam Core) and identify each swatch with the name, style number, color information, vendor name, etc. This is a master reference for all the fabrics that will be needed in the group. Trims, buttons, and exceptional details should also be noted.

Keep lab dips (small patches of colored fabric submitted to the designer to establish a match with other fabrics in the group) and croquis (painted swatches of prints especially made to coordinate with the group) on the board as well.

The fabric board is a reference for management, buyers, and the production department as the group is

duplicated (preparing multiple units of the original sample to send to regional sales offices) and finally is manufactured.

DESIGNER STORY BOARDS

A designer draws many ideas before selecting the most appropriate to make into samples. To keep track of ideas and styles, designers use several methods. A *story board* (also called a *work board* or *line sheet*) shows small sketches of each garment which has been made into a sample. The sketch can be done by hand or by computer depending on the preference of the designer and the resources available.

When doing a sportswear board, designers usually divide the styles by categories, grouping the jackets, soft tops, sweaters, bottoms, and novelty items. Designers devise logical ways to sort other types of lines by group or category of merchandise. At merchandising meetings, management gathers production, sales, and design personnel together to discuss the best items to include in the line. The fabric and story boards are valuable tools to record discards, corrections, and finally style numbers.

Some designers use a pin board to keep track of the samples. Small sketches are pinned to a cork board with notes and swatches to guide design room personnel. The

disadvantage of this system is that the information is not portable, but this can be corrected by transferring the sketches to an illustration board when the styles are set. This method is especially handy to keep track of very large groups and item or dress lines which change a great deal during the design process.

Computerizing the sketching process aids in generating the many sketches used in the design and sales process. The same style is often repeated in several groups. Sketches guide the sample cutter and maker while constructing the first sample and are needed on the cost sheet, specification (spec) sheet, sales bulletins, pattern, and production cards. Computer generated sketches have a consistent quality and may be endlessly duplicated.

DESIGNER'S ROLE IN SALES AND PRODUCTION

Many designers continue their involvement with the line after it has left the design room. A designer often presents each group to the sales force, explaining the fashion statement, fabric story, and theme so the sales person can explain in turn to the retail buyer. Designers often visit stores to see firsthand how the customer reacts to their garments. *Trunk shows* allow a designer to preview the styles by showing samples directly to the customer and taking orders for various items. This sales method is primarily used by high-priced manufacturers.

Many designers work with the production pattern maker to make sure that the final fit reflects their original intent. Designers often assist the production department by preparing boards identifying the fabrics, lining and interlinings, buttons, trims, color thread, etc. to be used in each garment. This eliminates questions and problems in manufacturing the garment.

REVIEW

Word Finders

Define the following words and terms from the chapter you have just read.

1. acceptance phase
2. bridge merchandise
3. classic
4. cost sheet
5. cottage industry
6. duplicates
7. fabric board
8. fashion climate
9. fast turn
10. group line
11. innovator
12. item line
13. lab dips
14. lead time
15. merchandiser
16. off shore
17. overhead
18. promotional phase
19. price leader
20. rejection phase
21. resource
22. trend setter
23. trunk show

DISCUSSION QUESTIONS

1. Define classics and give examples of five classics. Clip photographs of three examples of each from very different price and category (example, junior or missy) ranges. Note the manufacturer (including private label items) for each example.

2. Discuss how the price of a garment is determined and documented during the manufacturing process.

3. What are the three departments in a manufacturing firm and the

responsibilities each has to prepare merchandise for delivery?

4. Describe ten sources of inspiration commonly used by a commercial designer. Highlight the five that most appeal to you as a creative person.

5. Compare and contrast an item and group line. What are the benefits of each method of organizing a line?

6. Discuss how a computerized design room would aid the designer to communicate ideas and merchandising information to the various divisions of a company.

2

U N I T

INTRODUCTION

Each chapter in Unit II is devoted to a specific category of apparel. Because the designer must understand garment construction and fit in order to sketch a design which can be constructed, each chapter starts with silhouettes of the basic pattern pieces typically used to make the garments discussed. Using the basic pattern pieces as a guide, the designer moves style lines and then adds fullness and details to create a unique garment. When appropriate, separate pattern pieces for stretch fabric garments are included.

Studying basic garment forms orients the student to typical style lines used to design men's and women's wear. The guide lines on these forms influence the placement of darts, seams, gores, and ease because they go over the fullest part of the body. A review of the basic methods of shaping fabric to fit the curves of the body clarifies construction methods for all categories of men's and women's garments.

DARTS

A *dart* is a wedge-shaped piece of fabric that is used to stitch out excess fabric where the body is most slender and tapers to nothing where the body is fullest (at the bust, for example.) A *fish-eye dart* starts and ends without touching the edge of the pattern. Darts may radiate from the fullest part of the body to any part of the pattern, but the divisions of the women's and men's dress forms suggest typical commercial placement of darts.

SEAMS AND GORES

Gores are vertical pieces of fabric that shape the fabric to the body when sewn together. They are often placed on the standard princess lines of the dress

GARMENT
CONSTRUCTION

form. They can add fullness to the garment as well as remove excess fabric. The *gore lines* run from edge to edge of the pattern pieces. *Seam* is the name given to the sides of pattern pieces which are stitched together to form the garment.

EASE

Style *ease* is extra fabric which is distributed over the curves of the body by gathering or pleating fabric into a seam. Style ease can be distributed in a great variety of ways and is a primary method for designing oversized, draped, and soft apparel.

YOKES

Yokes are horizontal divisions in a garment used for styling and fitting. Yokes are often placed at the shoulder line where they are particularly effective when they are used to control ease (gathered or pleated fullness). Yokes may be curved and shaped to detail a garment. Waist and hip line yokes are also popular for both men's and women's apparel.

The following chapters on details (sleeves, necklines, collars, etc.) include pattern silhouettes where appropriate.

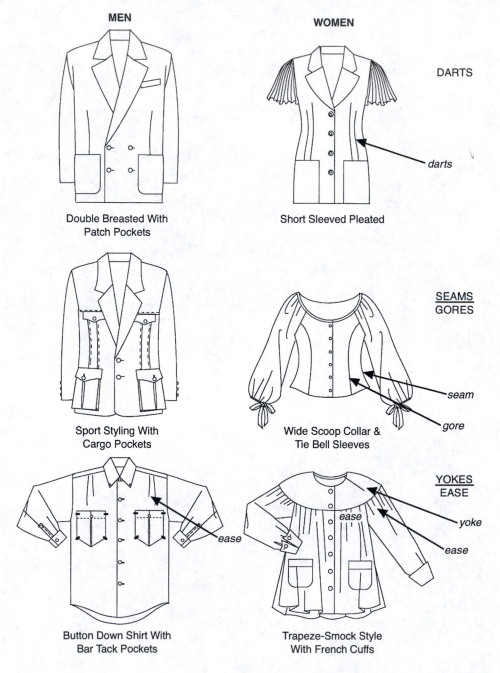

MEN

WOMEN

DARTS

darts

Double Breasted With
Patch Pockets

Short Sleeved Pleated

SEAMS
GORES

seam

gore

Sport Styling With
Cargo Pockets

Wide Scoop Collar &
Tie Bell Sleeves

YOKES
EASE

ease

yoke

ease

ease

Button Down Shirt With
Bar Tack Pockets

Trapeze-Smock Style
With French Cuffs

Basic Torso Silhouettes

DESIGN PRINCIPLES FOR WOMEN

Fitted Bodices

The *bodice* is a garment or part of a garment that covers the body from the waist up. The basic bodice has two front darts which are combined into one for dart manipulation and two back darts which make flat fabric conform to the body's curves. Pattern makers use the basic block to develop

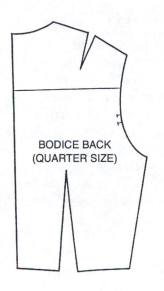

BODICE BACK
(QUARTER SIZE)

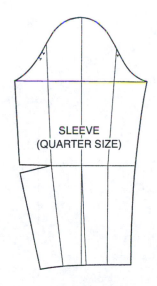

SLEEVE
(QUARTER SIZE)

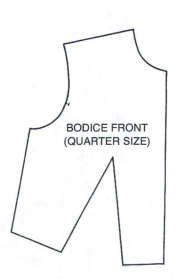

BODICE FRONT
(QUARTER SIZE)

other style variations. *Pattern-making for Fashion Design* by Helen Armstrong (HarperCollins. 1994) is an excellent reference book which illustrates how basic blocks can be manipulated into a wide variety of bodice styles.

Knit Bodices

Darts can be eliminated completely when designing with *stretch knits*. Side seams are used to fit the garment to the body, and the elasticity of the knit fabric ensures a snug fit. The garment is sewn together with an overlock stitch which stretches with the fabric so the seams do not pop.

Shirts

The *classic shirt* is loosely fitted and often has a drop shoulder imitative of men's wear styling. The basic bodice block

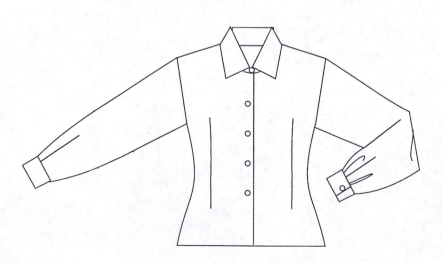

is modified by extending the bodice block to mid-hip and adding ease to the side seams and shoulder area to form a shirt block. The bust dart is often incorporated into a pleat or gathers controlled by a shoulder yoke. Of course, darts, yokes, and gores can be used to style the garment. The basic components of a classic shirt are a tailored collar, front placket, and cuffed sleeves. *Shirt dresses* are longer versions of the classic, often styled with innovative details.

Women's Jackets

The *blazer*, borrowed from men's wear, is the definitive classic women's jacket style. The body can be loosely fitted (with only a bust dart) or fit the body closely when designed with gores and darts. An underarm panel is often used to trim the waist line without adding obvious style lines. Sleeves are usually fitted with a similar underarm panel which shapes the sleeve but still allows movement.

Traditional jackets are constructed with hand padded, inner construction (tiny stitches secure the interlining to the top fabric) which reinforces the shape of the collars, lapels, and front panel. Less expensive construction achieves a similar

effect by using iron-on interlinings to firm and tailor the lapels and collar.

Shoulder pads are usually used to reinforce the shoulder line.

Women's jackets have a wide variety of styling options. *Tailored jackets* are influenced by men's wear. They include the *cardigan jacket*, which has no lapels and an easy fit, and the *bomber jacket*, which is cropped at the waist or top of the hip. *Dressmaker jackets* are softer and incorporate details like flounces, peplums, and soft sleeves, which are typical dress style elements.

DESIGN PRINCIPLES FOR MEN

Shirts

The *classic dress shirt* has a tailored collar, front placket, shoulder yoke, long sleeves finished with a cuff, and fits the body with comfortable ease. Darts are not usually included in a mass produced shirt, but custom-made garments are occasionally fitted with fish-eye darts at the waist. Style variations mainly occur in the collar size, shape, spread (the width between the collar points in the center front), and the fabric combinations selected.

Formal shirts are worn with tuxedos and other formal attire and are usually styled with a pleated front inset and wing collar. *Studs* (tiny contrasting buttons on a chain and stop) are usually worn instead of buttons.

Sports shirts have a wide range of styling options and may be designed with woven and knit fabrics in a single style. Print shirts in basic styles are a popular option. Trims appropriate for all price ranges include top stitching, appliques, spot embroidery, and pockets. Active

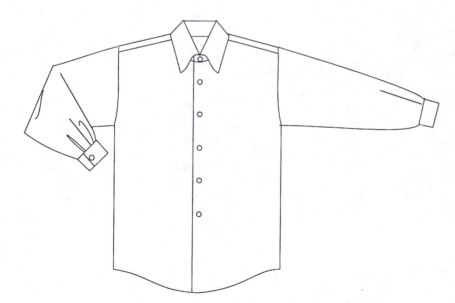

sportswear has influenced men's shirt design. Classics such as the *polo shirt*, *sweat shirt*, and *safari shirt* have been styled into many novelty versions.

Men's Jackets

Men's wear jackets generally have a collar and lapel, breast and hip line pockets, padded shoulders and are fitted to the body using fish-eye darts and gores. Jackets may be *single* or *double breasted*. When styling tailored men's wear, subtlety of cut, fabrication, and details are the most important styling devices. Men's wear tends to change more slowly than women's wear, and styles often linger in the fashion cycle because they appeal to a specific customer base. An example is the *Italian cut suit*, which is very fitted and was considered high fashion in the 1970s and early 1980s. This styling is very popular with a certain customer, even though high-styled European fit is now more relaxed.

Active wear is derived from clothes worn while performing active sports. Traditional favorites include the *bomber jacket*, casual *knit tops* based on the sweat shirt, *safari jackets*, and *sports coats* in tweed fabrics which began as traditional hunting apparel in England in the late nineteenth century.

REVIEW

Word Finders

Define the following words and terms from the chapter you have just read.

1. bodice
2. blazer
3. classic men's wear shirt
4. dressmaker jacket
5. hand padded

6. Italian cut suit
7. knit bodice
8. shirt dress
9. studs
10. tailored jacket

DISCUSSION QUESTIONS

1. Compare and contrast a tailored women's jacket with a dressmaker jacket. Design two garments of each type.

2. Design five men's casual shirts, using details from active sportswear influences.

3. Research typical shirt dress styling in current fashion magazines and catalogs. Design a dressy shirt dress in a silk crepe, a shirt dress appropriate for a career woman in a light weight wool, and a casual knit shirt dress which would be worn during an informal afternoon.

4. Research and design two men's blazers in navy flannel. One should be double breasted, and the second should be single breasted.

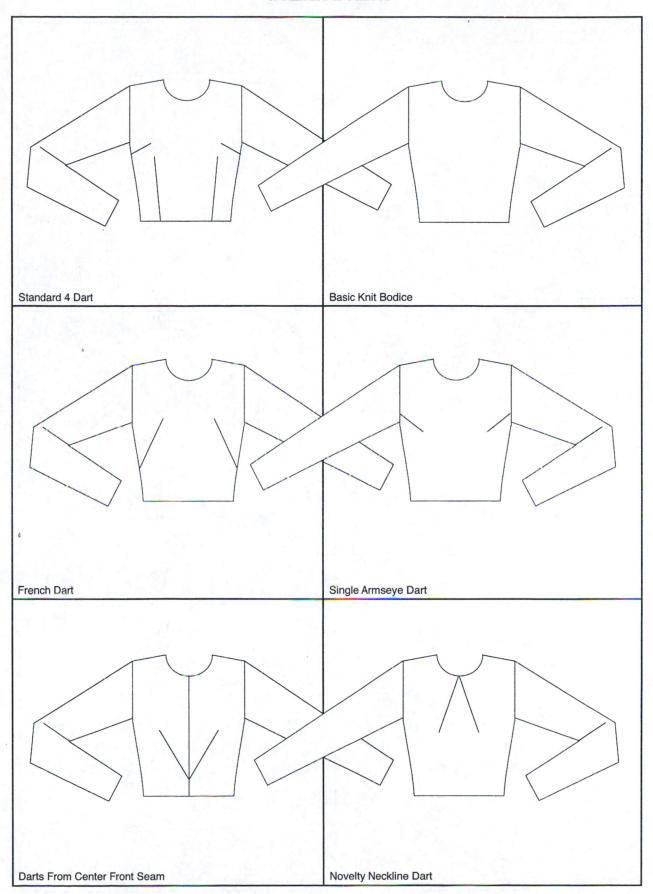

Standard 4 Dart

Basic Knit Bodice

French Dart

Single Armseye Dart

Darts From Center Front Seam

Novelty Neckline Dart

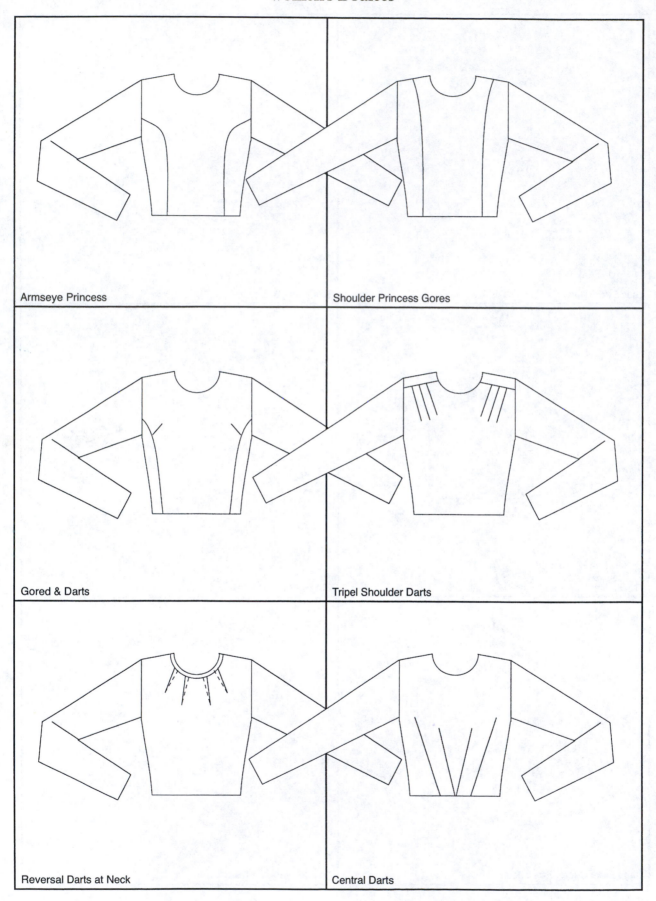

Armseye Princess

Shoulder Princess Gores

Gored & Darts

Tripel Shoulder Darts

Reversal Darts at Neck

Central Darts

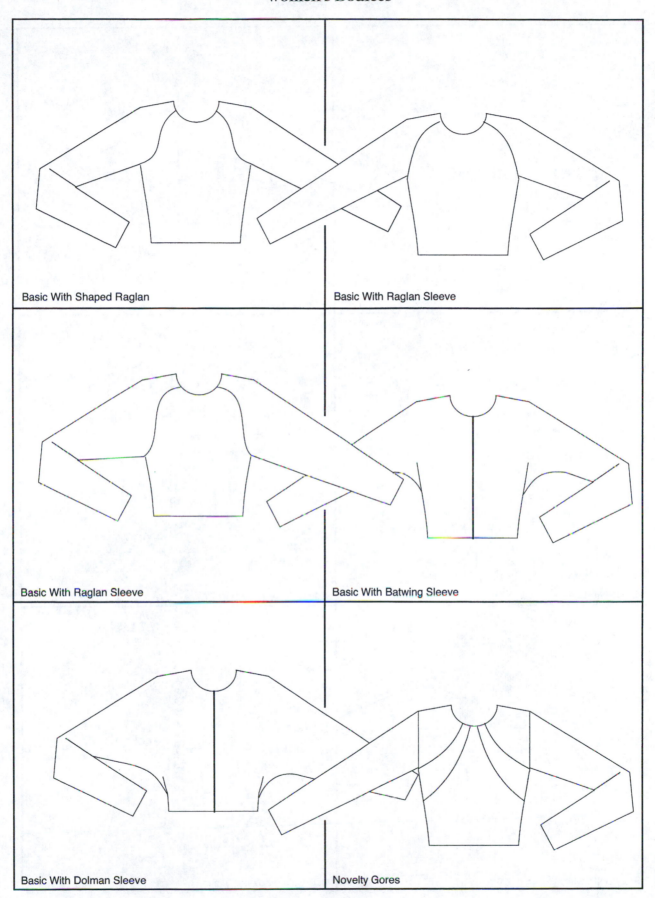

Basic With Shaped Raglan

Basic With Raglan Sleeve

Basic With Raglan Sleeve

Basic With Batwing Sleeve

Basic With Dolman Sleeve

Novelty Gores

Women's Basic Shirts

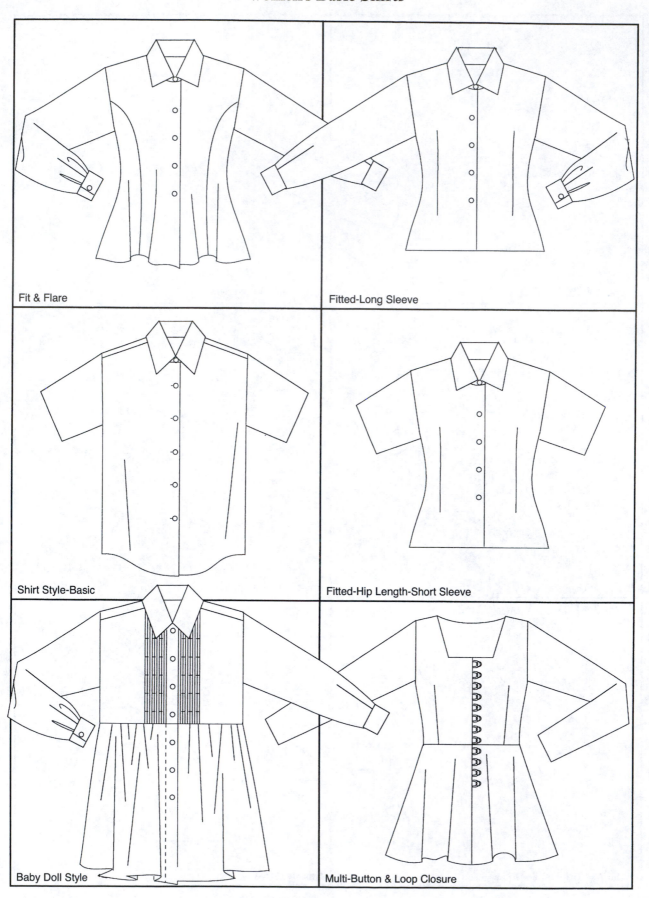

Fit & Flare

Fitted-Long Sleeve

Shirt Style-Basic

Fitted-Hip Length-Short Sleeve

Baby Doll Style

Multi-Button & Loop Closure

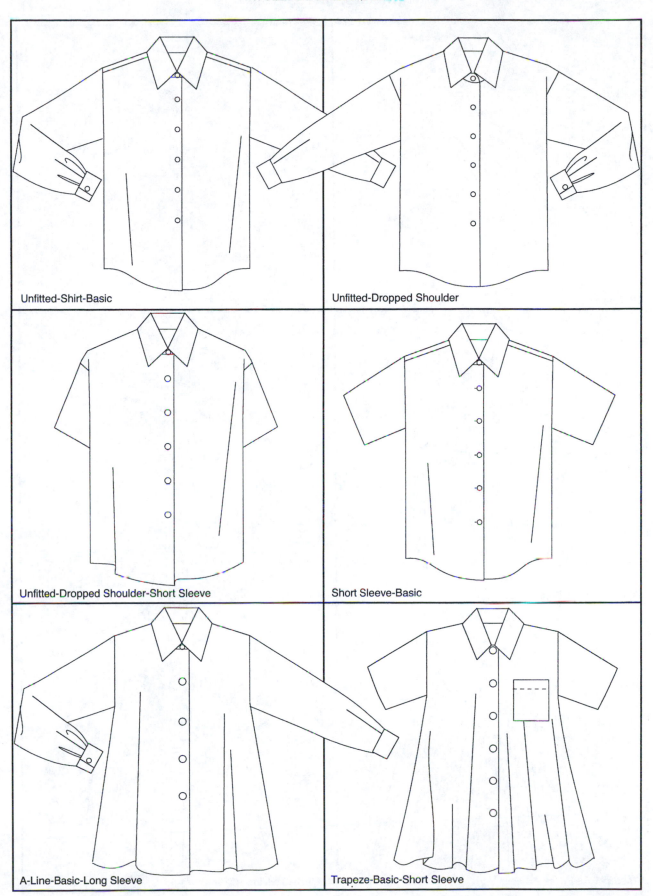

Unfitted-Shirt-Basic

Unfitted-Dropped Shoulder

Unfitted-Dropped Shoulder-Short Sleeve

Short Sleeve-Basic

A-Line-Basic-Long Sleeve

Trapeze-Basic-Short Sleeve

Women's Novelty Tops

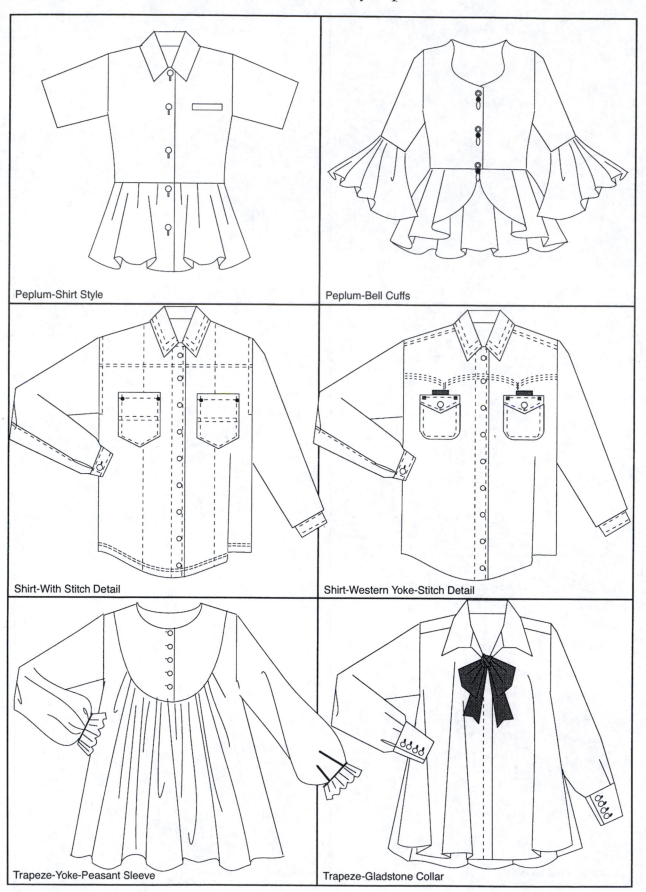

Peplum-Shirt Style

Peplum-Bell Cuffs

Shirt-With Stitch Detail

Shirt-Western Yoke-Stitch Detail

Trapeze-Yoke-Peasant Sleeve

Trapeze-Gladstone Collar

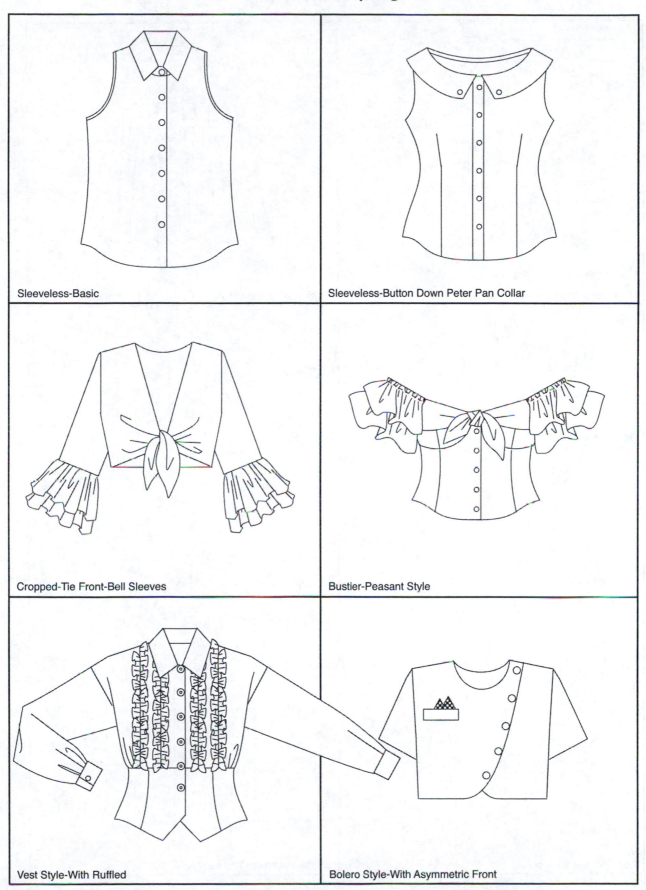

Sleeveless-Basic

Sleeveless-Button Down Peter Pan Collar

Cropped-Tie Front-Bell Sleeves

Bustier-Peasant Style

Vest Style-With Ruffled

Bolero Style-With Asymmetric Front

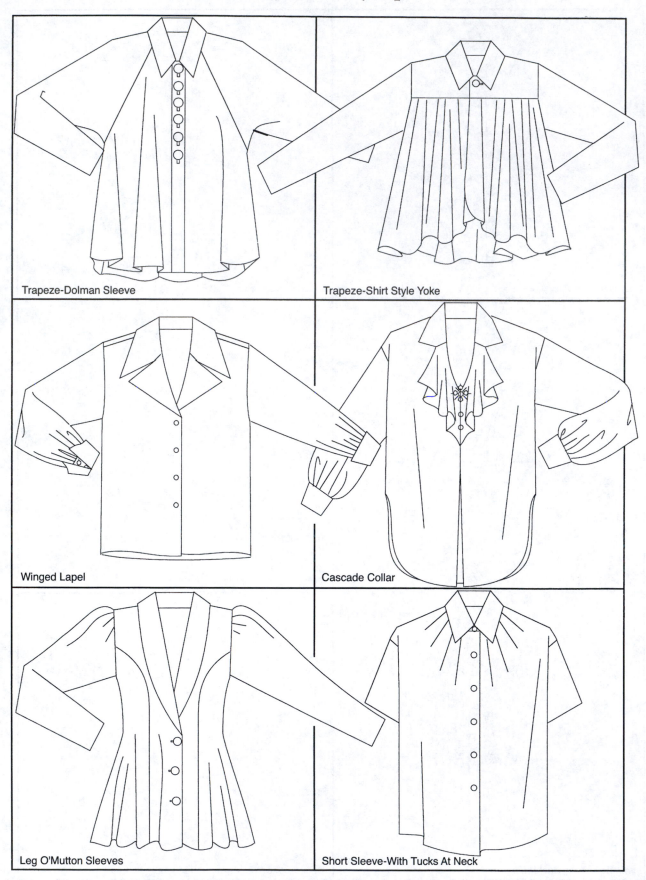

Trapeze-Dolman Sleeve

Trapeze-Shirt Style Yoke

Winged Lapel

Cascade Collar

Leg O'Mutton Sleeves

Short Sleeve-With Tucks At Neck

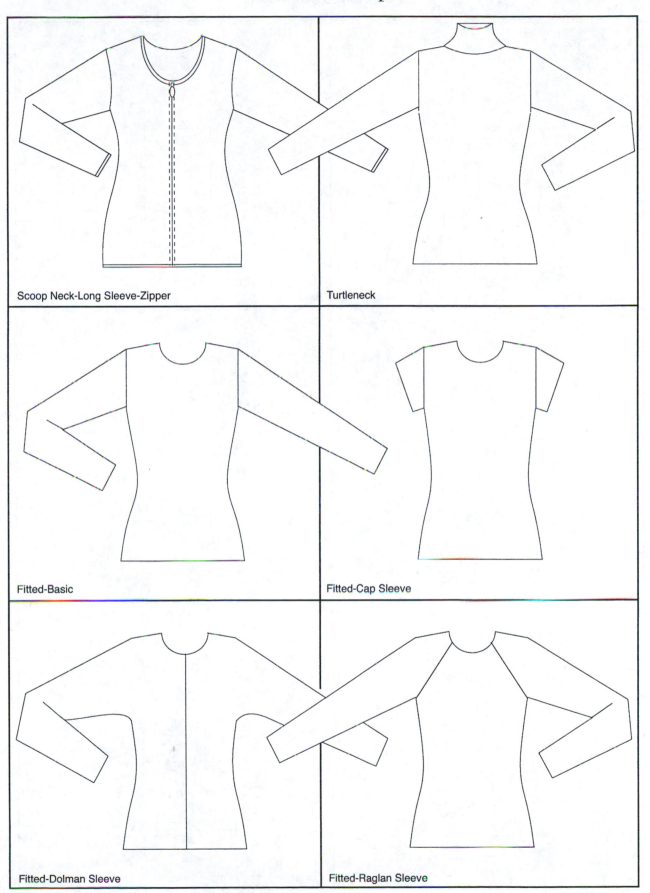

Scoop Neck-Long Sleeve-Zipper

Turtleneck

Fitted-Basic

Fitted-Cap Sleeve

Fitted-Dolman Sleeve

Fitted-Raglan Sleeve

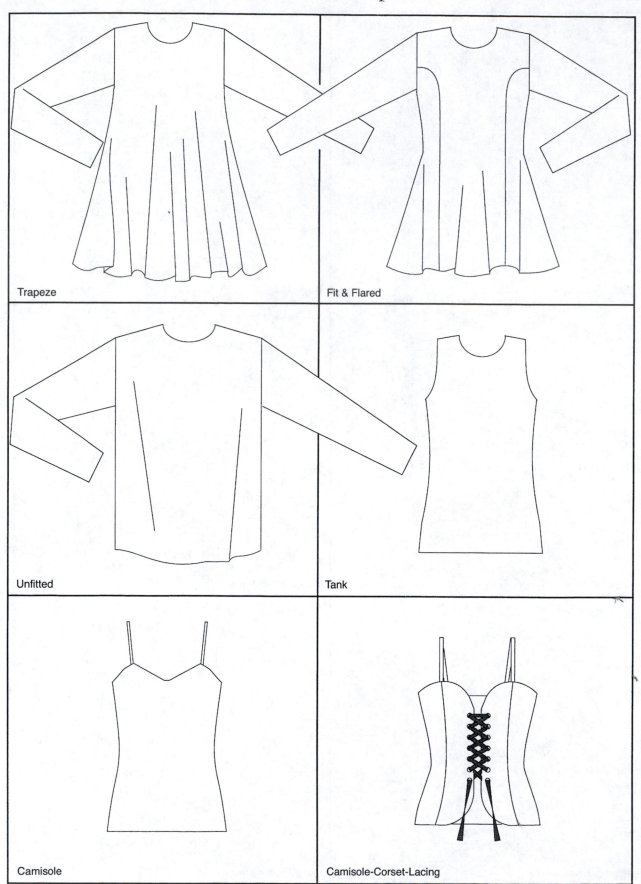

Trapeze

Fit & Flared

Unfitted

Tank

Camisole

Camisole-Corset-Lacing

Women's Blazers—Basic and Darted Styles

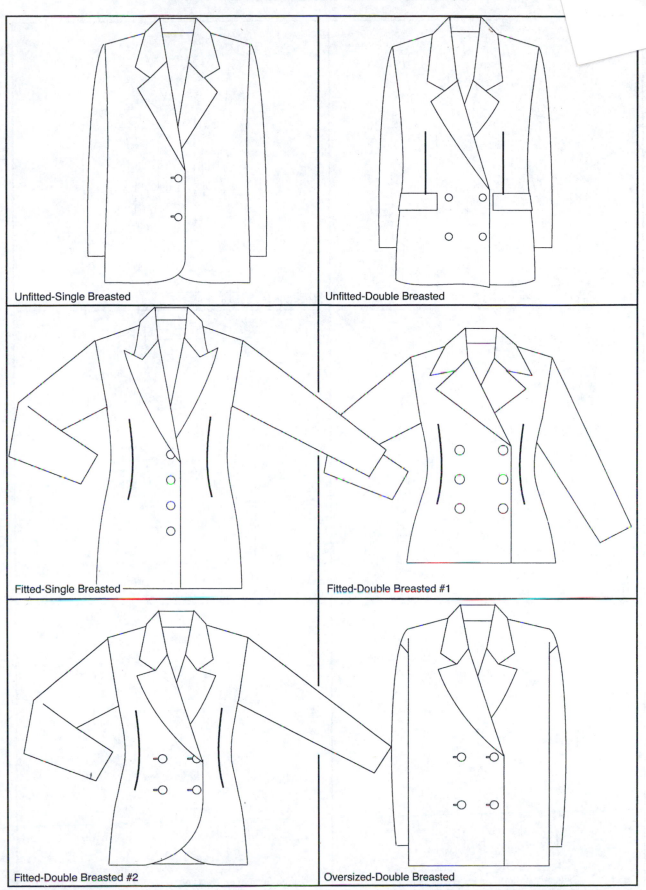

Unfitted-Single Breasted

Unfitted-Double Breasted

Fitted-Single Breasted

Fitted-Double Breasted #1

Fitted-Double Breasted #2

Oversized-Double Breasted

Women's Blazers—Basic and Gored Styles

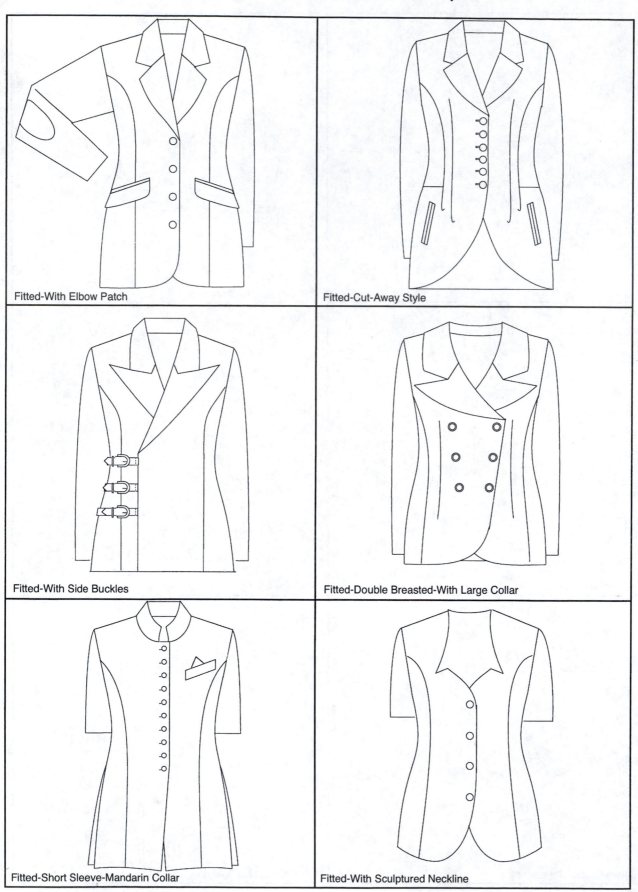

Fitted-With Elbow Patch

Fitted-Cut-Away Style

Fitted-With Side Buckles

Fitted-Double Breasted-With Large Collar

Fitted-Short Sleeve-Mandarin Collar

Fitted-With Sculptured Neckline

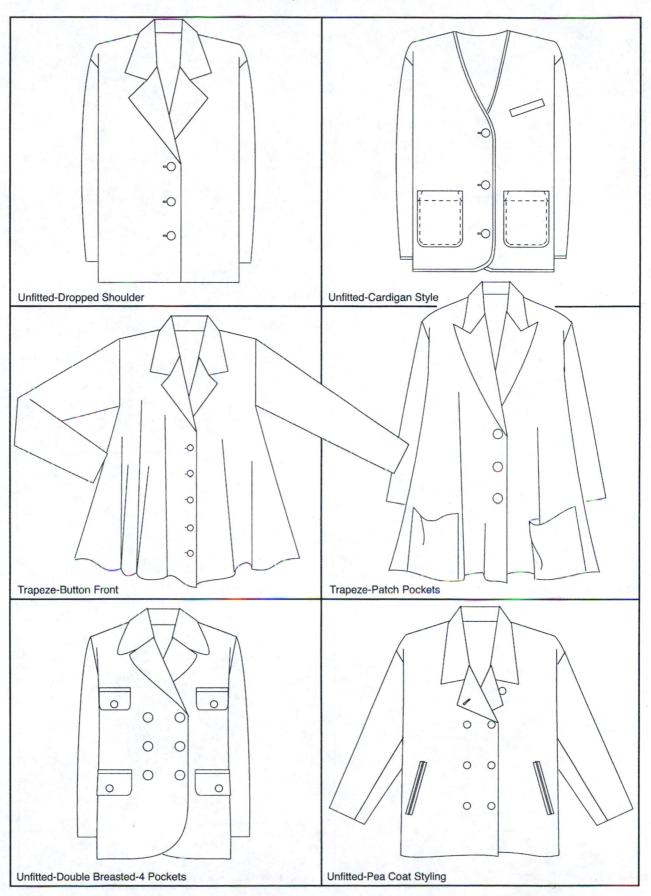

Unfitted-Dropped Shoulder

Unfitted-Cardigan Style

Trapeze-Button Front

Trapeze-Patch Pockets

Unfitted-Double Breasted-4 Pockets

Unfitted-Pea Coat Styling

Women's Jackets—Cropped

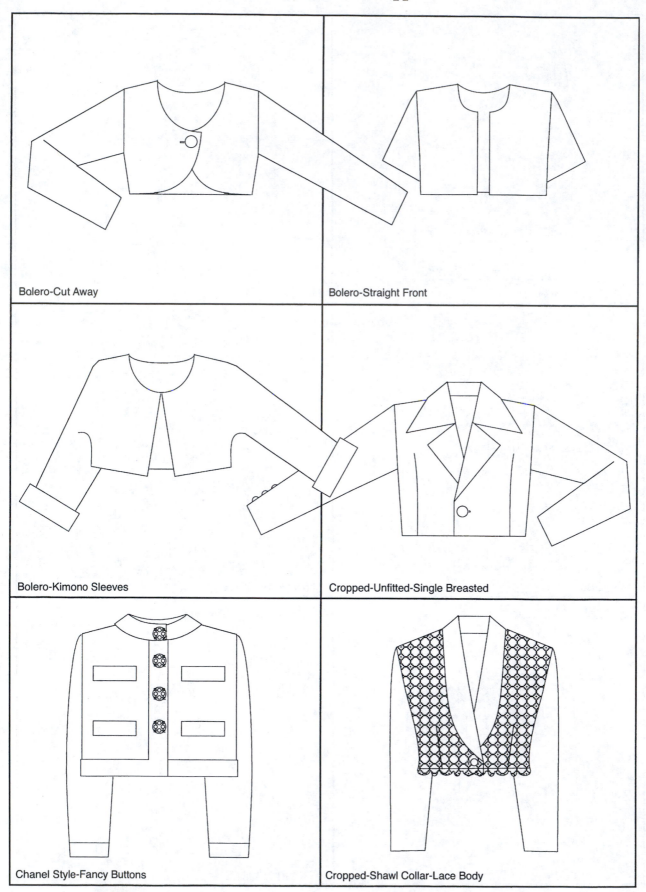

Bolero-Cut Away

Bolero-Straight Front

Bolero-Kimono Sleeves

Cropped-Unfitted-Single Breasted

Chanel Style-Fancy Buttons

Cropped-Shawl Collar-Lace Body

Women's Dressmaker Jackets

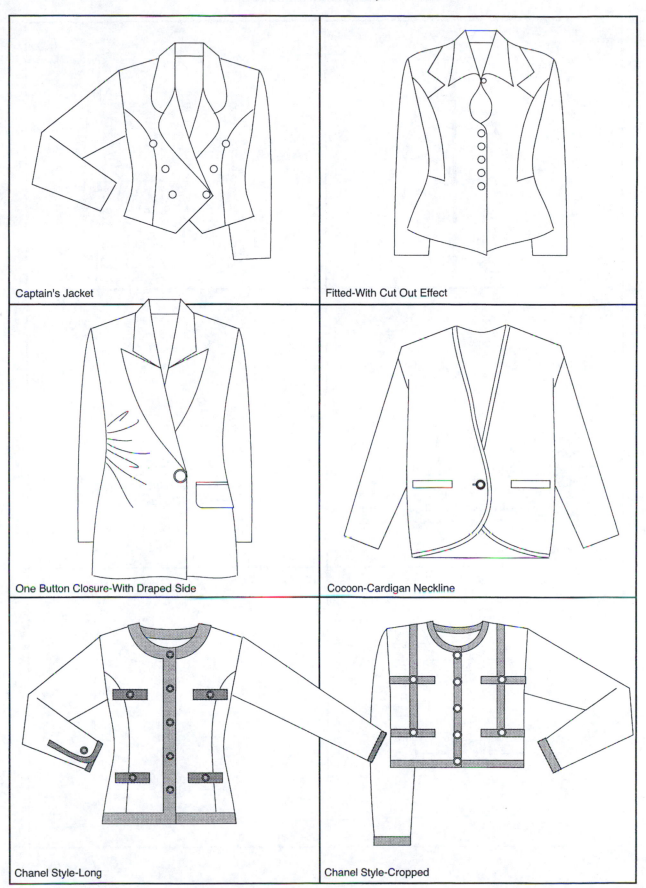

Captain's Jacket

Fitted-With Cut Out Effect

One Button Closure-With Draped Side

Cocoon-Cardigan Neckline

Chanel Style-Long

Chanel Style-Cropped

Women's Sports Jackets

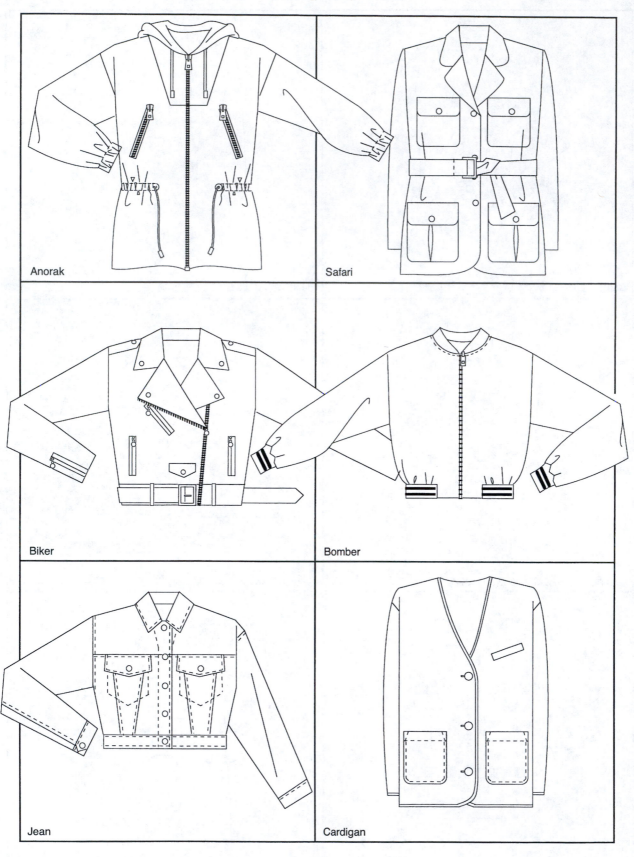

Anorak

Safari

Biker

Bomber

Jean

Cardigan

Unisex Tops

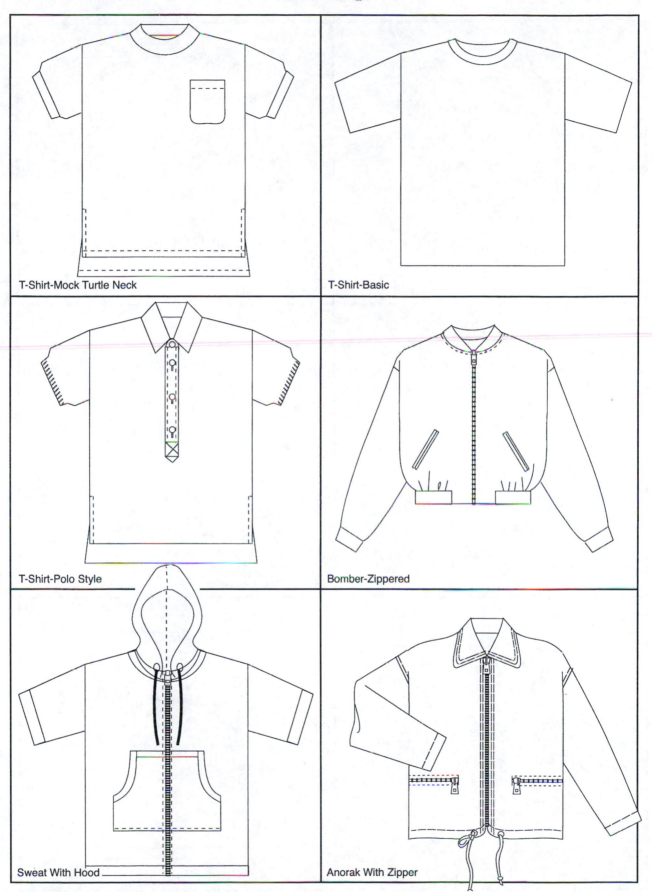

T-Shirt-Mock Turtle Neck

T-Shirt-Basic

T-Shirt-Polo Style

Bomber-Zippered

Sweat With Hood

Anorak With Zipper

Unisex Tops

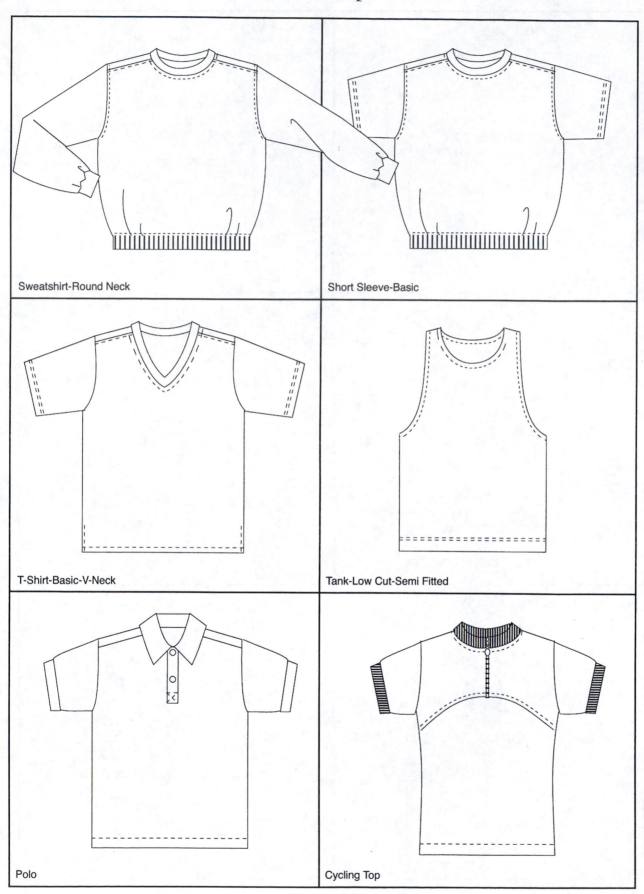

Sweatshirt-Round Neck

Short Sleeve-Basic

T-Shirt-Basic-V-Neck

Tank-Low Cut-Semi Fitted

Polo

Cycling Top

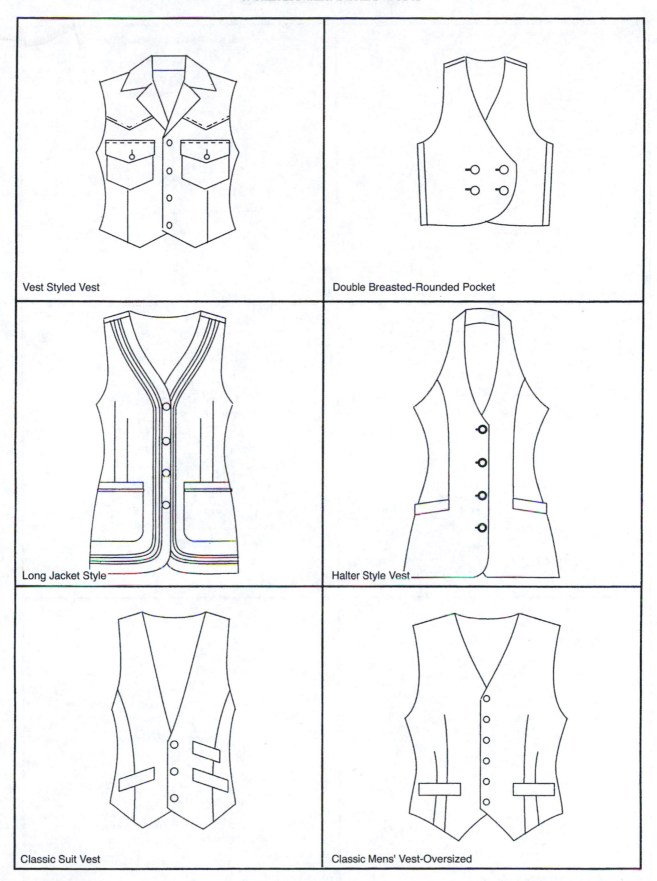

Vest Styled Vest

Double Breasted-Rounded Pocket

Long Jacket Style

Halter Style Vest

Classic Suit Vest

Classic Mens' Vest-Oversized

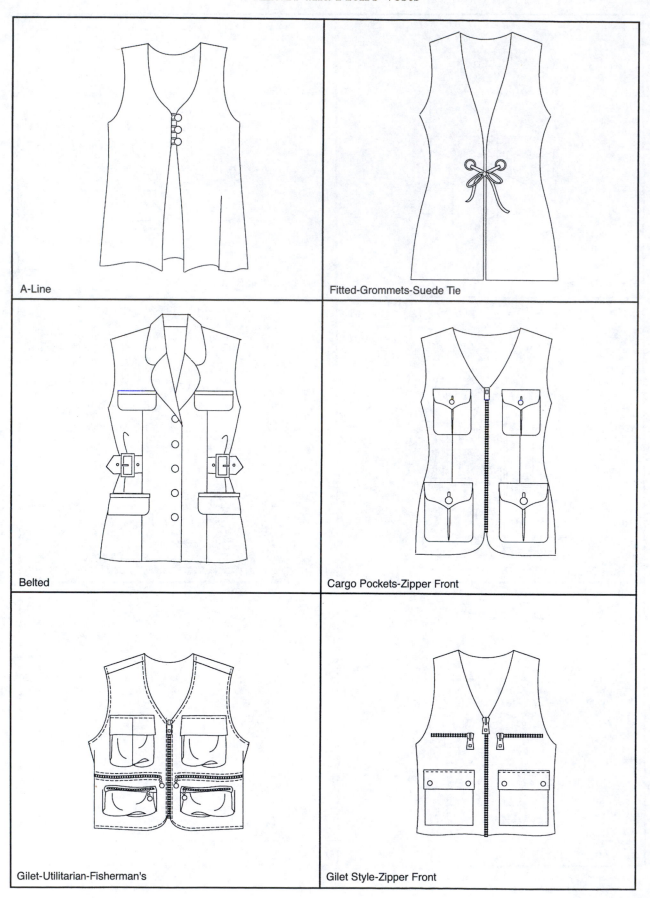

A-Line

Fitted-Grommets-Suede Tie

Belted

Cargo Pockets-Zipper Front

Gilet-Utilitarian-Fisherman's

Gilet Style-Zipper Front

Men's Shirts

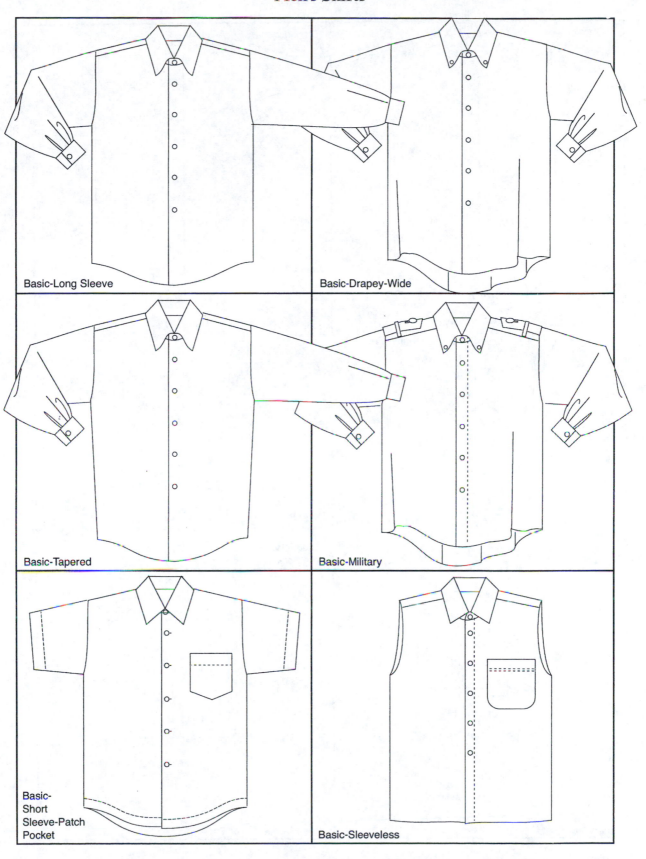

Basic-Long Sleeve

Basic-Drapey-Wide

Basic-Tapered

Basic-Military

Basic-
Short
Sleeve-Patch
Pocket

Basic-Sleeveless

Men's Shirts

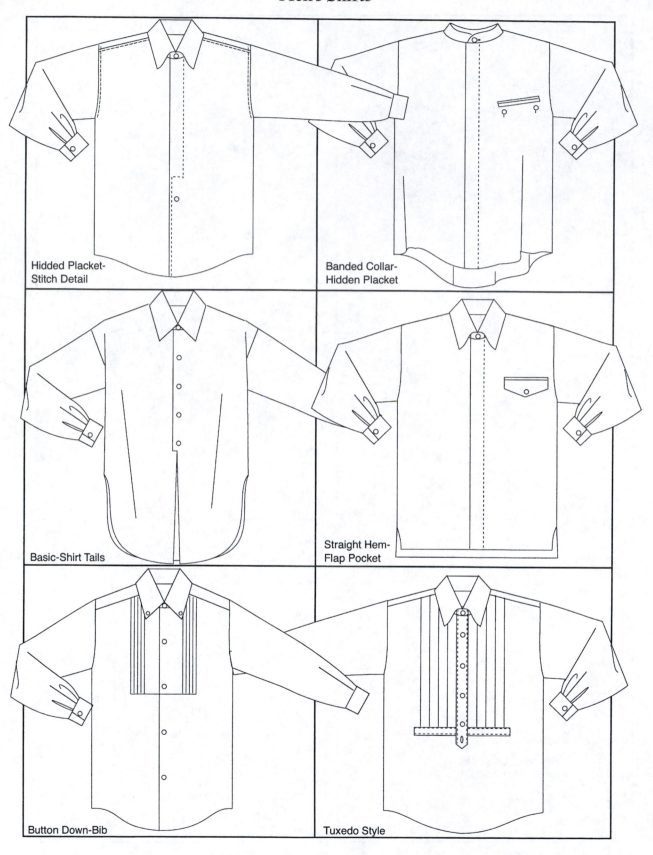

Hidded Placket-
Stitch Detail

Banded Collar-
Hidden Placket

Basic-Shirt Tails

Straight Hem-
Flap Pocket

Button Down-Bib

Tuxedo Style

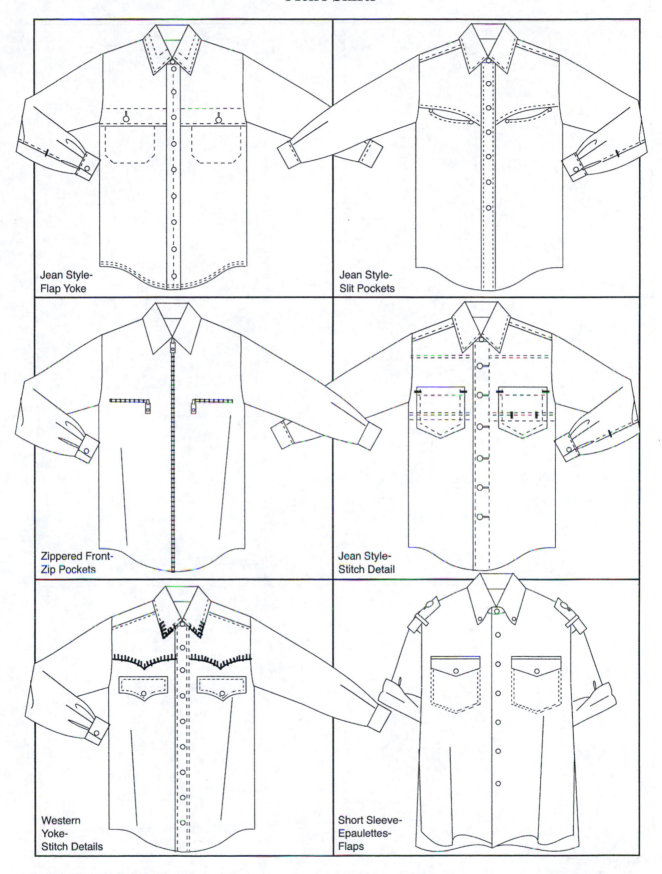

Jean Style-
Flap Yoke

Jean Style-
Slit Pockets

Zippered Front-
Zip Pockets

Jean Style-
Stitch Detail

Western
Yoke-
Stitch Details

Short Sleeve-
Epaulettes-
Flaps

Men's Knit Tops

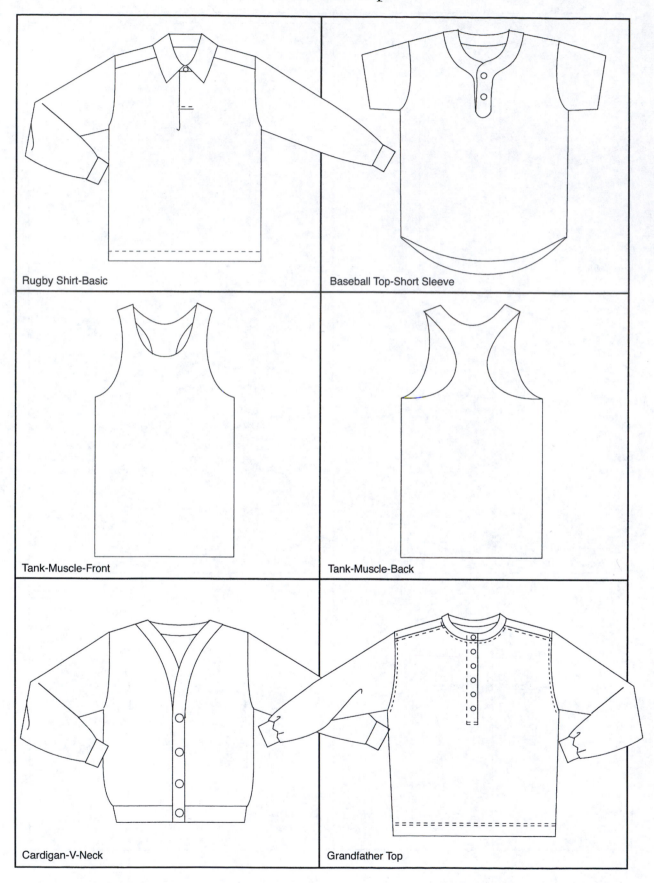

Rugby Shirt-Basic

Baseball Top-Short Sleeve

Tank-Muscle-Front

Tank-Muscle-Back

Cardigan-V-Neck

Grandfather Top

Men's Blazers

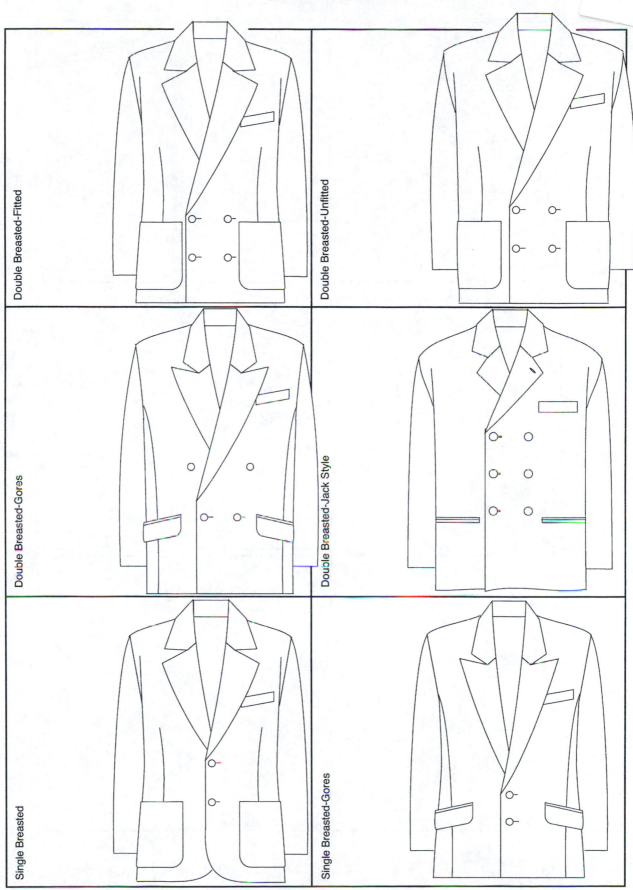

Double Breasted-Fitted

Double Breasted-Unfitted

Double Breasted-Gores

Double Breasted-Jack Style

Single Breasted

Single Breasted-Gores

Men's Casual Jackets

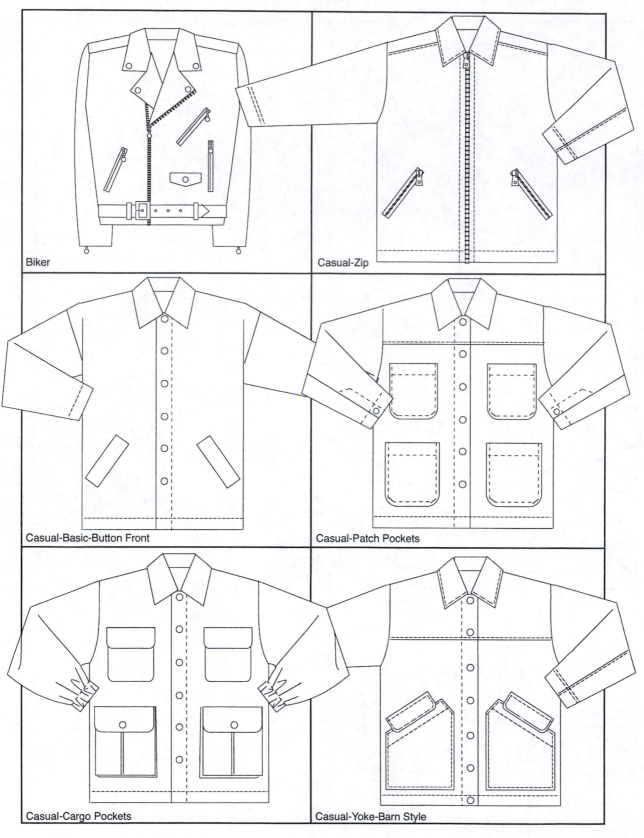

Biker

Casual-Zip

Casual-Basic-Button Front

Casual-Patch Pockets

Casual-Cargo Pockets

Casual-Yoke-Barn Style

Sleeves

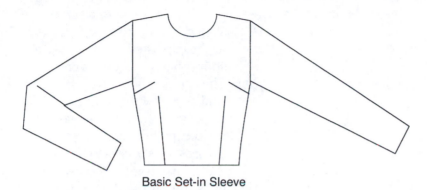

Basic Set-in Sleeve

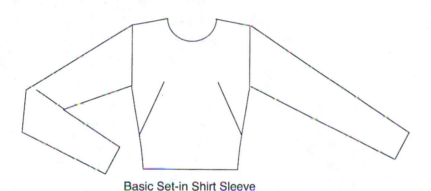

Basic Set-in Shirt Sleeve

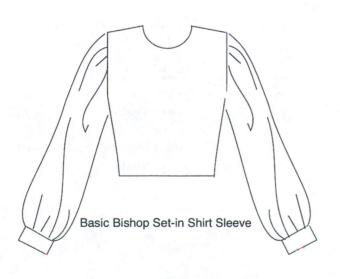

Basic Bishop Set-in Shirt Sleeve

Illustration Courtesy StyleLens.com

The two families of sleeves are *set-in sleeves* and *sleeves cut in one* with the bodice or incorporate part of the bodice into the sleeve. The most popular type of sleeve is the set-in, which requires a seam at the armseye. There is little styling difference between basic sleeves used for men's and women's apparel, but predictably, women's wear uses a wider variety of shapes, novelty treatments, and cuff details.

SET-IN SLEEVES

The parts of the set- include the cap, wh

the top of the arm above the *biceps line* (the measurement of the sleeve at the underarm point). The underarm seams join the sides of the sleeve pattern together to form a tube. Snug sleeves have an elbow dart which provides enough ease to allow the arm to bend. The placket line follows the wrist bone up the sleeve and is an opening which allows the hand to enter the sleeve. The end of the sleeve can be finished with a facing or a cuff.

A great variety of styling possibilities exist in a set-in sleeve. When fullness is added to the cap, the *bishop* or *puff* (a short bishop) sleeve is created. The cap can be made shallower by dropping the armseye seam and increasing the biceps line, creating the *classic shirt sleeve.* Moving the armseye seam towards the neckline makes the bodice look trimmer and neater, but the sleeve cap has to be lengthened to allow the arm to move. Lowering the armhole allows the sleeve to be made larger and softer.

Tailored set-in sleeves are often cut in two pieces. An underarm panel allows the seam to fit the arm with less binding. Ease can be subtly added at the elbow with this construction. A seam bisecting the sleeve from the center of the cap to the wrist is also used in tailored coats and suits.

SLEEVES INCORPORATING PART OF THE BODICE

Raglan, dolman, and *kimono* sleeves all incorporate part of the bodice. The raglan is similar to a set-in sleeve but has a seam connecting the

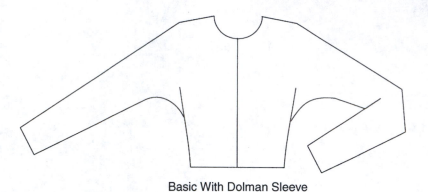

Basic With Dolman Sleeve

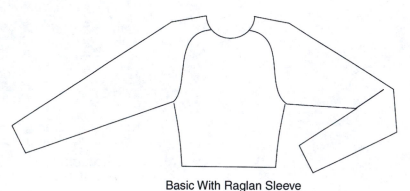

Basic With Raglan Sleeve

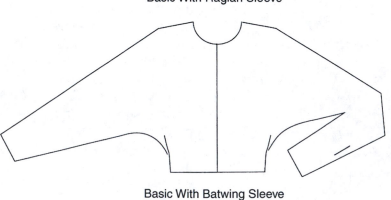

Basic With Batwing Sleeve

underarm seam with the neckline of the garment. This may be shaped in a variety of ways. Usually the armseye is deeper for a raglan sleeve to allow for movement, and a dart or shoulder seam is necessary to shape the sleeve to the curve of the shoulder. Simple raglan sleeves are popular in men's casual wear.

Dolman sleeves are cut in one with the entire bodice. When dolman sleeves are full length, a center front and back seam is required because of the span of the body with the arms extended. *Gussets* are triangular pieces of fabric added to the underarm which allow the dolman sleeve to fit more snugly. A seam at the top and underline of the sleeve is also required to shape a dolman sleeve. This sleeve is not often found in men's wear.

The classic Japanese kimono sleeve is a simple rectangle seamed on to a columnar garment which forms a T shape when laid flat. Kimono sleeves fall from a lowered shoulder line on the body and are graceful but bulky. Both men and women can wear the classic Japanese kimono, but in Western apparel, the kimono sleeve is rarely used in men's wear.

Modern styling variations of the kimono sleeve vary greatly in appearance from the classic Japanese application. Kimono sleeves are shortened, shaped, and trimmed but retain the basic rectangular shape.

SLEEVE LENGTHS

This chart provides a variety of sleeve lengths and their names. Many variations are possible when designing by changing the length, shape, and volume of a sleeve.

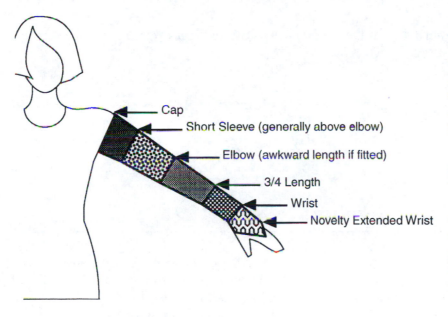

Cap

Short Sleeve (generally above elbow)

Elbow (awkward length if fitted)

3/4 Length

Wrist

Novelty Extended Wrist

PADDED SLEEVES

Padding is used in tailored garments even when the wedge shape is not in style. A small pad adds structure and shape to the sleeve. Padding is especially important in men's jackets to reinforce the natural wedge of the masculine silhouette. Padding may be added to both families of sleeves, but a rounded shoulder pad is most natural for the sleeves without a shoulder seam.

The greater the amount of padding used, the larger the shoulder and armseye of the garment will be. Truly exaggerated wedge shapes require a large shoulder pad.

CUFFS AND SLEEVE FINISHES

A great many styles of sleeve and cuff endings are possible. Contrasting cuffs, novelty buttons, and shaped facings are used to style *cuffs*. Many can be adapted to a variety of sleeve lengths. Men's wear tends to be more conservative, favoring hemmed sleeves, classic French and single cuffs, and knit banding details.

REVIEW

Word Finders

Define the following words and terms from the chapter you have just read.

1. biceps line
2. bishop sleeve
3. cuff
4. dolman
5. elbow dart
6. French cuff
7. gusset
8. kimono
9. padding
10. puff sleeve
11. raglan
12. set-in sleeve

DISCUSSION QUESTIONS AND EXERCISES

1. Discuss the illusion created by padding the shoulder line. Design a shirt with a natural shoulder line and one with a padded shoulder line. Evaluate the effect created by padding the shoulder line.

2. Select a basic shirt body and sketch three versions with a dolman, raglan, and set-in sleeve. Evaluate the effects created and answer these questions. Which sleeve makes the body seem the slimmest? Which sleeve creates the most exaggerated wedge effect? Which shirt takes the least amount of fabric?

3. Sketch four basic fitted bodices and add a set-in sleeve in four lengths. Vary the shapes to experiment with different effects. Add a variety of sleeve endings and cuffs which enhance the length of each sleeve you have selected.

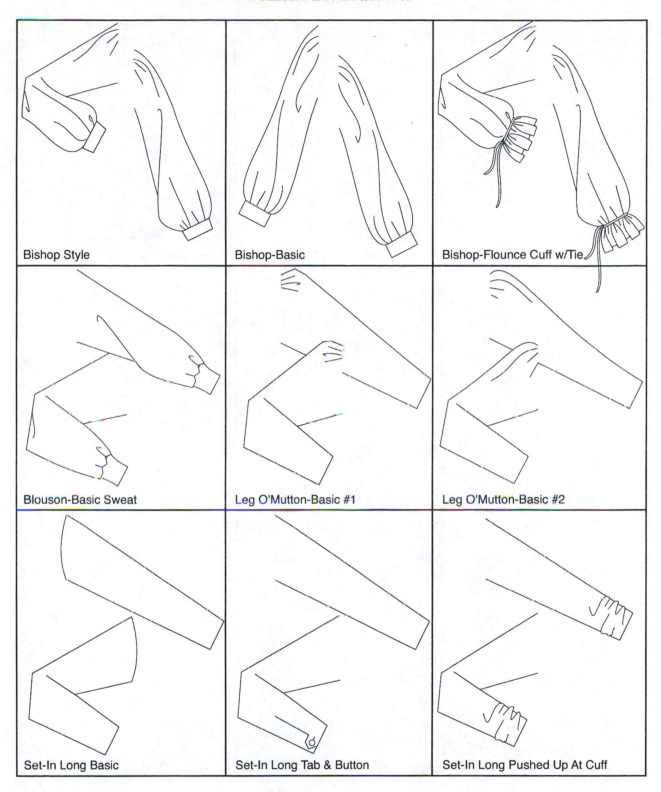

Bishop Style

Bishop-Basic

Bishop-Flounce Cuff w/Tie

Blouson-Basic Sweat

Leg O'Mutton-Basic #1

Leg O'Mutton-Basic #2

Set-In Long Basic

Set-In Long Tab & Button

Set-In Long Pushed Up At Cuff

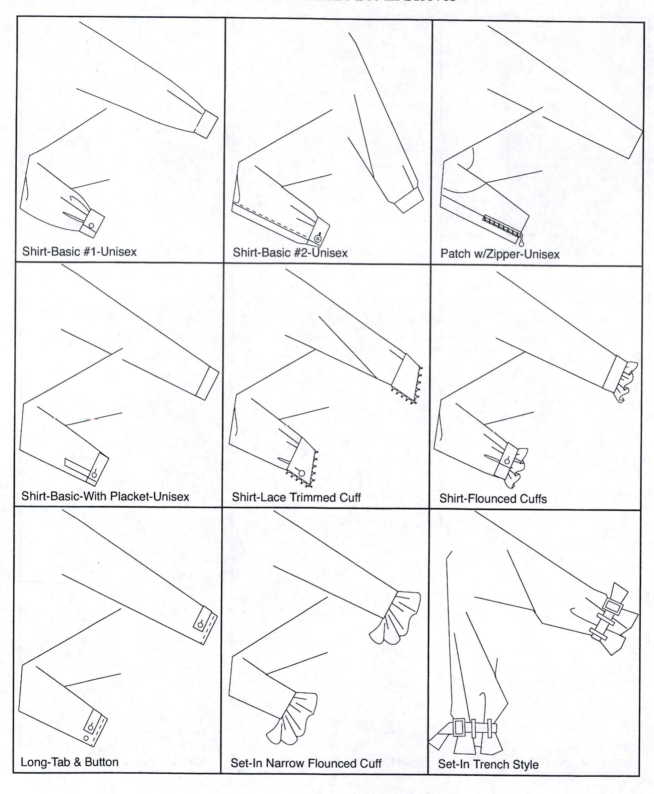

Shirt-Basic #1-Unisex

Shirt-Basic #2-Unisex

Patch w/Zipper-Unisex

Shirt-Basic-With Placket-Unisex

Shirt-Lace Trimmed Cuff

Shirt-Flounced Cuffs

Long-Tab & Button

Set-In Narrow Flounced Cuff

Set-In Trench Style

Puff-Basic #1

Puff-Basic #2

Puff-Basic #3

Puff-Draped

Pouf-Full

Short-Tied

Petal

Cap-Cut Out Shoulder

Lantern-Basic

Cap-Basic #1

Cap-Basic #2

Cap-Basic #3

Short-Basic #1

Short-Basic #2-Cuffed

Short-Drop Shoulder

Short With Top Stitching

Short-French Cuff

Short-Cap Style With Tabs

Women's Novelty Set-in Sleeves

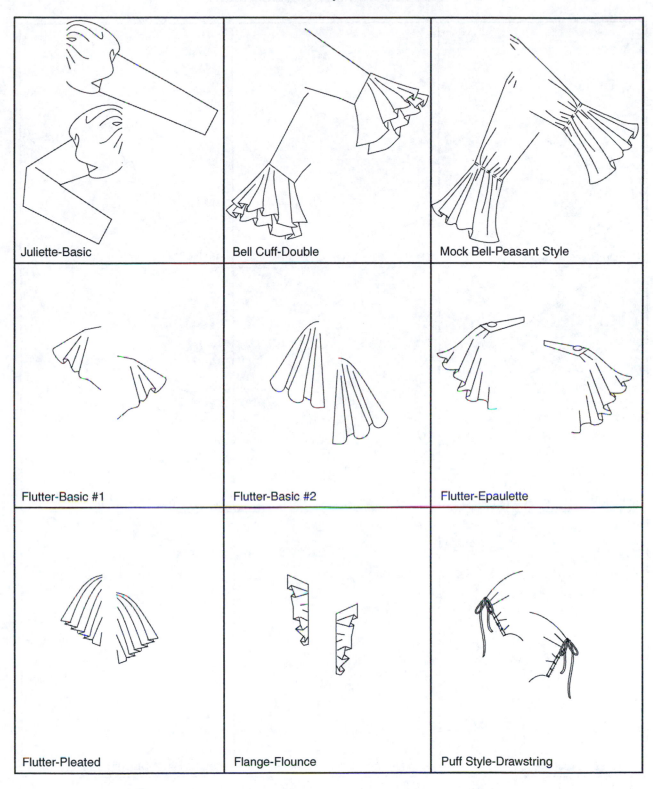

Juliette-Basic	Bell Cuff-Double	Mock Bell-Peasant Style
Flutter-Basic #1	Flutter-Basic #2	Flutter-Epaulette
Flutter-Pleated	Flange-Flounce	Puff Style-Drawstring

Raglan-Basic-Shaped Seam

Raglan-Wide-Shaped Seam

Raglan-Basic-Circular Seam #1

Raglan-Basic-Circular Seam #2

Raglan-Basic-Angular Seam

Raglan-Wide-Straight Seam

Raglan-Cap-Circular Seam

Raglan-Short-Circular Seam

Raglan-Short-Straight Seam

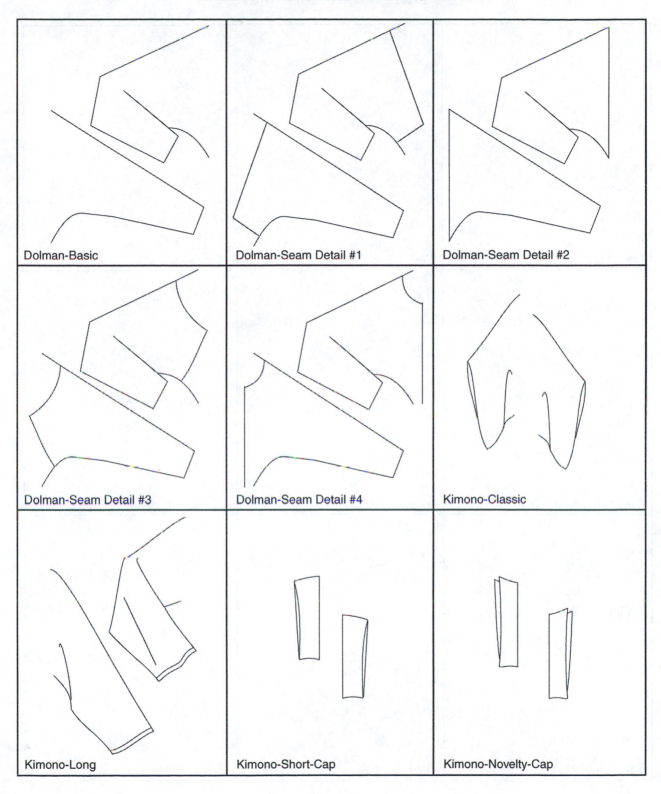

Dolman-Basic

Dolman-Seam Detail #1

Dolman-Seam Detail #2

Dolman-Seam Detail #3

Dolman-Seam Detail #4

Kimono-Classic

Kimono-Long

Kimono-Short-Cap

Kimono-Novelty-Cap

French-Basic #1

French-Basic #2

French-Basic #3

French-Basic-Braid Trim

Pleated Cuff

Rib With Stripes

Shirt-Flounce trim

Shirt-Panelled Cuff

Shirt-Rolled Up Cuff

Flounce-Ruffle	Flounce With Tie	Flounce With Cuff
Shirt-Stitched Placket	Shirt-Tab Closure	Shirt-Tab Styling
Shirt-Wide Cuff-4 Buttons	Shirt-2 Buttons	Shirt-Wide-Cuff Links

Necklines, Collars, and Plackets

NECKLINES

A *neckline* is the edge of the garment which surrounds the neck and shoulders. Classic unisex neckline shapes include the basic *round neckline* (called a *jewel neckline* in women's wear) and the *V neckline*. Many other novelty necklines are used to style women's wear. The neckline may be finished with a *facing* (a flat piece of fabric which finishes the raw edge and is hemmed on the inside of the garment), a *knit*, *ribbed*, or *elasticized band*; or a *trimmed edge*.

COLLARS

The most popular neckline finish for both men's and women's wear is a *collar*. The collar is an added piece of fabric that surrounds the neck and is attached to the neckline of the garment. Usually, collars are interlined to give them shape and a crisp form. The collar frames the face. The factors influencing the style of the collar are the following:

1. Height of the stand (the part of the collar from the neckline to the fall);
2. Shape and depth of the fall;

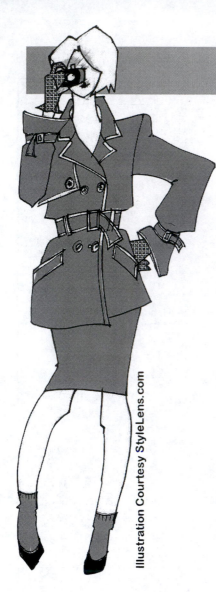

Illustration Courtesy StyleLens.com

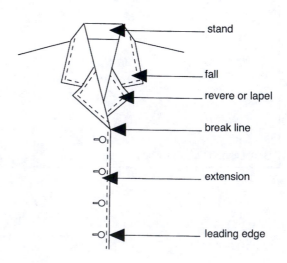

- stand
- fall
- revere or lapel
- break line
- extension
- leading edge

3. Distance between the neckline and the base of the neck;

4. Distance between the points of the collar (called the *spread*—typical of a shirt collar); and

5. Size and shape of the revere and lapel (if used).

The three basic families of collars are the *shirt and revere, flat* (like the Peter Pan and middy), and the *ruffle*. Novelty collars include the *turtleneck, cowl,* and *hood*. The *shirt collar* is the most popular unisex collar. When cut in two pieces with a band and fall, the dress shirt collar is crisp and rigidly shaped. Both parts of the collar may be incorporated into one pattern piece for a softer, less rigid effect and is the basis for the *revere collar*. Men's woven sports shirts and many soft women's wear blouses are also trimmed with this collar.

The *straight band collar* is a version of the *stand collar* without a fall. During the nineteenth century, men's formal shirts had detachable collars which buttoned on an attached band so that they could be washed separately from the body of the shirt. This novelty style is called a *mandarin, Cossack, Wallace Beery* (an actor who often wore this style shirt), or a *Nehru collar* (a name derived from the jacket worn by a prime minister of India who made the jacket of the same name popular). The *band collar* is used for men's and women's wear in all categories of tops. For example, the *wing collar* is a band with two V-shaped front tabs typically worn under a tuxedo for men's formal wear. The band also has been extensively used in sportswear to camouflage a zipper pocket which contains a hood.

The softest version of the band collar is for women's wear and is a bias strip of fabric, often doubled and styled with long tails which can be tied in a bow at the front of the neck. The *mandarin* collar is popular in Chinese native costume and is often used in women's blouses and dresses.

The revere collar incorporates part of the bodice fabric into a lapel or under a lapel. The front of a jacket or shirt is finished with a large facing and opens into a graceful V which focuses attention on the face and neckline. The *roll line* divides the stand from the fall. The *break line* is where the top revere reverses to the facing and is determined by the top button. The revere is a traditional jacket collar and combines well with other blouse necklines. A great variety of shapes and styles are possible. The jacket may have a single or double breasted closing which influences the shape and size of the lapel and collar.

A *shawl collar* is a version of a revere, except that it has no points and the collar extends into the front of the jacket or shirt as facing. This collar is typical of men's formal wear and is used as a novelty women's wear collar.

Classic flat collars, like the *Peter Pan,* have the same curved shape as the basic round neckline of the garment and lie flat on the shoulders with little or no stand. This collar is primarily used in women's wear, though it gets its name from the popular literary hero who wore this classic nineteenth century boy's style. When the outer edge of a Peter Pan collar is straightened out, the stand becomes taller. A *Puritan collar* is a Peter Pan collar which extends to mid-shoulder. Larger Peter Pan collars resemble small capes and are called *berthas*. The largest, a cape typical of a Sherlock Holmes overcoat, is called a *pelerine*.

Middy or *sailor collars* are traditionally used on sailors' uniforms and also lie flat on the shoulders but extend from a V neckline. A contrasting tie is often teamed with this collar, which can be trimmed with braid and stars. This timeless novelty is appropriate for both young and old. The size and shape of the sailor collar may be varied for many novelty effects and is often styled in nautical colors of white, gold, navy blue, and red.

A *ruffle trimmed* neckline reverses the construction principle of the Peter Pan collar and increases the amount of fabric at the edge of the collar to form a ruffle. The neckline edge of the collar can also be increased for additional volume. This feminine collar is typical of dressy women's wear tops.

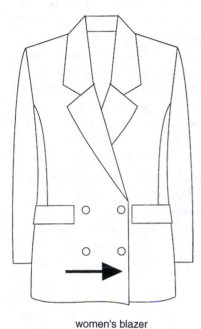

women's blazer

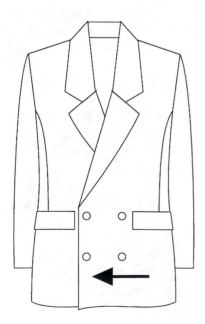

men's blazer

Cowl necklines and collars are draped on the bias and fall softly in front of the face. Named after the drape typically found on a priest's robe, this neckline is now used for women's wear. Soft, pliable knits and wovens are best suited to this style because they fall gracefully in natural folds. The collar is a separate piece of fabric attached to the neckline of the garment.

Hoods are popular collars for outerwear. Both men and women's outerwear often feature hoods because they protect the head in inclement weather. Styled hoods can be designed to fall gracefully over the head and shoulders.

Woven and knit collars can be used interchangeably on shirts made from both fabrics. Additional care is necessary when combining flexible knits with inflexible woven fabric to make sure that sufficient room is available to slip the garment over the head.

Turtlenecks are classic unisex collars popular for casual garments. When styled in a knit fabric, the turtleneck stretches enough to be pulled over the head. A zipper or other opening is necessary when a turtleneck is made from a rigid fabric. A *mock turtle* is a band collar which is shorter and less bulky than a classic turtleneck.

Collars often contrast with the body of the shirt to focus attention on the face. Trims including *passementerie* (braids and cording), *frogs* (knot-shaped buttons and trim made from cord), *velvet collars, lace, top stitching, embroidery, bows,* and *ribbons* are possible collar trims.

PLACKETS

A review of the difference in the direction men's and women's wear front opening garments close is in order before discussing plackets. As we mentioned in Chapter 1, men's garments button left over right, and women's the opposite, right over left. Remember that you must place the templates on your body, facing outward to identify the direction the placket or garment should button. When placed in front

of the designer, the garment will appear to button in the opposite direction.

A *placket* is an opening in a garment which allows the body to enter. Plackets are most often placed at the center front and wrist. A shirt placket is an interlined, flat piece of fabric sewn to the front opening of the garment to hold the button holes. This opening is usually reinforced with top stitching. A hidden placket is camouflaged with a plain piece of fabric so the buttons and holes are not visible.

Buttons are placed at evenly spaced intervals on the center front line of the garment at pressure points created by the curves of the body. The top button controls the depth of the neckline. A button is necessary at the bust line, hip, and waist of a woman's garment. The rest of the buttons are usually evenly spaced between these points and the bottom of the garment. Jackets may have a single button, depending on the style. The size of the button and the bulk of the fabric determine the size of the *extension* (the space between the leading edge of the placket and the center front of the garment). The extension should be large enough to visually balance the size of the button.

Buttons are measured by *line* and may have a variety of shapes. Refer to the sample chart to check some typical button sizes. Buttons are selected to complement the garment, and the designer should consider the price as

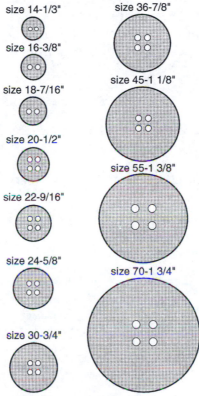

size 14-1/3"

size 16-3/8"

size 18-7/16"

size 20-1/2"

size 22-9/16"

size 24-5/8"

size 30-3/4"

size 36-7/8"

size 45-1 1/8"

size 55-1 3/8"

size 70-1 3/4"

Button Line Chart: This convenient chart allows designers to choose and order buttons both quickly and accurately.

well as the esthetics of the button. Plastic is often used to make buttons and can be died to match the color of the garment. Other materials include mother-of-pearl (the classic shirt button), wood, cloth, leather, bone, horn, jewels, and metal.

Buttonholes are usually made by a specialty machine which overcasts the edges of the fabric, which is then cut to allow the button to pass through. *Bound* or *corded button-holes* may be used in fine garments but must be finished by hand, and so are more expensive to make.

Shirt buttons are placed vertically on the placket, because the buttons are small and lightweight, and there is little stress on them. Buttonholes which secure heavier buttons on bulky fabric are best placed horizontally to the front of the garment because the button is firmly held on the center front of the garment. *Loop buttonholes* are made from bias over a cord center and are stitched into the center front of a placket and button over full or half ball buttons.

Garments may be closed with a variety of other methods, including *zippers*, *velcro fasteners* (tiny plastic hooks mounted on tapes which interlock when pressed), *snaps*, *laces*, or *ties*. Each method of closing a garment requires thoughtful placement of the detail to create an effective way to secure the garment.

REVIEW

Word Finders

Define the following words from the chapter you have just read:

1. band collar
2. buttonhole
3. collar
4. cowl
5. extension
6. facing
7. fall
8. hidden placket
9. hood
10. jewel neckline
11. loop buttonhole
12. mandarin collar
13. middy collar
14. mock turtleneck
15. neckline
16. Nehru collar
17. passementerie
18. pelerine
19. Peter Pan collar
20. placket
21. revere
22. shawl collar
23. spread
24. stand
25. turtleneck
26. velcro
27. wing collar

DISCUSSION QUESTIONS AND EXERCISES

1. Sketch three basic jackets and add a shawl collar and two different revere collars. Evaluate each design and determine which looks the most contemporary and which is the most formal.

2. Diagram the basic parts of a revere collar and identify the following components: stand, revere, fall, roll line, break line, extension, and leading edge.

3. Draw three revere jackets and experiment with a variety of blouse and shirt neckline combinations to determine which are the most compatible.

4. Draw a basic shirt for both men and women. Identify the stress points and place the buttons appropriately on the plackets for each type of garment

5. Draw a basic shawl collared jacket and change it with three different types of trim.

Women's and Men's Necklines

V Neck-Asymmetric	V Neck-Asymmetric-Deep	V Neck-Basic-Deep
V Neck-Deep	V Neck-Deep-Wide	V Neck-Ribbed
V Neck-Cardigan	V Neck-Cardigan	V Neck-Cardigan
V Neck-Cardigan Placket	V Neck-Edging	V Neck-Edging-Deep
V Neck-Pleated	V Neck-Pleated	V Neck-Scalloped-Tie

Square-Basic	Square-Edging	Square-Flounced
Square-Rounded Corners	Back View-Criss Cross	Back View-X Style
Back View-Multi Strap	Back View-Criss Cross	Cross Over
Cut Out Shoulders	Knotted Straps	One Shoulder-Knotted
Spaghetti-Basic	Spaghetti-Plunge	Spaghetti-Round Neck
Spaghetti-Tie Front	Tank Style-Cross Back	Woven Straps

Women's and Men's Necklines

Hooded-Basic	Hooded-Drawstring	Hooded-Drawstring
Hooded-Drawstring	Hooded-Collar Style	Hooded-Collar Style
Hooded-Collar Style	Hooded-Back View-Down	Hooded-Back View-Down
Sculptured-Geometric	Sculptured-Square-Edging	Sculptured-Sweetheart
Sculptured-Sweetheart	Sweetheart-Basic	Sweetheart-Basic
Sweetheart-Basic	Sweetheart-Basic	Sweetheart-Basic

Halter-Bow	Halter-Cowl Style	Halter-Cross Over
Halter-Cut Out Shoulder	Halter-Cut Out-Plunge	Halter-Draped-Tie
Halter-Draped	Halter-Draped-Cowl	Halter-Keyhole
Halter-Single Breasted	Halter-Shirt Style	Halter-Side Pleats
Halter-Square Cut	Halter-Turtleneck	Halter-Twisted
Raised-Hehru/Mandarin Style #1	Raised-Hehru/Mandarin Style #2	Raised-Yoke-Zipper

Women's and Men's Necklines

Scoop-Basic

Scoop-Basic

Scoop-Plunging

Scoop-Pleated Inset

Scoop-Tied

Scoop-Scarf Inset

Bustier-Tie Front-Cut Out

Cut Out-Center Ring

Cut Out-Key Hole

Cut Out-Criss Cross

Cut Out-Stand Collar

Cut Out-Tie Neck

Draped-Straps

Draped-Scarf-Bow

Wrap-Inset

Wrap-Off The Shoulder

Wrap-Basic-Surplice

Wrap-Raised Neck-Surplice

Women's and Men's Necklines

Round-Basic	Round-Basic-Bound	Scoop-With Bow
Round-Basic-Placket	Round-Bound-Notched	Round-Flounced
Round-Draped Scarf	Round-Chanel Style	Round-Buttoned
Round-Edging	Round-Keyhole	Round-Slash
Round-Placket-Laced Front	Round-Button Loops	Round-Roll Back & Buttoned
Round-Zipper	Round-Drawstring	Round-Flap-D-Ring

Women's and Men's Collars

Shawl-Inset-Notched	Shawl-Triple	Shawl-Triple
Shawl-Fringed	Shawl-Square Cut	Shawl-Winged
Shirt-Basic	Shirt-Basic	Shirt-Convertible
Shirt-Convertible	Shirt-Convertible	Shirt-Lapel Style
Shirt-Round Edged-Basic	Shawl-Blanket Stitch Trim	Shirt Edged
Shirt-Ruffled	Wing-Basic	Wing-Chelsea Style

Women's and Men's Collars

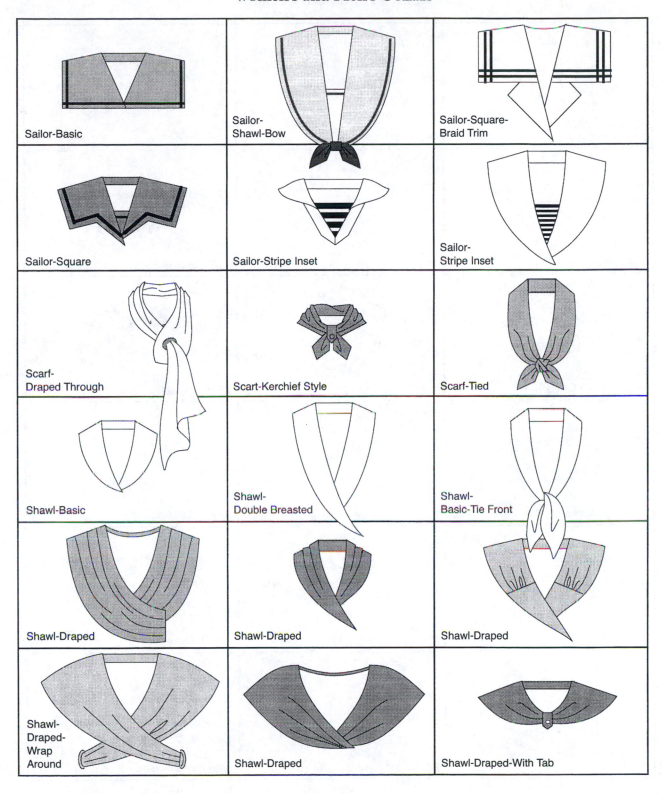

Sailor-Basic

Sailor-Shawl-Bow

Sailor-Square-Braid Trim

Sailor-Square

Sailor-Stripe Inset

Sailor-Stripe Inset

Scarf-Draped Through

Scart-Kerchief Style

Scarf-Tied

Shawl-Basic

Shawl-Double Breasted

Shawl-Basic-Tie Front

Shawl-Draped

Shawl-Draped

Shawl-Draped

Shawl-Draped-Wrap Around

Shawl-Draped

Shawl-Draped-With Tab

Women's and Men's Collars

Peter Pan-Basic	Peter Pan	Peter Pan
Peter Pan	Peter Pan	Peter Pan-Scalloped
Peter Pan-Shirt Style	Peter Pan-Flounce Trim	Peter Pan-Placket
Pleated-Pierrot Style	Pleated-Scarf Style	Pleated-Square Style
Portrait-Basic	Portrait-Stand Style	Portrait-Button Trim
Rib-Basics	Raised-Turtleneck-Basics	Raised-Wrap & Shawl Style

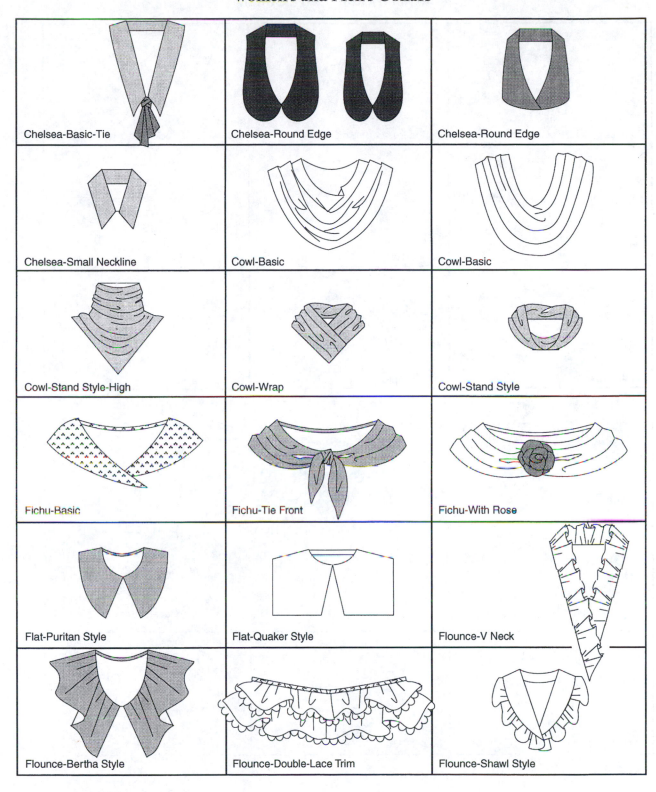

Chelsea-Basic-Tie	Chelsea-Round Edge	Chelsea-Round Edge
Chelsea-Small Neckline	Cowl-Basic	Cowl-Basic
Cowl-Stand Style-High	Cowl-Wrap	Cowl-Stand Style
Fichu-Basic	Fichu-Tie Front	Fichu-With Rose
Flat-Puritan Style	Flat-Quaker Style	Flounce-V Neck
Flounce-Bertha Style	Flounce-Double-Lace Trim	Flounce-Shawl Style

Women's and Men's Collars

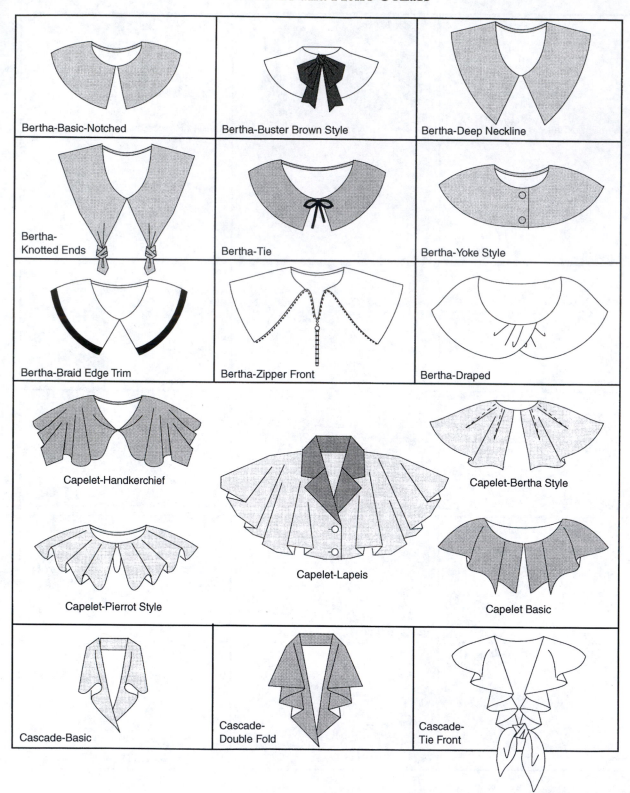

Bertha-Basic-Notched

Bertha-Buster Brown Style

Bertha-Deep Neckline

Bertha-Knotted Ends

Bertha-Tie

Bertha-Yoke Style

Bertha-Braid Edge Trim

Bertha-Zipper Front

Bertha-Draped

Capelet-Handkerchief

Capelet-Bertha Style

Capelet-Pierrot Style

Capelet-Lapeis

Capelet Basic

Cascade-Basic

Cascade-Double Fold

Cascade-Tie Front

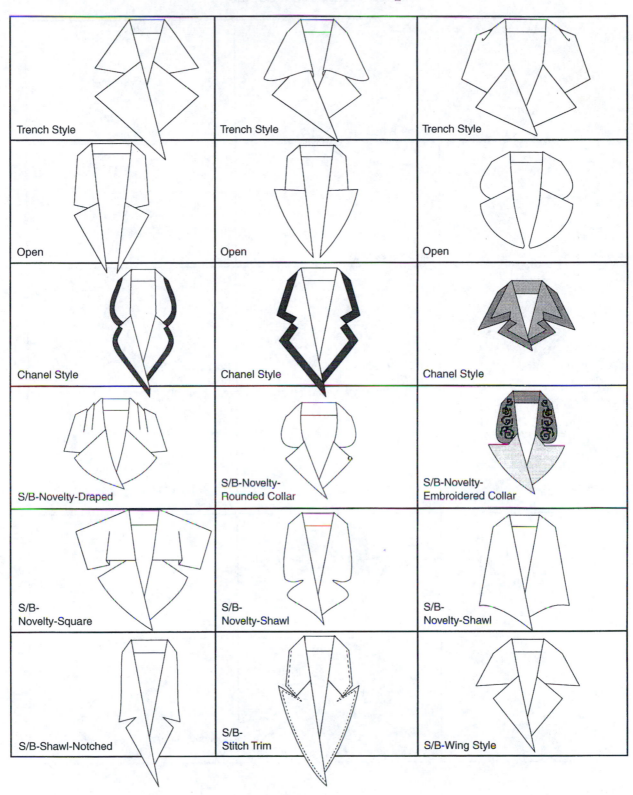

Trench Style

Trench Style

Trench Style

Open

Open

Open

Chanel Style

Chanel Style

Chanel Style

S/B-Novelty-Draped

S/B-Novelty-Rounded Collar

S/B-Novelty-Embroidered Collar

S/B-Novelty-Square

S/B-Novelty-Shawl

S/B-Novelty-Shawl

S/B-Shawl-Notched

S/B-Stitch Trim

S/B-Wing Style

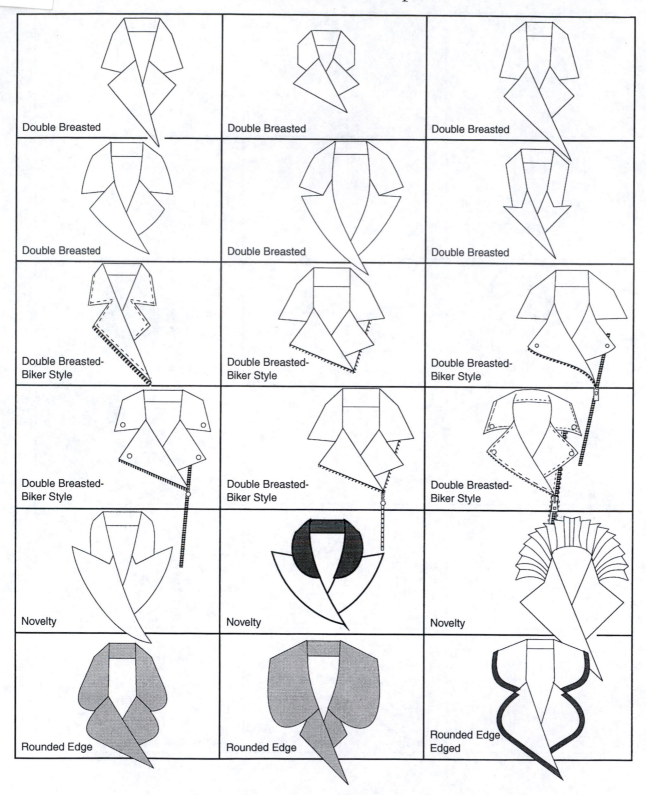

Double Breasted | Double Breasted | Double Breasted

Double Breasted | Double Breasted | Double Breasted

Double Breasted-
Biker Style | Double Breasted-
Biker Style | Double Breasted-
Biker Style

Double Breasted-
Biker Style | Double Breasted-
Biker Style | Double Breasted-
Biker Style

Novelty | Novelty | Novelty

Rounded Edge | Rounded Edge | Rounded Edge
Edged

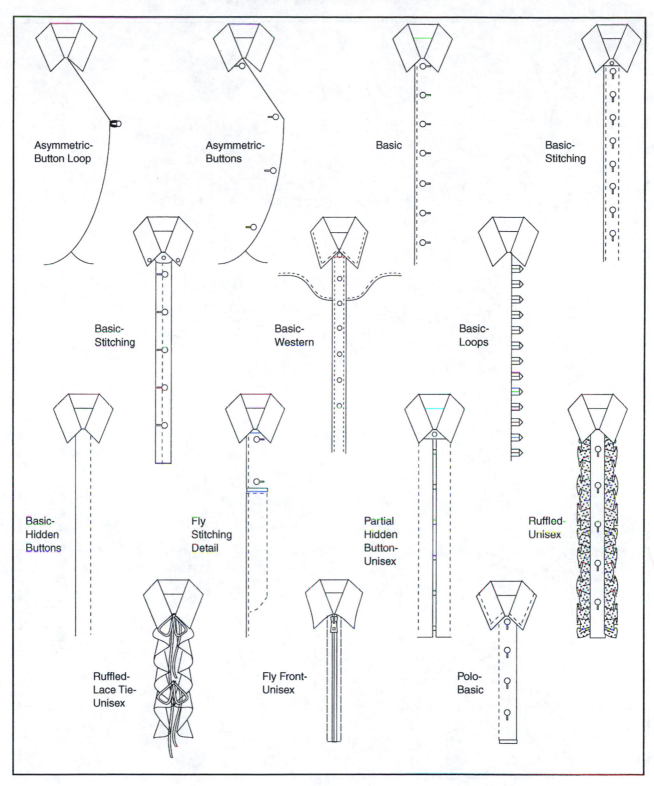

Asymmetric-Button Loop

Asymmetric-Buttons

Basic

Basic-Stitching

Basic-Stitching

Basic-Western

Basic-Loops

Basic-Hidden Buttons

Fly Stitching Detail

Partial Hidden Button-Unisex

Ruffled-Unisex

Ruffled-Lace Tie-Unisex

Fly Front-Unisex

Polo-Basic

Women's and Men's Plackets

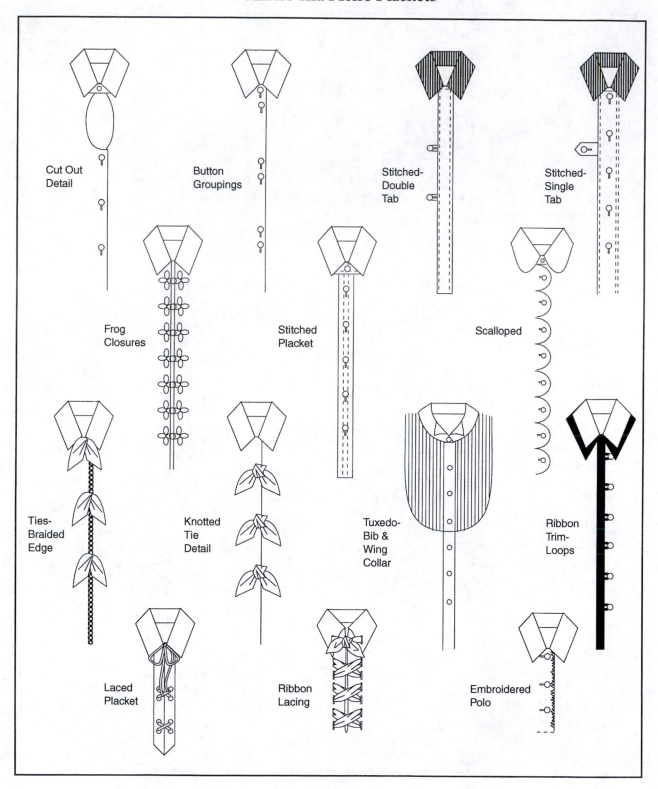

Cut Out
Detail

Button
Groupings

Stitched-
Double
Tab

Stitched-
Single
Tab

Frog
Closures

Stitched
Placket

Scalloped

Ties-
Braided
Edge

Knotted
Tie
Detail

Tuxedo-
Bib &
Wing
Collar

Ribbon
Trim-
Loops

Laced
Placket

Ribbon
Lacing

Embroidered
Polo

CHAPTER 7

Skirts and Dresses

A *skirt* is a tube of fabric which covers the body from the waist to the hem. Skirts and *dresses* (a skirt with a bodice attached) are primarily worn by women. Notable exceptions include the *kilt* (national costume of the Scotsman) and the *sarong* (worn by Polynesian men). There are four basic skirt silhouettes: straight, flared or gored, pegged, and circular.

STRAIGHT SKIRTS

The basic *straight* or *sheath skirt* has four darts in the front and back panels and curved side seams to remove fabric from the waist and yet allow enough room at the hip to sit down and move. A straight skirt is the same width at the hips as it is at the hem. The center back seam is often styled with a pleat or slit to make walking easier. A *dirndl* is a straight skirt with ease at the waist line instead of darts to control the difference in fabric needed at the waist and hips. Gores can also be used to shape a straight skirt. These can be placed on the princess lines of the dress form.

Pleated skirts are straight pieces of heat sensitive fabric which are exposed to heat, steam, and pressure to impress the shape of the pleats on the fabric. A special contractor usually pleats the fabric, using a large oven and patterns for each size. Pleat patterns include *straight* or *knife pleats, box pleats, accordion,* and *crystal pleats.* Engineered pleats are stitched into a seam to allow a person to move more comfortably.

FLARED SKIRTS

A *flared skirt* is wider at the hem than at the waist. The side seams slant outward from the fullest part of the hip. Because the side seams are not on the straight grain of the fabric, the skirt is cut partially on the bias, which influences the way it hangs. Gores allow a designer to add fullness to the flared skirt and to stabilize the bias grain line.

Typical distribution of gores in a flared skirt are the *three-gored skirt* (center back seam and two side seams), the *four-gored skirt* (with side seams and center front and back seams), and the multi-gored skirt (which uses novelty gores and shapes to style a wide range of skirts).

The flared skirt is extremely flattering because it makes the waist and legs seem slim. The wide hem line allows free movement and is very comfortable. Soft, pliable fabrics make the most graceful flared skirts.

Illustration Courtesy StyleLens.com

Straight Skirt

Flared Skirt

Pegged or Draped Skirt

Circular Skirt

PEGGED SKIRTS

The hipline of a *pegged skirt* is wider than the hem line. This shape exaggerates the size of the hip. The skirt often has slits at the hem line to facilitate movement. A draped skirt has ease or pleats at the waist line and is most often used for evening wear.

The *sarong* (also sometimes called a pared) is a version of the draped skirt which first became fashionable after World War II, influenced by the popularity of Polynesian styles. It is characterized by an asymmetrical closing, a side slit, and soft draping at the waist line.

CIRCULAR SKIRTS

Circular skirts require very wide fabric to the cut in one piece. For this reason, they take an enormous amount of yardage and are rarely used commercially. An exception was during the 1950s when circle skirts made from felt and decorated with small motifs were popular. Felt is the ideal fabric for a circular skirt because there is no grain line, it is very wide, and it does not have to be hemmed.

Circular skirts are used in expensive evening wear. Designer fashions often include several circles of chiffon in a single skirt which creates a dramatic and feminine silhouette. *Half-circle skirts* have front and back or side seams ad are more economical to manufacture.

SKIRT LENGTHS

The most dramatic way of altering the silhouette of a skirt is to raise or lower the hem line. Since the beginning of this century, hem lines have varied from the micro mini, which barely covers the crotch, to floor length. A variety of lengths are currently fashionable and often reflect the category of merchandise, where and how it will be worn

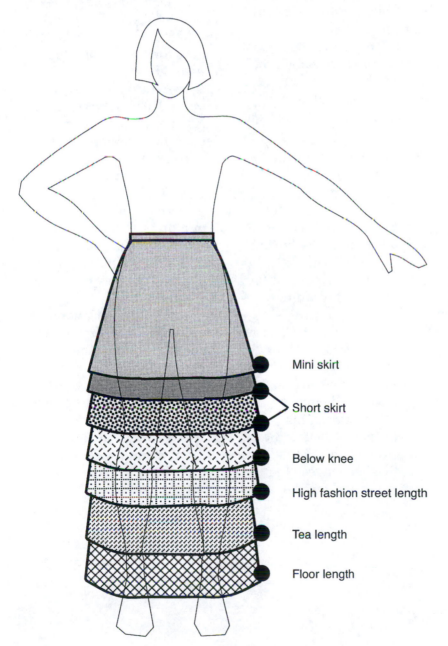

Mini skirt

Short skirt

Below knee

High fashion street length

Tea length

Floor length

rather than the rigidly dictated hem lines that have characterized past decades.

STYLING THE SKIRT

Waistband and yoke treatments are important ways to style a skirt. Using a yoke can eliminate the need to use gores and darts. Waistbands and belts are natural styling devices for both skirts and dresses.

DRESS STYLING

A *dress* is defined as a single garment that covers the torso and legs. Merchandising trends divide dresses by age, use, and price range. Also note that dress departments sell jumpsuits, ensembles, and two-piece dresses.

Traditional size and age divisions in the dress area are *junior* and *missy*. The average age of the junior dress customer is 14 to 25 years. Missy dresses are divided in additional categories which cater to customers wiling to purchase a variety of prices and style designations. For example, the age of a contemporary customer is typically 18 to 50, she has a youthful figure, and she wants innovative styling. The traditional missy customer is more conservative and usually wants a dress in an easy

care fabric, with sleeves and a traditional length and silhouette.

Specialty size categories include *petite* (for women under 5 feet 3 inches in height), *large*, *half*, and *tall* sizes.

Dresses are often grouped by end use. Manufacturers concentrate on designations such as *maternity*, *bridal*, *cocktail*, and *evening wear*.

The dress is an extremely diverse style category. The two main body categories are *horizontally divided dresses* and *one-piece garments*.

The dress may be divided horizontally at any point on the body, but the most typical divisions are shoulder yolk, empire line, natural waist, and low torso dresses.

1. *Shoulder yoke.* This is a classical styling device for shirt dresses, controlling bust ease.
2. *Empire line.* This division falls right under the bust to mid-rib cage. This style is especially popular for junior and wedding dresses because it is youthful. A *babydoll* is an empire dress with a short, flared skirt. This silhouette creates an illusion of height.
3. *Natural waist.* This division is the traditional and the most natural division between the bodice and the skirt. This

division is often emphasized with trim.

4. *Low or drop torso dress.* This features a division below the hip line. Two-piece dresses often feature this division which can camouflage a wide waist and problem hips.

Dresses which have no horizontal divisions emphasize height and slenderize the figure, especially when vertical design elements like gores, center front style lines, and plackets are used. Alternate names for straight one-piece dresses are *shift*, *tube*, and *sheath*. A dress styled with gores is called a *princess line*. *Coat* and *shirt dresses* are styled with details common to shirts and coats. A *jumper* is designed to be worn with a blouse. *Tent*, *trapeze*, and *A-line* are alternate names for a flared dress. Optional self-belts are often included on a sheath dress so the wearer has the option of softly belting the dress at the waist.

Countless variations are possible because dresses are an extremely versatile category of apparel, but the classics are the basis of dress styling and are reinterpreted during various fashion cycles. Proportion and current detailing are important to successfully design dresses.

REVIEW

Word Finders

Define the following words from the chapter you have just read:

1. circular skirt
2. contemporary customer
3. dirndl
4. dress
5. empire
6. engineered pleat
7. flared skirt
8. jumper
9. low torso
10. natural waist
11. pegged skirt
12. pleated skirt
13. princess line
14. sarong
15. sheath
16. shoulder yolk
17. skirt
18. three-gored skirt

DISCUSSION QUESTIONS AND EXERCISES

1. Discuss three pleat styles. Design three dresses using each pleat style.

2. Select a skirt silhouette and design three versions which are mini, at the knee, and mid-calf.

3. Adapt shirt dress details to the four basic horizontal divisions of the dress and design shirt dress versions.

4. Design three dresses for a contemporary customer. Describe the stores where the dress would be sold and research contemporary dress lines before beginning to design. One dress is appropriate for casual weekend wear, the second to be worn for business, and the third a cocktail dress.

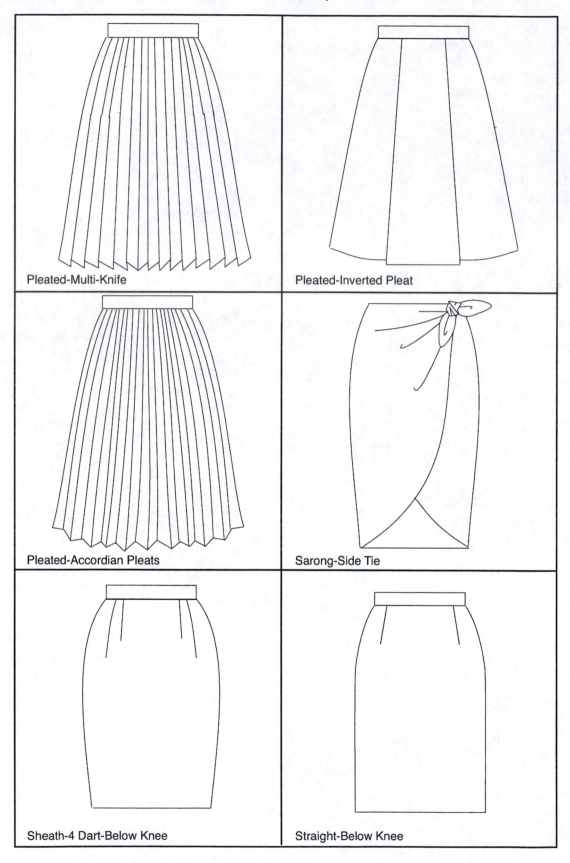

Pleated-Multi-Knife

Pleated-Inverted Pleat

Pleated-Accordian Pleats

Sarong-Side Tie

Sheath-4 Dart-Below Knee

Straight-Below Knee

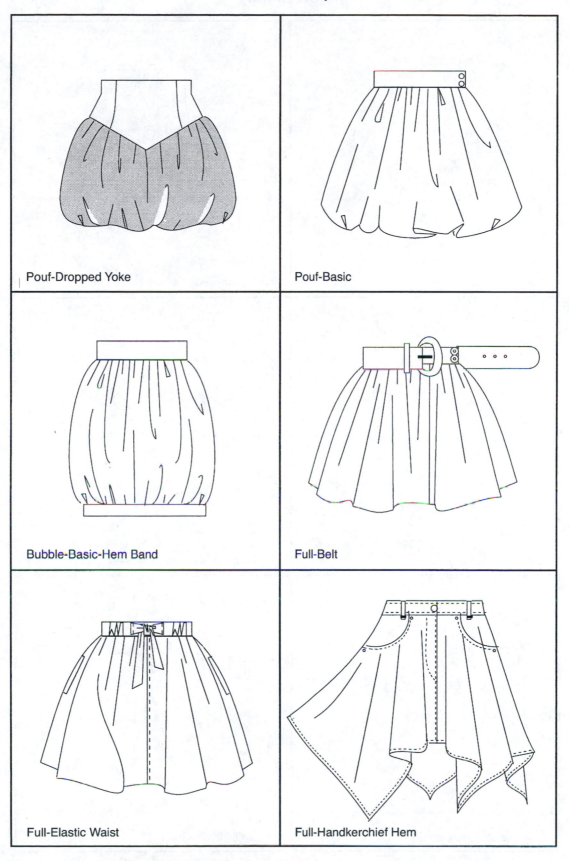

Pouf-Dropped Yoke

Pouf-Basic

Bubble-Basic-Hem Band

Full-Belt

Full-Elastic Waist

Full-Handkerchief Hem

Skirt Library

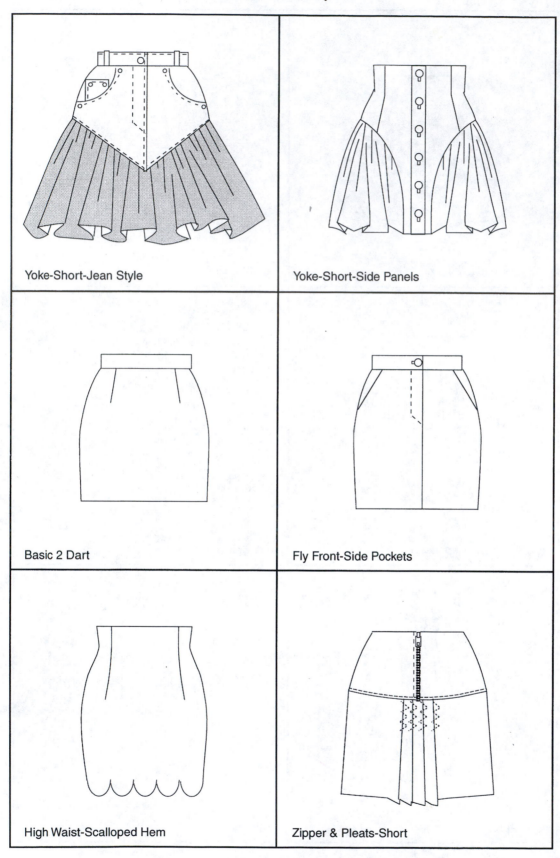

Yoke-Short-Jean Style

Yoke-Short-Side Panels

Basic 2 Dart

Fly Front-Side Pockets

High Waist-Scalloped Hem

Zipper & Pleats-Short

Skirt Library

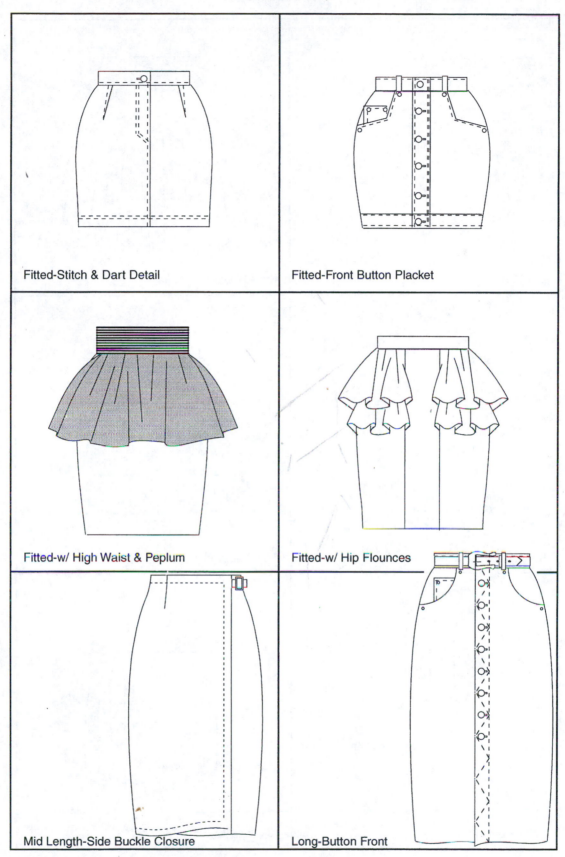

Fitted-Stitch & Dart Detail

Fitted-Front Button Placket

Fitted-w/ High Waist & Peplum

Fitted-w/ Hip Flounces

Mid Length-Side Buckle Closure

Long-Button Front

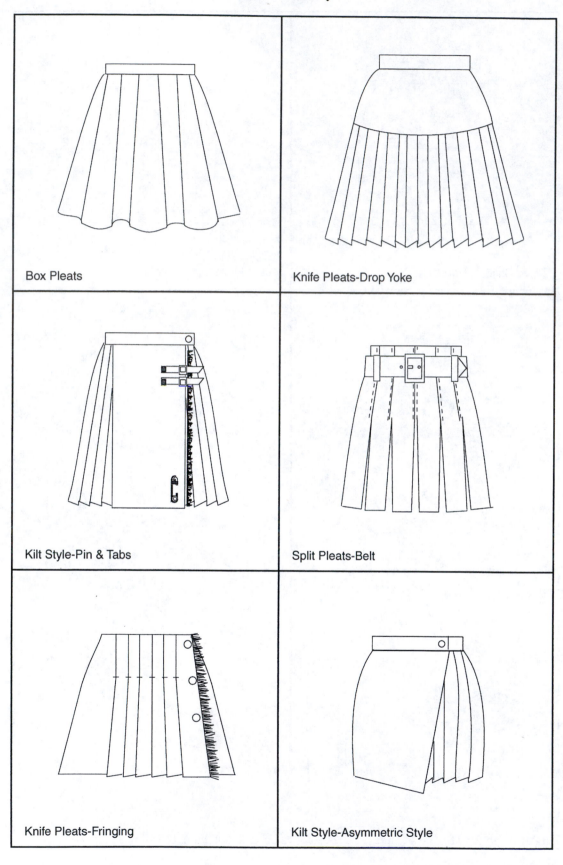

Box Pleats

Knife Pleats-Drop Yoke

Kilt Style-Pin & Tabs

Split Pleats-Belt

Knife Pleats-Fringing

Kilt Style-Asymmetric Style

Skirt Library

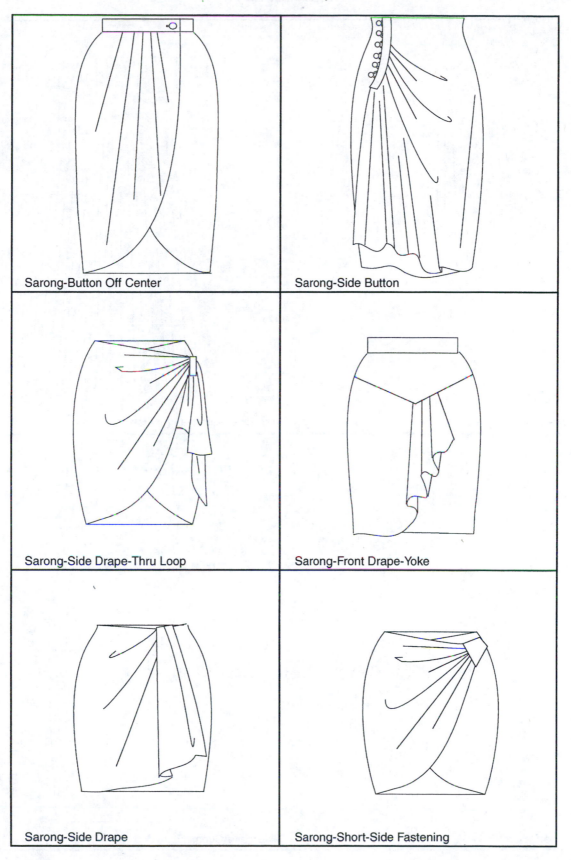

Sarong-Button Off Center

Sarong-Side Button

Sarong-Side Drape-Thru Loop

Sarong-Front Drape-Yoke

Sarong-Side Drape

Sarong-Short-Side Fastening

Dress Library

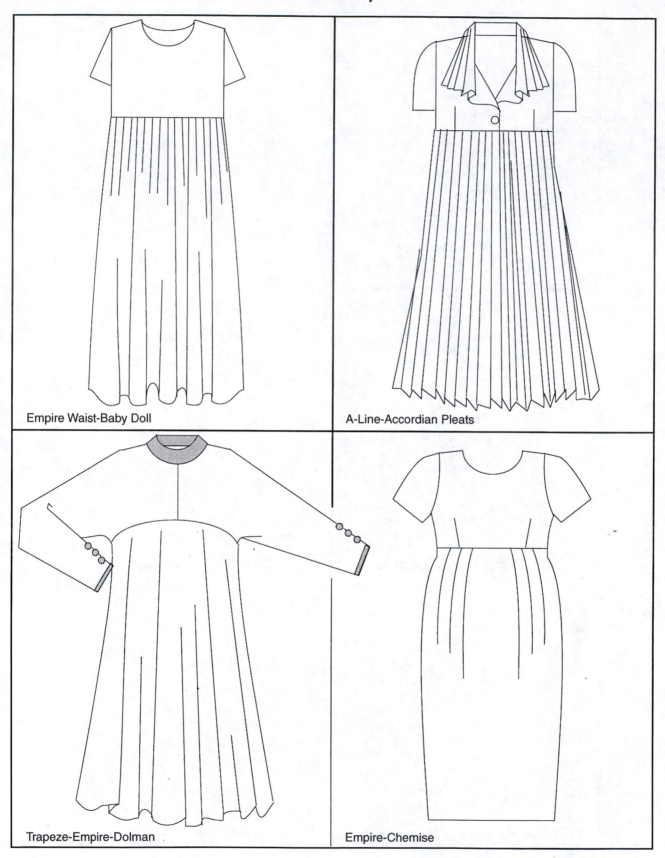

Empire Waist-Baby Doll

A-Line-Accordian Pleats

Trapeze-Empire-Dolman

Empire-Chemise

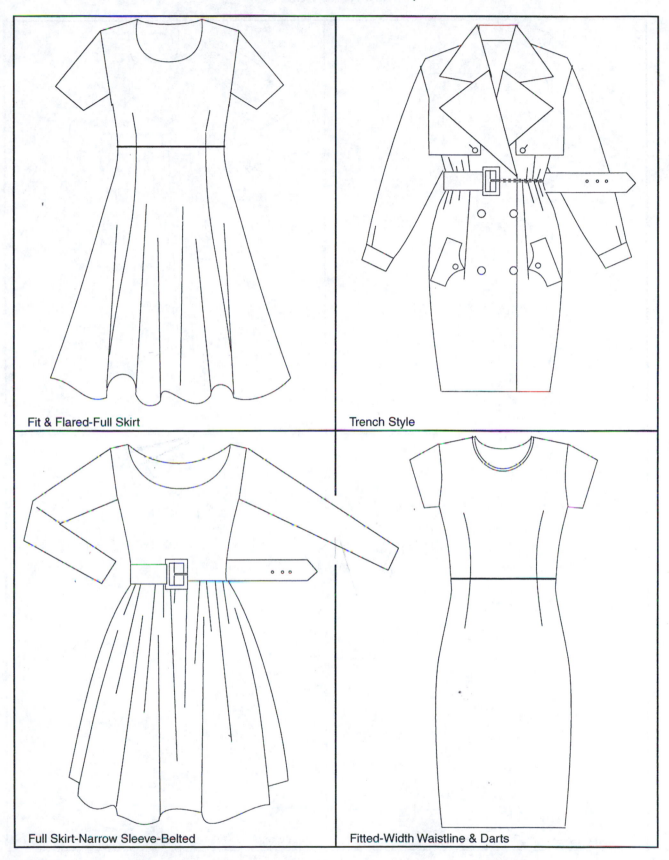

Fit & Flared-Full Skirt

Trench Style

Full Skirt-Narrow Sleeve-Belted

Fitted-Width Waistline & Darts

Columnar

Smock

Peasant Smock

Shirt Style

Sundress With Godets

Fit & Flared Princess Line

Unfitted-Princess Line-Overall

Jean Style-Long-Sleeveless

Gored Dress Library

Fitted Shoulder-Princess

Fitted Stretch-Princess Line

Coat Dress With Cuffs

Zippered Front

Shift, Chemise, or Cocoon Dress Library

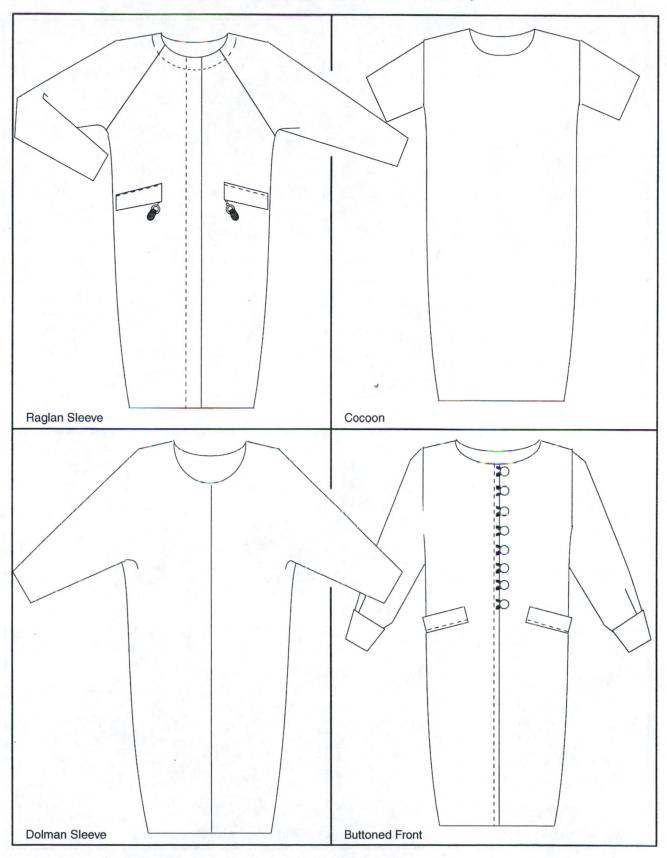

Raglan Sleeve

Cocoon

Dolman Sleeve

Buttoned Front

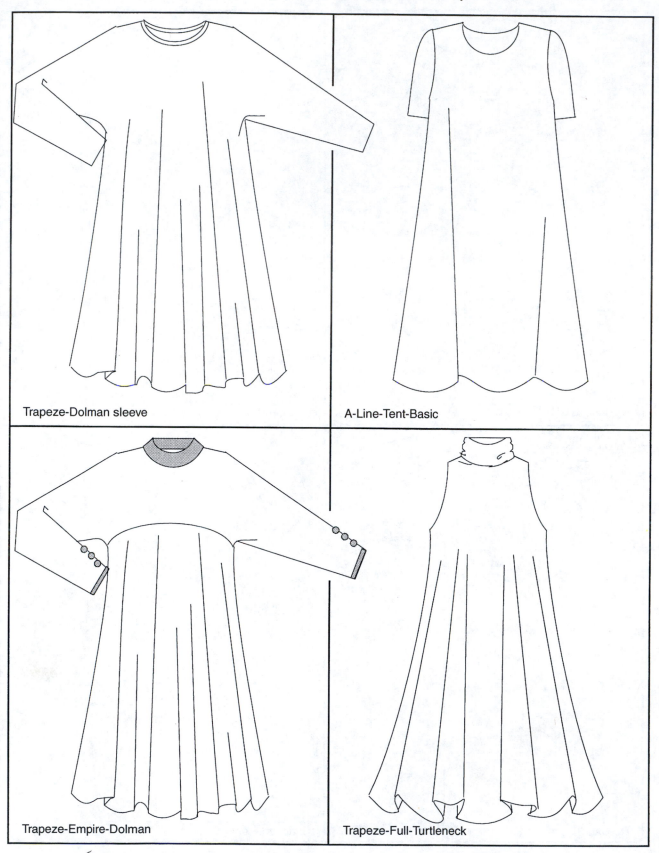

Trapeze-Dolman sleeve

A-Line-Tent-Basic

Trapeze-Empire-Dolman

Trapeze-Full-Turtleneck

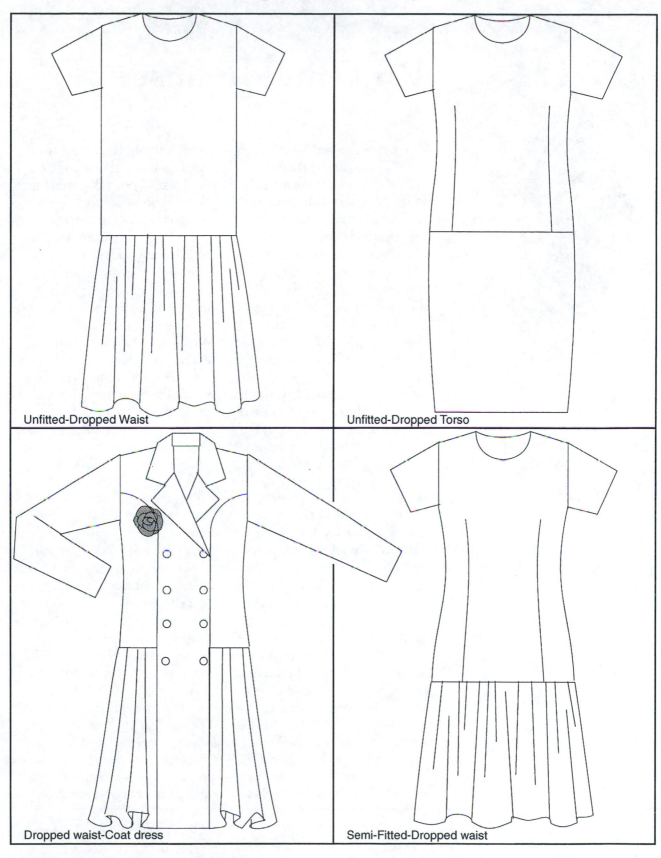

Unfitted-Dropped Waist

Unfitted-Dropped Torso

Dropped waist-Coat dress

Semi-Fitted-Dropped waist

Pants and Jumpsuits

Illustration Courtesy StyleLens.com

Women borrowed pants from men, first wearing them for active sportswear because full long skirts and tight corsets did not allow women to ride bicycles and horses easily. These sports required the legs to be free, so adventuresome nineteenth-century women adapted men's pants to the modest standards of the period. The trend continues to this day—pants and active sportswear for men and women are remarkably similar.

Of course, the fit of men's pants differs considerably from that of women's wear, but basic pant styling falls into similar categories for both sexes. *Jeans* are snugly fitted pants made from heavy canvas or twill which have functional pockets at the waist and hips. *Trousers* have a looser fit, styled with pleats and darts to slim the hipline. Pockets are usually included at the side seam and back. Novelty treatments for both sexes include cuffs, belt loops, length variations, and a wide variety of fabric selections.

Both sexes wear *shorts*. A surprising variety of silhouettes can be achieved by adding fullness, flare, knit cuffs, and waist line yokes and details to all lengths of pants. *Pants* are,

by definition, two tubes of fabric sewn together to cover the legs. Almost all pants must be constructed with a center front and back under crotch seam. The exceptions are the *brief, bathing suit,* or very *short shorts* which may be styled with a crotch *gusset* (a fabric inset which shapes the garment between the legs). A *jump-suit* is created when a bodice is added to a pant.

Designers must carefully study the fit, shape, and size of the pant leg because it is a critical factor in pant design. Subtle variations in the width of the cuff and knee greatly effect the cut of the pant. Fit is so critical to the success of a pant that popular styles are often sized for a great variety of customers. For example, the basic five-pocket man's jean is offered by many manufacturers in a *slim cut,* a *mature fit* (greater ease in the seat), a *boot leg* (wider at the cuff to accommodate boot tops), and an *oversized fit* for trendy teenagers.

Pants traditionally have been made in a *bottom weight* fabric, a heavier textile than one worn as a shirt or bodice. Recently, fuller, softer pants, and skin tight styles have

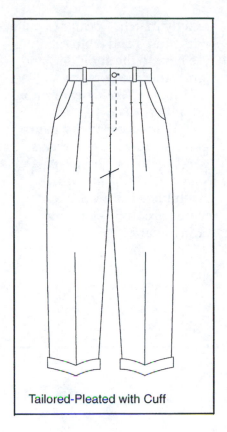

Tailored-Pleated with Cuff

5 Pocket Jean-Front-Basic

5 Pocket Jean-Back-Basic

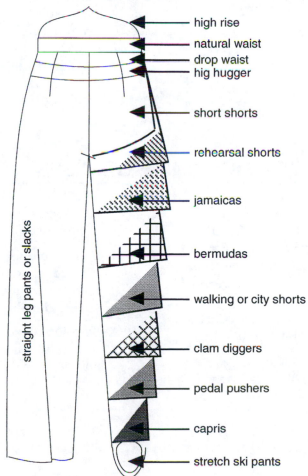

high rise

natural waist

drop waist

hig hugger

short shorts

rehearsal shorts

jamaicas

bermudas

walking or city shorts

clam diggers

pedal pushers

capris

stretch ski pants

straight leg pants or slacks

become fashionable for both sexes. Knits have revolutionized pant styling because they stretch more than wovens. Though skin tight bicycle shorts styled in a shiny stretch fabric tend to be worn by the young, even conservative men and women wear pull-on sweat pants borrowed from the gym.

Tailored men's wear relies on two fashion formulas—a matching jacket and pant (the business suit) and the more informal sports coat and contrasting trouser. Spectator sportswear, or the pants suit, is the woman's version of the man's suit and sports coat. First accepted as informal day wear, today, pants suits are worn for almost every occasion. Mismatched suits are often fashionable and are typical of sportswear ensembles. *Separates* are pants, jackets, and other items which are sold as individual units and do not exactly match. *Overalls* (a pant with straps and a bib securing the pant to the shoulder) and jumpsuits are popular informal or work wear options for both sexes.

Women's novelty pants parallel skirt shapes. Pleats, gores, gathers, and drapes shape *palazzo pants*, which resemble a full skirt but which are divided with a crotch seam.

REVIEW

Word Finders

Define the following words from the chapter you have just read:

1. boot leg
2. bottom weight
3. crotch gusset
4. jeans
5. jumpsuit
6. overalls
7. palazzo pants
8. pants
9. pants suit
10. separates
11. shorts
12. spectator sportswear
13. sweat pants
14. trousers

DISCUSSION QUESTIONS AND EXERCISES

1. Shop a men's jeans store or department and list the variety of sizes offered in basic styles. Discuss the way waist and pant lengths are sized. How does this parallel women's sizing? *Stock keeping units* (SKUs) increase greatly when many sizes or styles are offered. Estimate how many SKUs are necessary to fit a man with a size 32 waist.

2. Style three palazzo pants, using gathers, a drape, and pleats to add fullness to the basic body. Add different novelty waist treatments to complement each style.

3. Style two unisex trousers, modifying the silhouettes so they are appropriate for men and women but using similar styling details.

4. Develop two casual jumpsuits—one with the traditional center front crotch seam and one with a gusset to shape the crotch.

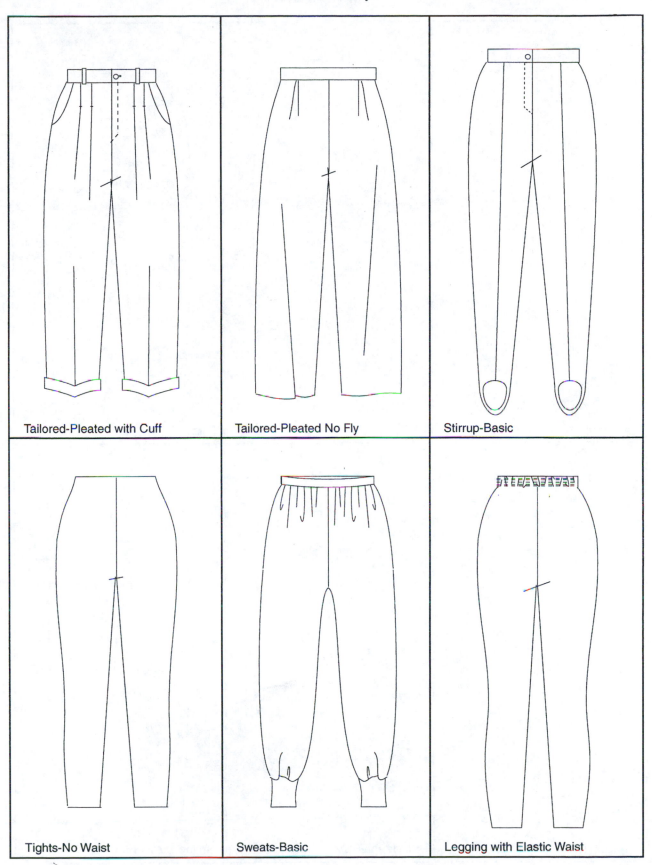

Tailored-Pleated with Cuff

Tailored-Pleated No Fly

Stirrup-Basic

Tights-No Waist

Sweats-Basic

Legging with Elastic Waist

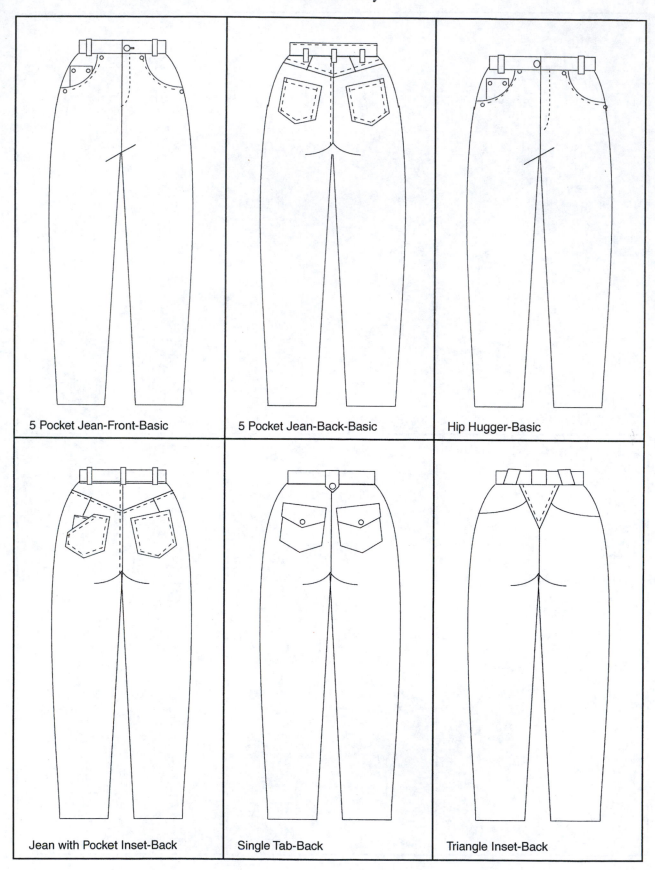

5 Pocket Jean-Front-Basic

5 Pocket Jean-Back-Basic

Hip Hugger-Basic

Jean with Pocket Inset-Back

Single Tab-Back

Triangle Inset-Back

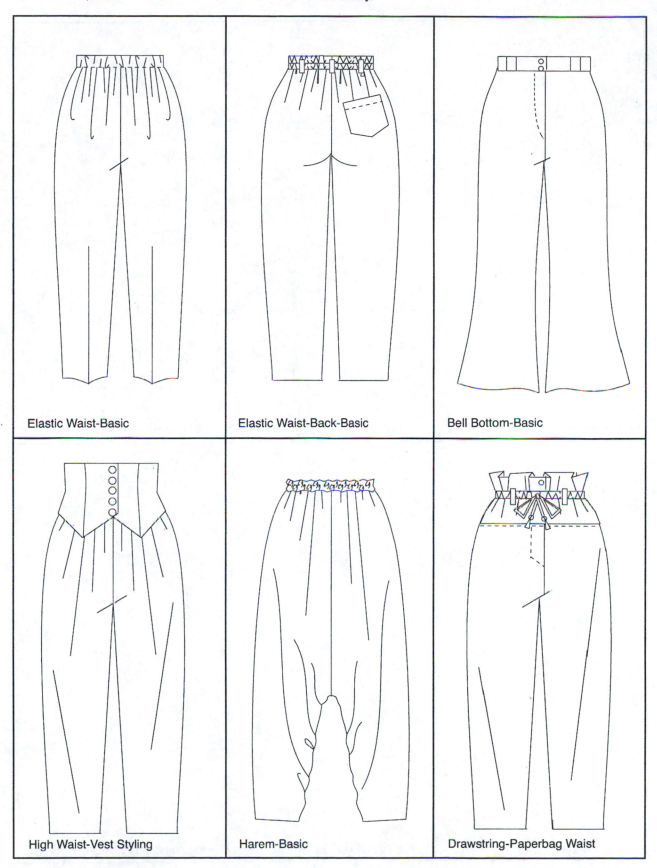

Elastic Waist-Basic

Elastic Waist-Back-Basic

Bell Bottom-Basic

High Waist-Vest Styling

Harem-Basic

Drawstring-Paperbag Waist

Pant Library

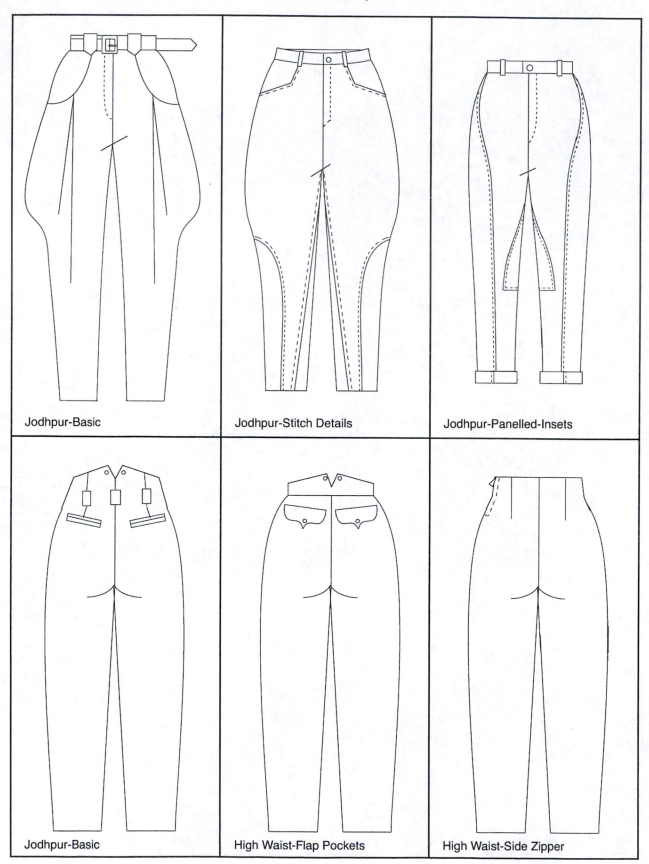

Jodhpur-Basic

Jodhpur-Stitch Details

Jodhpur-Panelled-Insets

Jodhpur-Basic

High Waist-Flap Pockets

High Waist-Side Zipper

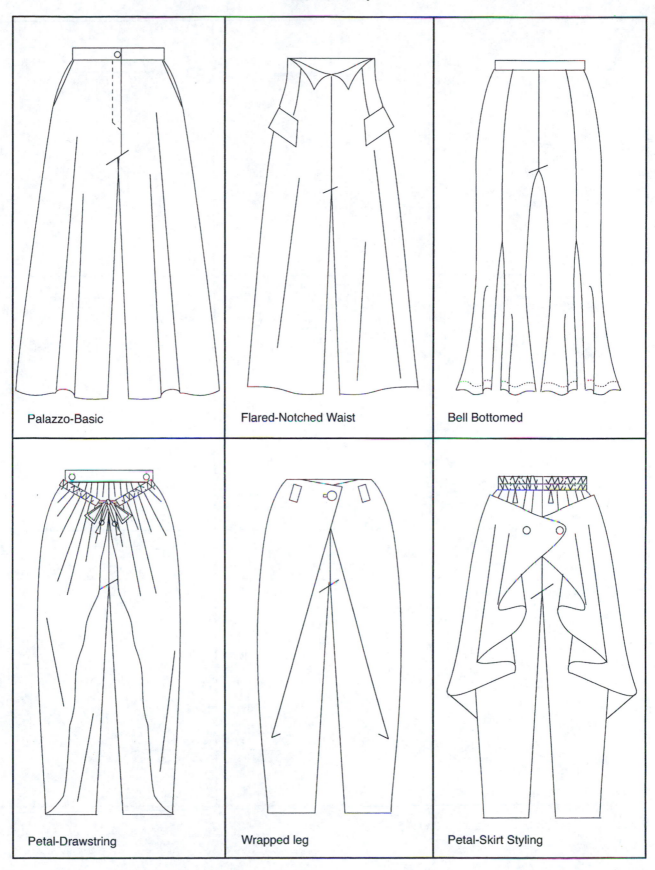

Palazzo-Basic

Flared-Notched Waist

Bell Bottomed

Petal-Drawstring

Wrapped leg

Petal-Skirt Styling

Short Library

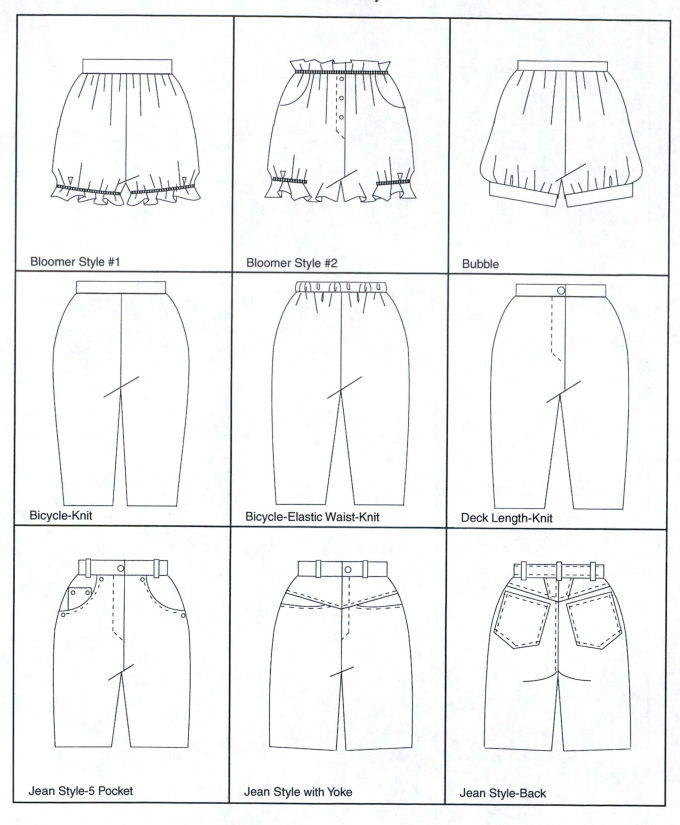

Bloomer Style #1

Bloomer Style #2

Bubble

Bicycle-Knit

Bicycle-Elastic Waist-Knit

Deck Length-Knit

Jean Style-5 Pocket

Jean Style with Yoke

Jean Style-Back

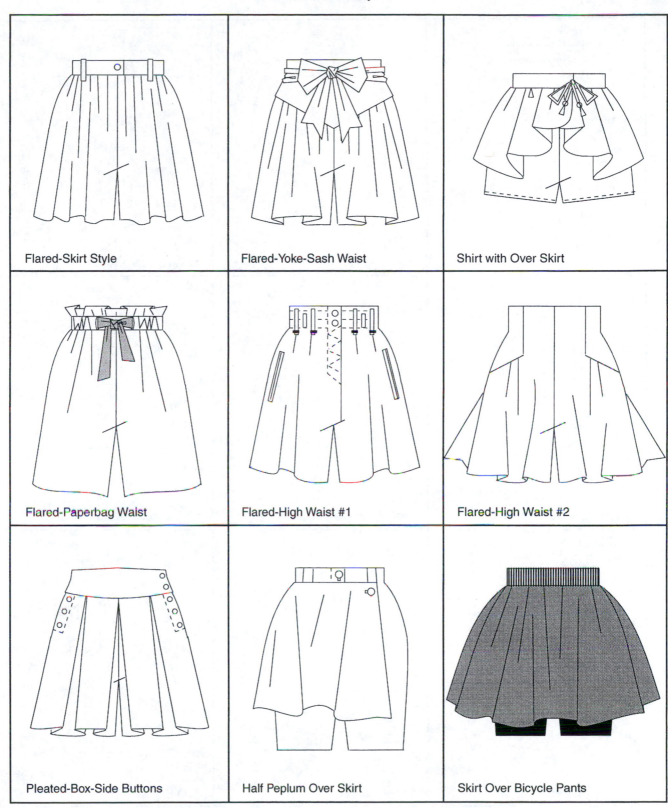

Flared-Skirt Style

Flared-Yoke-Sash Waist

Shirt with Over Skirt

Flared-Paperbag Waist

Flared-High Waist #1

Flared-High Waist #2

Pleated-Box-Side Buttons

Half Peplum Over Skirt

Skirt Over Bicycle Pants

Short Library

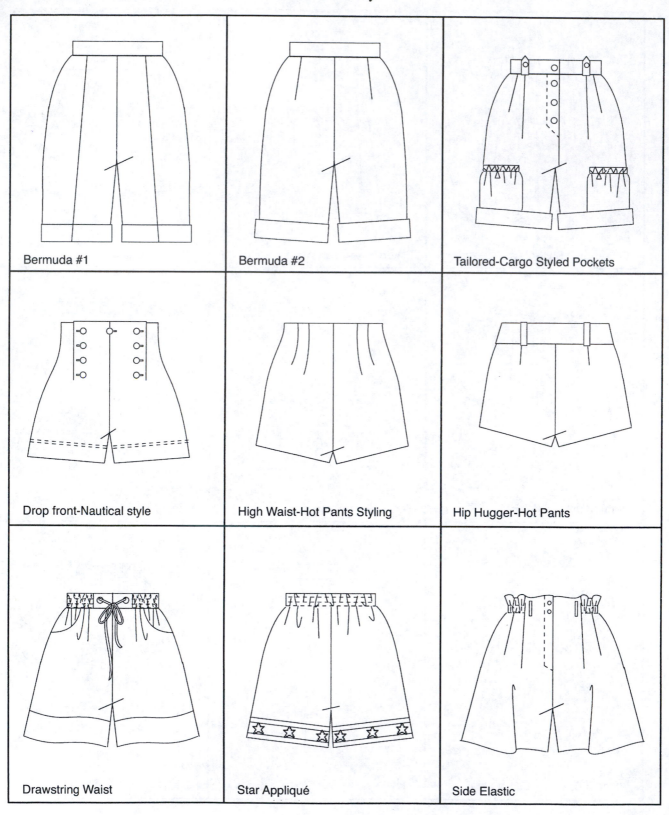

Bermuda #1

Bermuda #2

Tailored-Cargo Styled Pockets

Drop front-Nautical style

High Waist-Hot Pants Styling

Hip Hugger-Hot Pants

Drawstring Waist

Star Appliqué

Side Elastic

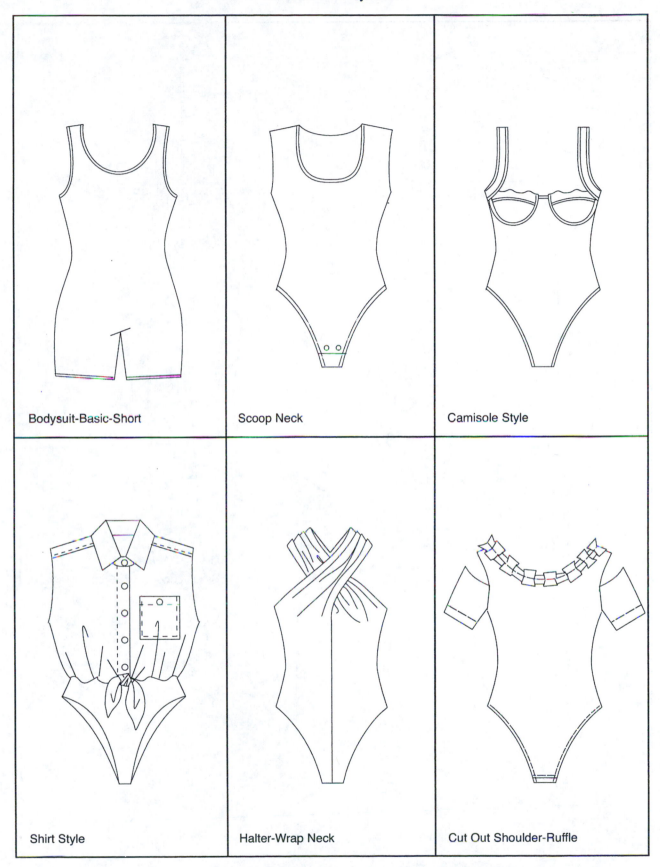

Bodysuit-Basic-Short

Scoop Neck

Camisole Style

Shirt Style

Halter-Wrap Neck

Cut Out Shoulder-Ruffle

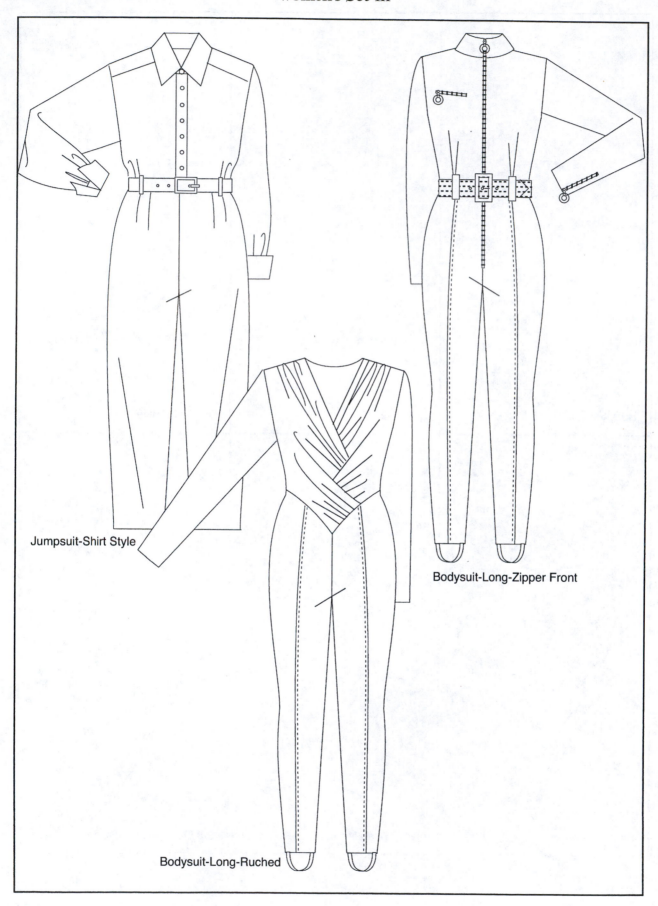

Jumpsuit-Shirt Style

Bodysuit-Long-Zipper Front

Bodysuit-Long-Ruched

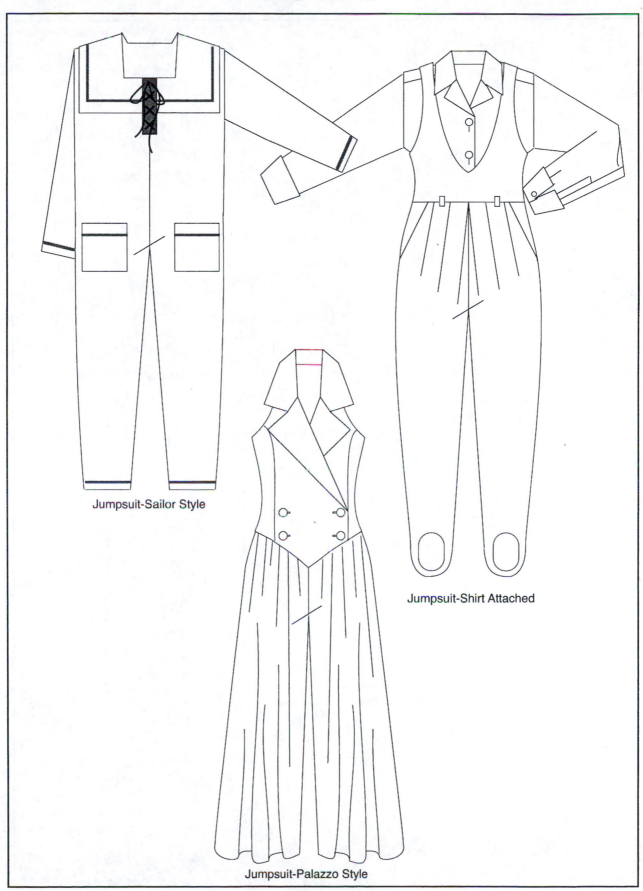

Jumpsuit-Sailor Style

Jumpsuit-Palazzo Style

Jumpsuit-Shirt Attached

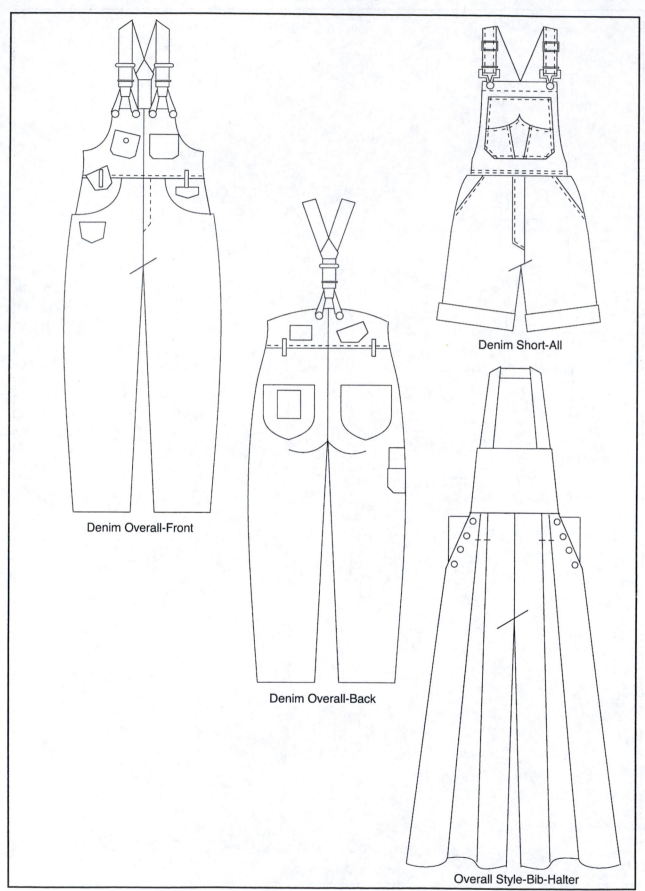

Denim Overall-Front

Denim Overall-Back

Denim Short-All

Overall Style-Bib-Halter

Men's Pants

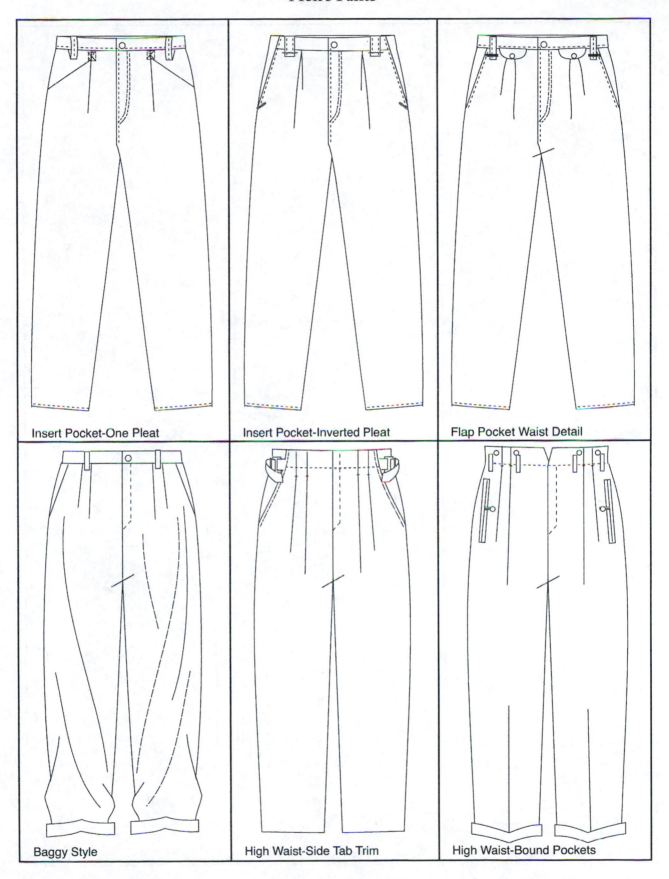

Insert Pocket-One Pleat

Insert Pocket-Inverted Pleat

Flap Pocket Waist Detail

Baggy Style

High Waist-Side Tab Trim

High Waist-Bound Pockets

Basic-Open Button Fly

Front Yoke

Button Fly-Knee Patch Insets

Sweatpant-Elastic Cuff-Panelled

Ski Pant-Center Leg Seam

Sweatpant-Crotch Panel Inset

Men's Shorts

Bermuda-Cargo Pocket

Cycling Short-Knee Length

Cycling Short-Mid Length

Tennis Style

Running Short-Basic

Running Short-Bound Edge

Jean Style-5 Pocket

Jean Style with Yoke

Jean Style-Stripe Inset

Details and Trims

Illustration Courtesy StyleLens.com

Trims decorate a garment with functional and unfunctional accessories and details. Technically, accessories are not part of the basic structure of the garment. Examples are buttons, detached belts, ribbons, and so on which are attached to the garment. *Details* are style elements or decorations sewn into the fabric or garment like appliqué, top stitching, ruffles, and the like. Trims enhance the garment and make it more salable but should not be so expensive that they limit sales. Trims should complement a design and have the same care requirements as the garment.

Trims which are made with special machines are usually made by outside contractors. For example, yardage or cut pieces are sent to an embroidery factory which applies the stitched motif and returns the pieces to the manufacturer to be sewn into a garment. It is important that the outside contractor be able to deliver the trimmed pieces quickly so production is not held up. Designers review trim lines for ideas and may design their own trims to create a unique garment.

Trims may be purchased from an outside supplier and sewn on to the garment by the manufacturer. Examples of this kind of trim are applied laces, collars, buttons, belts, and the like.

Details are designed into the garment. These include pockets, flounces, contrasting trims, and other details. Usually, these types of trims can be made in-house and do not hold up the manufacturing of the garment.

CLOSURES, FASTENINGS, AND TRIMS

Novelty trims change rapidly, and it is important for designers to constantly search the market for the newest trends. *Self-ties*, *tabs*, and *laced fastenings* are novelty trims

which tend to be popular when ethnic and tribal garments are in style. *Decorative zippers* are a classic trimming device for active sportswear and outerwear and periodically are popular for spectator sportswear.

Passementerie trim is a broad term for most kinds of braided and corded trims. Usually braids are used to trim a curved edge of a garment because they are more flexible than ribbons. Ribbons are better used for straight trims.

Appliques, *patches*, and *embroidered motifs* are stitched details which have endless styling possibilities. They are especially popular for children's wear. Cartoon characters are popular subjects, but manufacturers must purchase the right to use them from the creator. Specialized equipment is needed to embroider the pattern on cloth. It may be done on a finished garment, but production is simpler and less expensive when done on cut pieces of the garment.

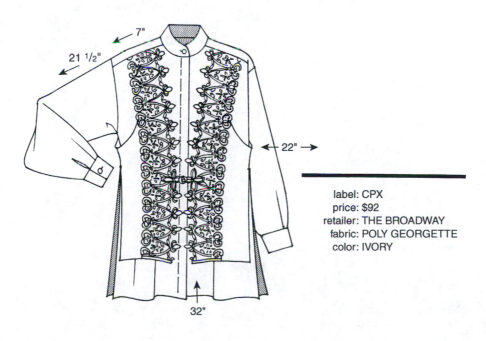

label: CPX
price: $92
retailer: THE BROADWAY
fabric: POLY GEORGETTE
color: CREAM

LACE APPLIQUE

8"

23"

24"

32"

7"

21 1/2"

22"

32"

label: CPX
price: $92
retailer: THE BROADWAY
fabric: POLY GEORGETTE
color: IVORY

Quilting

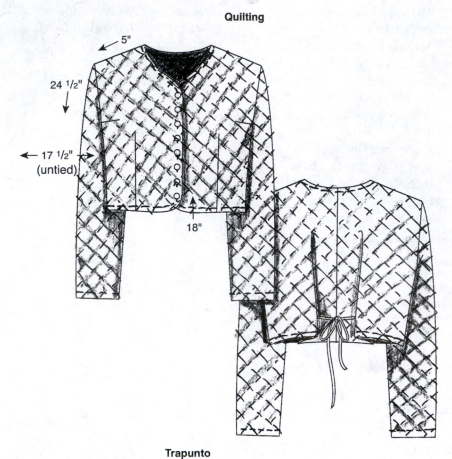

5"

24 1/2"

17 1/2"
(untied)

18"

Quilting is another stitched trim which usually has a polyester filler sewn between two light-weight fabrics, creating a spongy, warm textile typically used for robes and outerwear. Typical quilting patterns are *rail quilts* (straight lines approximately 3/4" to 1-1/2" apart), *chicken wire quilting* (resembles wire), and *novelty patterns. Trapunto* is a stitched design in one area of a garment that is padded for added dimensions.

Screen printing is used to apply printed designs to a garment. The fabric can be screened before it is sewn or added directly on to a specially designed finished garment called a *blank*. A wet ink printing process requires that a screen be made for each color in the design and printed separately on the fabric. Heat transfer prints are first printed on heat sensitive paper and applied to fabric using heat and pressure. These may have many colors, but only one application process is needed. The quality of wet printing continues to be superior in density of color and clarity of design, but heat transfer printing has the

Trapunto

4"

14"

19"

Straight Flounce

benefits of being inexpensive and easy to transfer to cloth with very simple equipment.

RUFFLES, FLOUNCES, AND PLEATS

There are two main *ruffle* shapes:

1. a straight piece of fabric gathered along one edge; or
2. a circular shape which can vary from a curved piece of fabric to a complete circle resembling a donut.

Curved Flounce

Both types of ruffles must be set into a seam, bound at one edge, and gathered or pleated to control the fullness. *Straight ruffles* tend to be crisp. *Circular ruffles* have a graceful, curved edge. A *flounce* is a long ruffle.

Ruffles and flounces are feminine details, typically used at the hem, neckline, placket, or as an area trim on a woman's bodice or skirt. Special care must be taken to hem the ruffle so it does not ravel or become too bulky. Doubling a thin fabric to eliminate the need for a hem is a popular way to finish a ruffle.

POCKETS

Pockets are important functional and decorative trims. Work clothes always include pockets so the wearer has a place to carry tools, even if it is only a pencil or a pen. Classic men's shirts have a pocket placed on the left side of the chest because most people are right handed, and it is most comfortable to reach to the left to store a pen. Additional rules governing pocket design and placement are the following:

1. Place the pockets where they are both functional and attractive. When adding pockets to a garment, consider the normal reach of the arm, hand size, and how it will be used.

Typical Pocket Placement

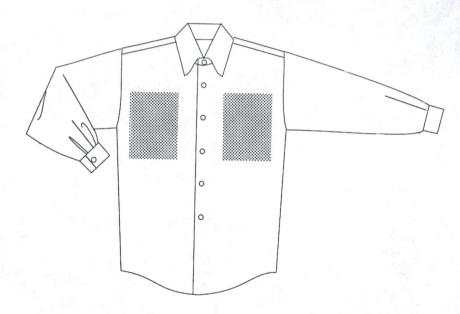

Pockets are too low.

Pockets are more appropriately placed.

2. The shape of the pocket should reflect the shape of other garment details. For example, a large square pocket will look out of place on a soft blouse with a Peter Pan collar.

3. Pockets used in pairs should have a related shape and size and be carefully placed. Large pockets at the waist and hip call attention to these areas and make then seem larger.

4. Beware of placing pockets with button flaps at the bustline of a woman's garment.

Left (below): Pocket-shape conflicts with other details.
Right (below): Pocket shapes are compatible.

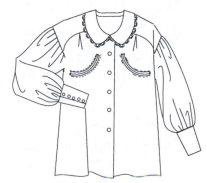

Left: Large pockets at the hipline make this area seem larger.
Right: Slash pockets slims the hipline.

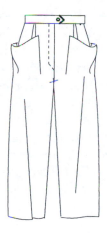
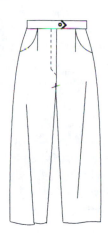

Left: Pocket shape conflicts with other details.
Right: Pocket shapes are compatible.

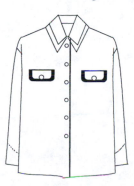
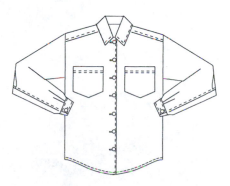

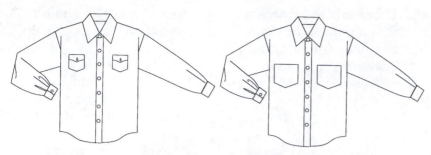

Pockets are too small. **Pockets balance shirt.**

5. Scale the size of the pocket to the size of the garment. For example, tiny pocket details on a garment for a large size man or woman will make the garment seem larger.

BELTS

Belts help sell a garment not only because they add a finishing touch but also because a customer can tighten or loosen the belt to make the garment fit more comfortably. There are three main shapes for belts:

1. *straight belts* which can be stiffened with interfacing;
2. *Contour belts,* always stiffened with interfacing, which have been shaped to conform to the hipline or waist; and

3. tie belts, like spaghetti (long stuffed cords of fabric), soft bows and sashes, and novelty scarves, chains, braids, and ribbons.

As with other trims, belts must be compatible with the garment's price. More expensive belts are sold as separate accessory items, and when included with a garment, the price of the belt is limited to a small percentage of the cost of the garment. Usually structured belts with interlinings, buckles, and belt holes are made by a specialty supplier. Belts made in-house are usually self-fabric, unstructured ties or sashes.

WAIST AND HIP DETAILS

Hip details include a wealth of treatments which can be used to design skirts and pants. Plackets, welts, pleats, shaped waistbands, wraps, and drapes can be used as hip details. Top stitching and contrast pockets and trims are excellent styling alternatives. Care should be used to select details that are compatible

with typical customer figure types. Details call attention to the area they are placed on. Bold details, heavy pockets, and contrasting colors will make the hip and waist line seem larger. Pants and skirts designed to be worn with coordinating jackets should be checked to make sure the hip detailing is compatible with the length of the jacket.

REVIEW

Word Finders

Define the following words from the chapter you have just read:

1. blank (garment)
2. contour belt
3. details
4. flounce
5. heat transfer prints
6. outside contractor
7. quilting
8. ruffle
9. screen printing
10. spaghetti belt
11. trapunto
12. trims
13. wet printing

DISCUSSION QUESTIONS AND EXERCISES

1. Select a novelty waist band and hip treatment. Sketch it first on a short, straight skirt, on a trouser pant and, finally, on a mid-calf length flared skirt. Evaluate the three sketches and determine which is most salable.

2. Define the two main ruffle shapes and design a dress with a straight ruffle and one with a circular ruffle.

3. Select a patch and slash pocket and design both a man's and woman's casual shirt using these details as trim.

4. Define three main ways of making belts and sketch examples of each on basic pant. Adapt the type of belt you select to the silhouette of the pant.

Basic-Square Buckle

Cinch-Square Buckle

Belt Loop-Pointed Tab

Wide-Ruched

Multi Ribbon-Tied

Tie-Spaghetti

Hip-Chanel Chain

Sash Knotted At Side

Sash-Tied In Knot

Obi Type

Tied Belt

Wide-Round Buckle

Round-Buckle-Open

Wide-Square Buckle

Western Buckle

D-Ring-Tied

Wide-Leather

Wide-Double Buckle

Trims

Baseball & University

Daisy Appliqués

Cut-Out Daisies

Roses

Geometric Buttons

Jewel Buttons

Heart Buttons

Toggles

Conches With Ribbon

Embroideries

Epaulettes

Pocket Squares

Men's Ties

Patches With Stitch Detail

Pom Poms

Western Bolo Tie

Tassels

Fastenings and Closures

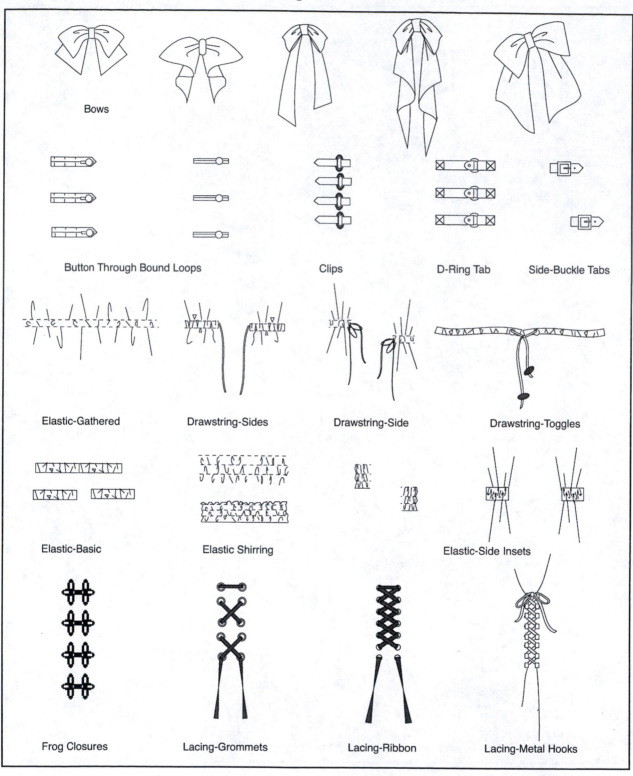

Bows

Button Through Bound Loops Clips D-Ring Tab Side-Buckle Tabs

Elastic-Gathered Drawstring-Sides Drawstring-Side Drawstring-Toggles

Elastic-Basic Elastic Shirring Elastic-Side Insets

Frog Closures Lacing-Grommets Lacing-Ribbon Lacing-Metal Hooks

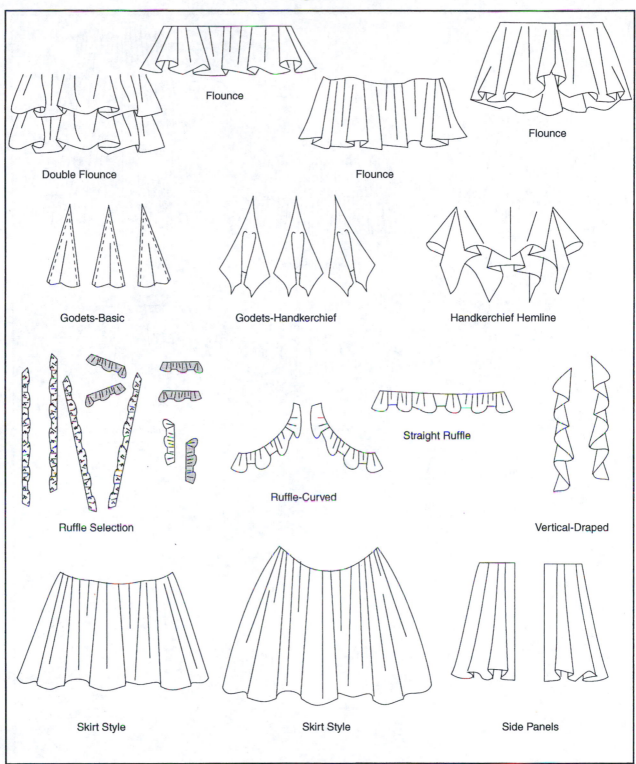

Flounce

Flounce

Double Flounce

Flounce

Godets-Basic

Godets-Handkerchief

Handkerchief Hemline

Ruffle Selection

Ruffle-Curved

Straight Ruffle

Vertical-Draped

Skirt Style

Skirt Style

Side Panels

Pleats

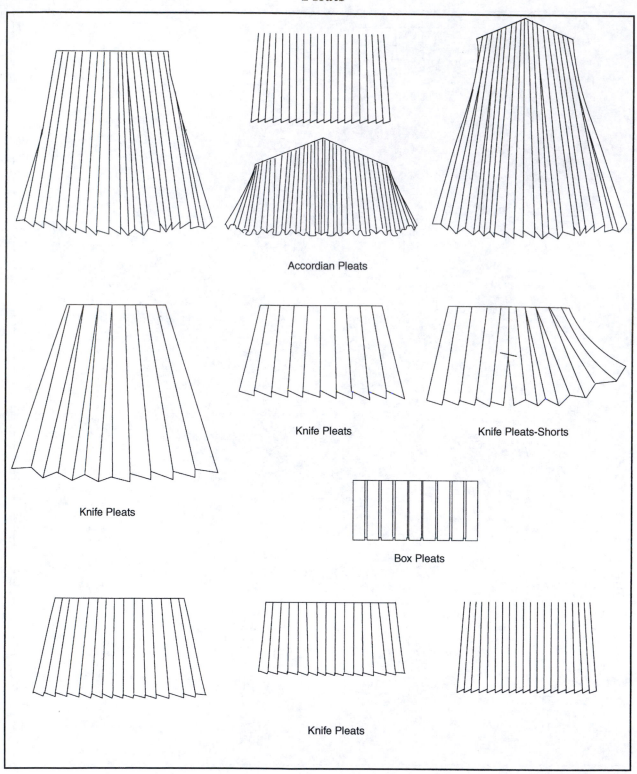

Accordian Pleats

Knife Pleats

Knife Pleats-Shorts

Knife Pleats

Box Pleats

Knife Pleats

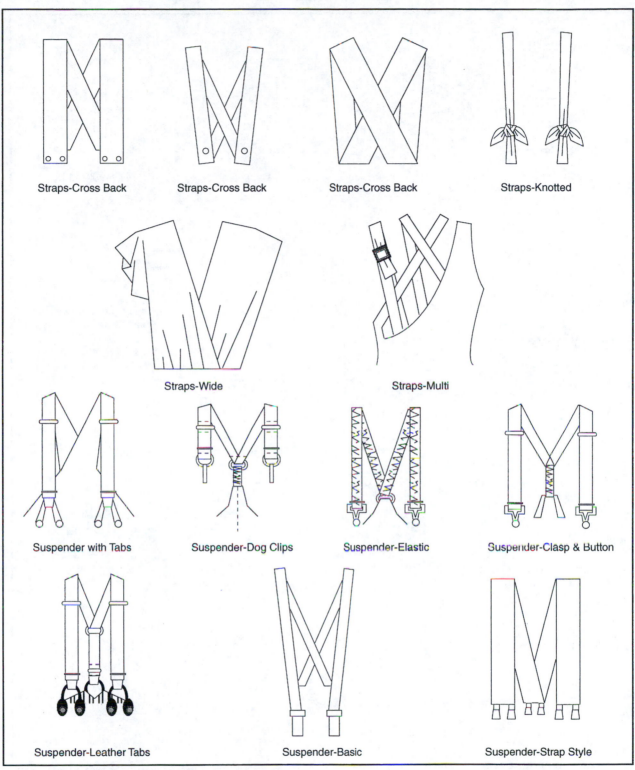

Straps-Cross Back

Straps-Cross Back

Straps-Cross Back

Straps-Knotted

Straps-Wide

Straps-Multi

Suspender with Tabs

Suspender-Dog Clips

Suspender-Elastic

Suspender-Clasp & Button

Suspender-Leather Tabs

Suspender-Basic

Suspender-Strap Style

Pockets

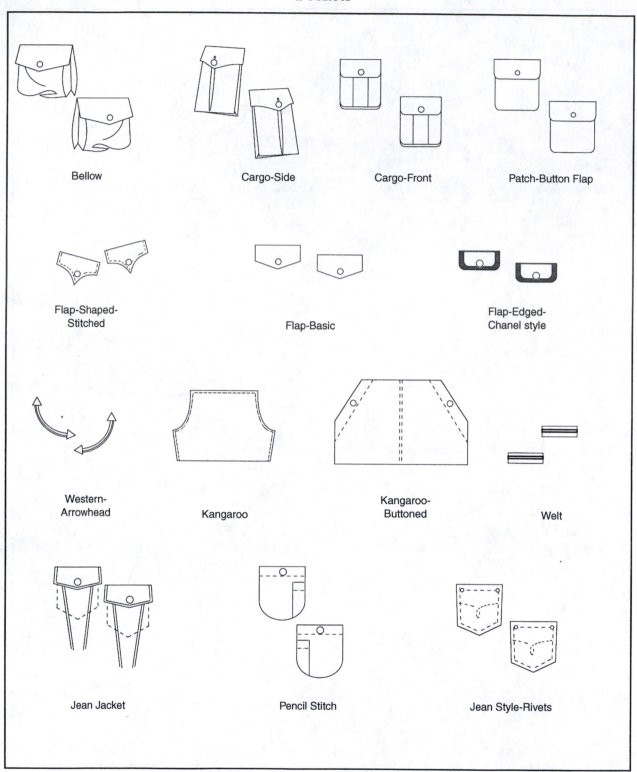

Bellow

Cargo-Side

Cargo-Front

Patch-Button Flap

Flap-Shaped-Stitched

Flap-Basic

Flap-Edged-Chanel style

Western-Arrowhead

Kangaroo

Kangaroo-Buttoned

Welt

Jean Jacket

Pencil Stitch

Jean Style-Rivets

Pant and Skirt Waistband Treatments

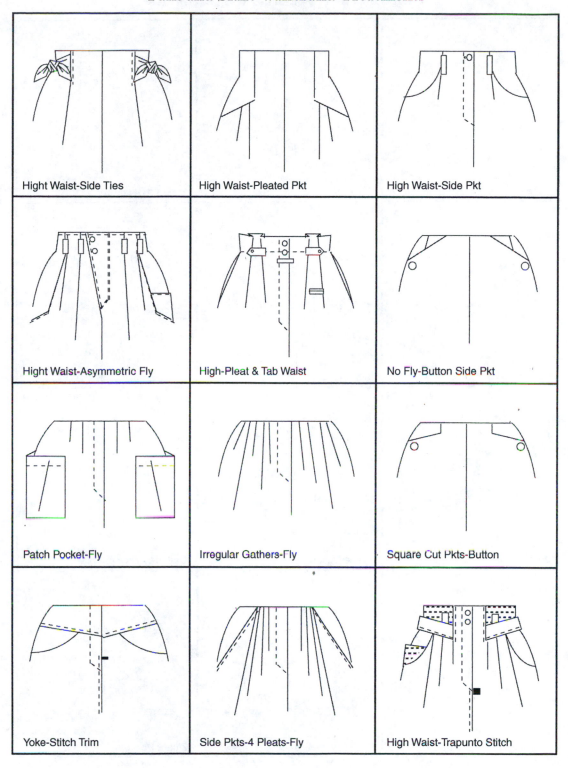

Hight Waist-Side Ties	High Waist-Pleated Pkt	High Waist-Side Pkt
Hight Waist-Asymmetric Fly	High-Pleat & Tab Waist	No Fly-Button Side Pkt
Patch Pocket-Fly	Irregular Gathers-Fly	Square Cut Pkts-Button
Yoke-Stitch Trim	Side Pkts-4 Pleats-Fly	High Waist-Trapunto Stitch

Pant and Skirt Waistband Treatments

2 Pleats-Button Fly

Side Pockets-3 Pleats

2 Pleats-Secured-Fly

Bound Pocket-Pleats

High Waist-Seaming

3 Open Pleats-Side Pocket

3 Pocket Jean-Fly

3 Side Buttons

Gathered-Side Buttons

3 Diagonal Zip Pockets

Gathered-Vertical Zip

Zipper Pockets

Outerwear Jackets, Sweaters, and Coats

Outerwear jackets, sweaters, and coats are designed to be worn over street apparel as protection against cold, rain, and snow. This category of merchandise is sold at specialty stores, in catalogs, and in outerwear departments. Fall and winter lines are the most important season for this type of apparel. Styling, especially jackets and coats, tends to change less frequently than other apparel categories. Many specialized fabrics are used for outerwear, including lightweight fabrics which have been treated to resist the elements, quilted to retain a layer of warm air close to the body as insulation, or specially woven or knitted to act as a block to cold air. *Sweaters* are made in knit fabric and differ from cut and sewn knit garments because they are knit in blocks or specifically shaped pieces and then crafted into a sweater.

Sweaters which are constructed from knit blocks which approximately conform to the dimensions of garment pieces may have self-knit bands, but often manufacturers with less sophisticated knitting machines use separate machines to knit trims and

then sew them to the sweater pieces to make a less expensive sweater.

The most expensive sweaters are *full fashion sweaters* (also called *handloomed*). Each piece of the sweater is knitted to the proper shape on a knitting machine. Ribs, patterns, and motifs can be knitted directly into the sweater pieces using a *jacquard, intarsia,* or *fancy stitch method.* The sweater is then sewn together, trimmed, and blocked.

Jacquard patterns usually have two to four yarn colors, and the pattern is created by allowing one color to be knit on the face of the fabric, while the yarns not in use are carried as floats on the back of the fabric. Jacquard patterns are usually allover patterns and *shadow* (the dark float yarns show through a light surface color) when knit with white and dark yarns.

Intarsia is a knitting technique which knits pattern blocks separate from the body of the sweater. These patterns are sewn into holes which have been left in the body block. This is a sophisticated, time-consuming operation which requires a great deal of hand finishing and is used for

Illustration Courtesy StyleLens.com

more expensive sweaters. Intarsia is usually made "offshore" in a country where hand labor is less expensive than available domestically.

Ribs, cables, knots, and *patterned* sweaters are also created by using a jacquard technique but are usually knit in a solid colored yarn. The sweater can be knit from colored yarn or dyed after being knit down to allow the manufacturer more flexibility to offer the season's most popular colors. Various *gages* (the size of the stitch is determined by the size of the yarn and needles) are used.

The price of a sweater depends on the price of the yarn, the time it takes to knit, block, and assemble the garment, the wage rate of the country it is made in, and the sophistication of the machinery available to produce the pattern. Because of the high degree of hand labor required to make a full-fashion sweater, expensive garments tend to be made in Europe and Hong Kong, whereas many moderate and inexpensive sweaters are made in Taiwan and Korea.

Hand-knit sweaters are made by individual knitters and require a great deal of skill and time to complete. Cottage industries of hand knitters exist in many countries and produce unique products. The *Irish fisherman's sweater,* also called an *Aryan knit* after the island where many of these elaborately patterned sweaters are crafted, is an excellent example of a national sweater style. Fine quality hand knits are made in England, Australia, and Scandinavia, and less expensive sweaters are imported from India, the Orient, and the Middle East.

Sweater designers concentrate on stitch, design, and yarn combinations to modify basic sweater bodies. Sweater length and volume can also alter the silhouette. Because sweaters are flexible, they can be unisex and are usually sized in S, M, and L. Typical bodies include the *pull over, vest, cardigan, turtleneck,* and with little variation, the shapes are similar for both men and women.

Outerwear jackets were first designed for active sportswear which required free leg movement. Many of the basic styles still reflect these end uses. Examples include the *bomber* (worn by pilots), *biker* (popular with motorcyclists), *base-ball, ski,* and *parka* styles, *anorak* (hunting and fishing), *pea jacket* (a sailor's cold weather uniform), and the *slicker* (rain wear). Modern versions for both sexes differ widely in fabrication and detail but retain the basic silhouette of the original functional jacket.

Coats have a similar evolution. Masculine styles which have been adapted for both sexes include the *trench coat* (originally worn by World War I soldiers in the trenches of Europe), *balmacaan* (casual rain wear), *Inverness cloak* (popularized by Sherlock Holmes), and the *Chesterfield* (a man's dress coat). Styles uniquely feminine are usually fitted, have exaggerated fullness, or have dressmaker details like the princess style, clutch, and cocoon.

REVIEW

Word Finders

Define the following words from the chapter you have just read:

1. anorak
2. Aryan knit
3. balmacaan
4. baseball jacket
5. bomber jacket
6. biker jacket
7. Chesterfield
8. clutch coat
9. cocoon
10. full-fashion sweaters
11. handloomed
12. hand-knit
13. intarsia
14. Inverness cloak
15. jacquard
16. offshore
17. parka
18. shadow
19. trench coat

DISCUSSION QUESTIONS AND EXERCISES

1. Collect *scrap* (photographs of interesting design ideas) for sweater patterns. Using one of the basic bodies, design a cable sweater, one with bold intarsia patterns, and a third with an overall contrasting design motif.

2. Select a basic sweater body to modify. Sketch the top third of the garment (to just under the armseye). Move the Sam or Sybil figure up so the hem line of the sweater falls at a desired place on the hip or thigh. Finish the sketch by tracing the lower 2/3 of the garment.

3. Select a basic coat or jacket suitable for a man. Restyle it for a woman by altering the basic size of the details, selecting a feminine color or details.

4. Select an outerwear jacket category for either men or women. Compare and contrast examples of the style made in leather, casual canvas or woven fabric, and knits. Sketch your own version of the jacket after researching the market and estimate the approximate retail cost governed by the research you have done.

Coats

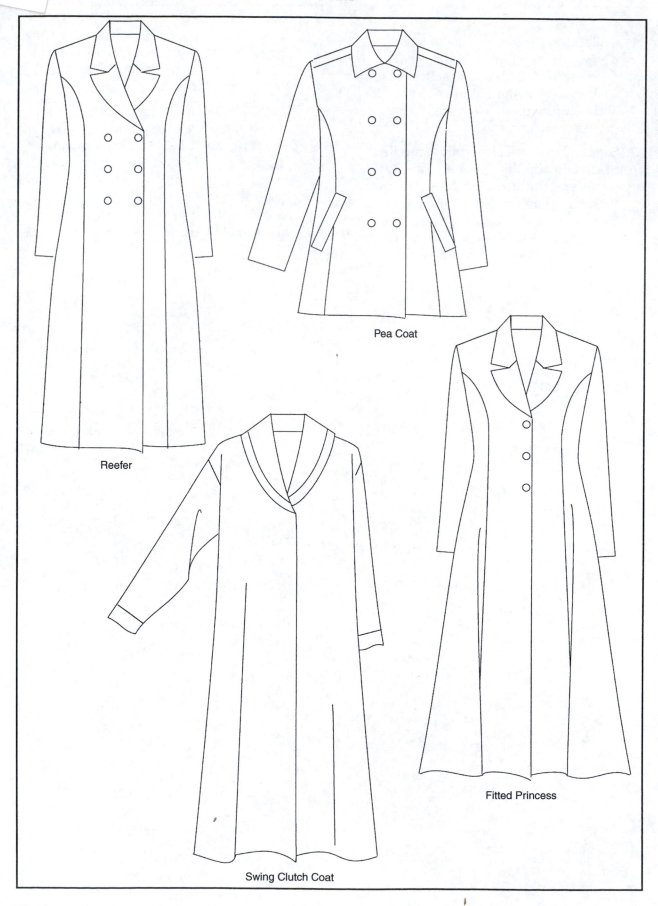

Reefer

Pea Coat

Swing Clutch Coat

Fitted Princess

Coats

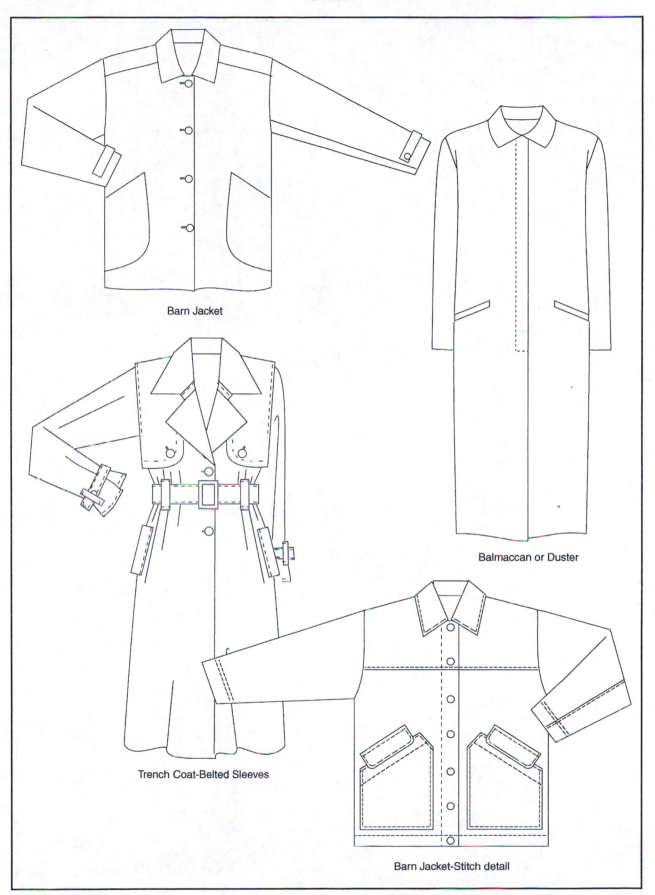

Barn Jacket

Balmaccan or Duster

Trench Coat-Belted Sleeves

Barn Jacket-Stitch detail

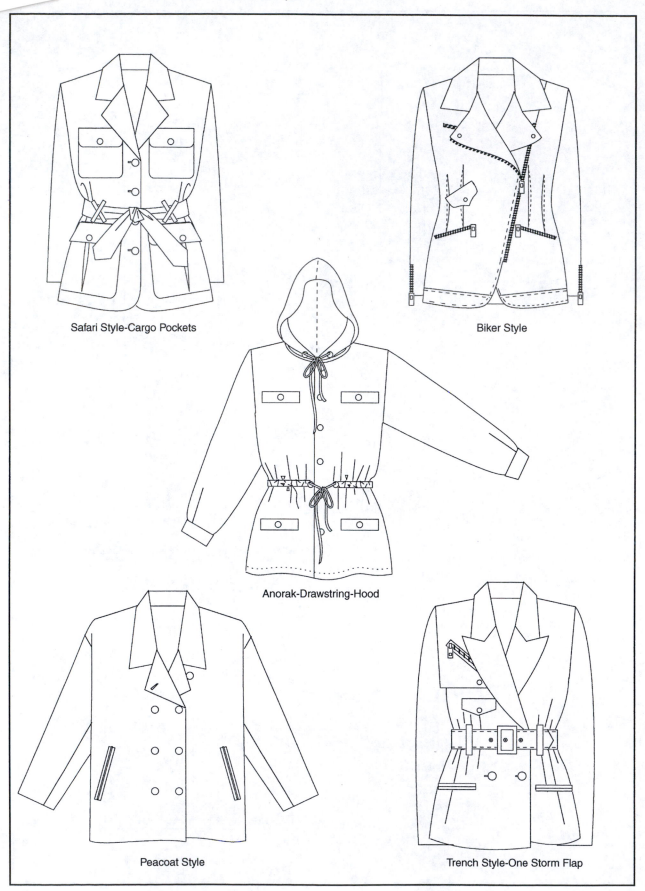

Safari Style-Cargo Pockets

Biker Style

Anorak-Drawstring-Hood

Peacoat Style

Trench Style-One Storm Flap

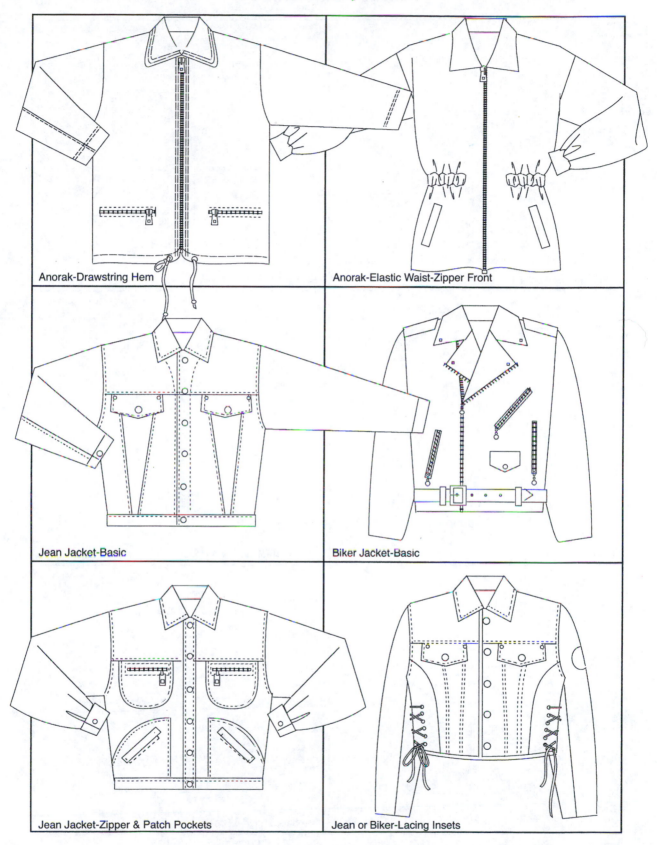

Anorak-Drawstring Hem

Anorak-Elastic Waist-Zipper Front

Jean Jacket-Basic

Biker Jacket-Basic

Jean Jacket-Zipper & Patch Pockets

Jean or Biker-Lacing Insets

Men's Casual Jackets

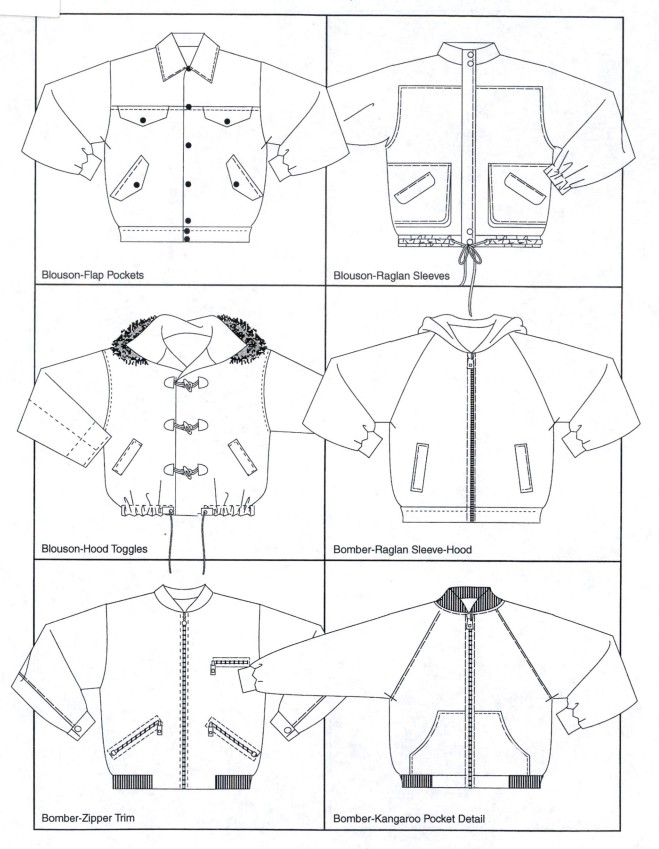

Blouson-Flap Pockets

Blouson-Raglan Sleeves

Blouson-Hood Toggles

Bomber-Raglan Sleeve-Hood

Bomber-Zipper Trim

Bomber-Kangaroo Pocket Detail

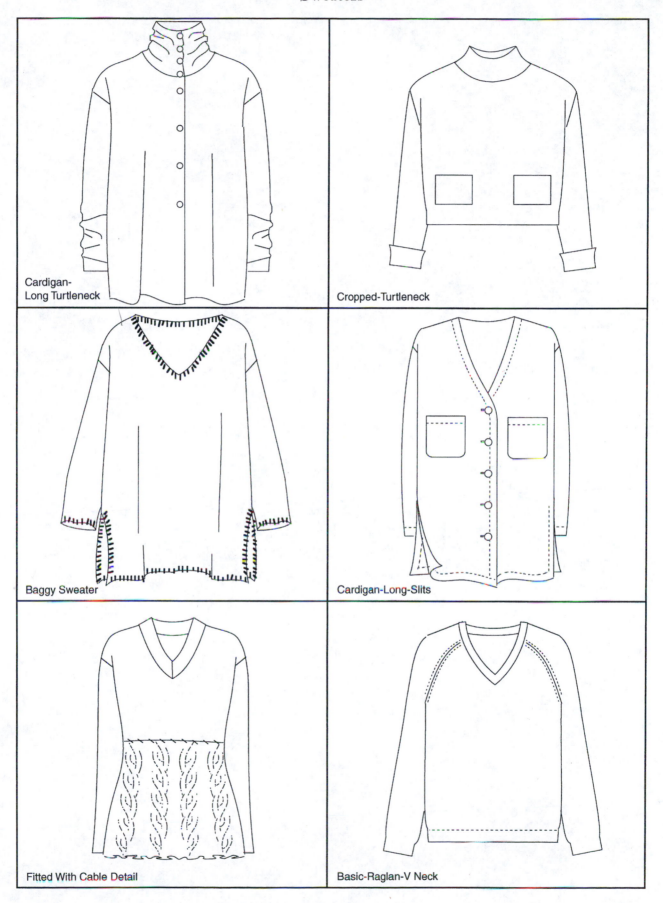

Cardigan-
Long Turtleneck

Cropped-Turtleneck

Baggy Sweater

Cardigan-Long-Slits

Fitted With Cable Detail

Basic-Raglan-V Neck

3

UNIT

Learning to draw flat line sketches using a figure croquis and adding the garment and various details quickly and easily is the goal of the first part of this book. The second goal is to render the color, texture, and pattern on your sketch with user-friendly tools like pencils, marking pens, and applied papers. Complicated rendering techniques using acrylic paint and transparent water colors are beyond the scope of this book.

This unit will concentrate on teaching simple methods of rendering a flat sketch (adding color, texture, and shadowing to create a realistic drawing typically used by a commercial apparel designer). Adding color, pattern, tone, and shadow give the croquis a three-dimensional appearance and shows how the garment will look when made up in fabric. Commercial designers use rendered sketches to sell their ideas to supervisors and buyers.

Rendering requires additional time and many designers rarely develop the sketch completely. Instead, they place a swatch of the fabric on the line drawing to guide design room personnel in making the sample.

Film and theater designers work differently. Because actors, directors, set designers, and producers must approve the working sketch, almost all costume sketches are completely rendered. In addition, accomplished theatrical designers render the actors' faces, hair styles, and makeup in addition to the clothes and accessories.

ADVANCED
DRAWING SKILLS

Basic Fabric Rendering

Rendering the basic croquis requires additional art supplies. A commercial designer rarely uses water colors, pastels, and acrylic paint to render fabrics but relies on *pencils*, *markers*, and *acetate screens*. Build your art supplies with these items.

MARKERS AND PENCILS

Prismacolor Pencils

Available in a wide variety of colors, these user-friendly pencils are excellent for coloring, shadowing, and detailing your sketches. Purchase a set of at least a dozen colors and several additional black pencils for outlining. Sets are available in a variety of selections and reduce the cost per pencil. Prisma pencils may also be purchased individually.

Markers

Blunt or chisel point markers are excellent for coloring in the basic sketch. Gray tones can be used for shadowing in combination with colored markers and for preparing black-and-white illustrations. The tones of gray are numbered—the lower the number, the lighter the tone. A #2, #4, #5, and #8 are a good range of tones. Select either cool or warm gray-colored markers, but avoid mixing the gray tones because the warm tones look dingy when compared to the cool grays. Colored sets of marking pens are less expensive than individual pens.

OTHER EQUIPMENT

Opaque White Paint and Brush

Highlighting pencil and marker illustrations is a quick and easy way to render many fabrics. In addition, corrections may be made to felt pen lines by painting out errors. This correction will not be visible if the sketch is copied or printed. Select a medium grade #1 pointed tip

water color brush for applying the paint.

Acetate Screens

Select several tones and patterns to experiment with and reserve additional purchases for special projects.

Purchase a small, pointed matt knife to cut the acetate screen.

SHADOWING THE GARMENT

Light tends to be reflected from the part of a body of material which is closest to the viewer. Using this principle, begin to practice shadowing which creates the illusion of depth with these two exercises:

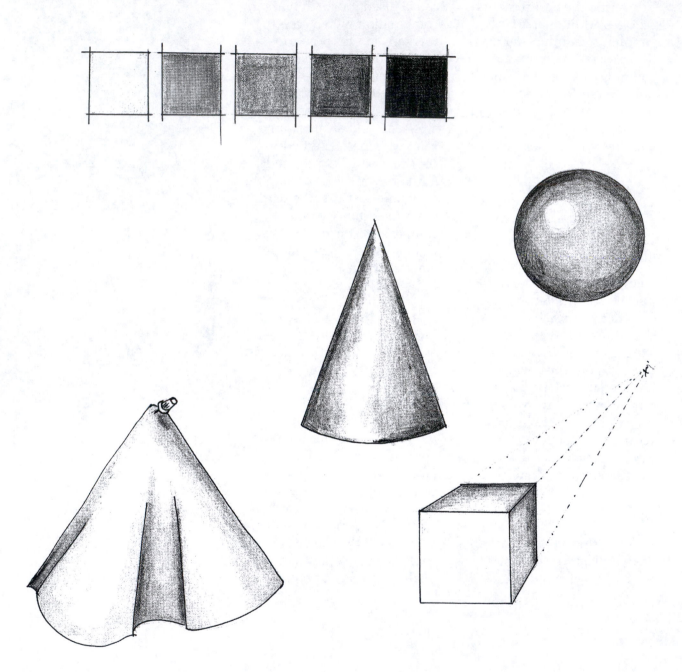

1. Use a lead pencil to draw five 1" by 1-1/2" rectangles. Color in the first rectangle with a dark black tone. Shade the other rectangles in increasingly lighter tones. Feel how much pressure you have to apply to the pencil point to create each step.

2. Draw a circle and imagine that it is a rubber ball with a light focused on the center (if you have a ball and light source, set it up as a real-life example.) Notice that the sides of the ball are darker compared to the spot where the light source is concentrated. Shade your circle so the outer edges are quite dark and successive rings of shadow lighten to the white part of the ball representing the reflection of the light.

Practice shadowing by drawing a cone and a cylinder and adding dimension to these geometric shapes as you did with the ball. Next, hang a piece of shiny fabric (taffeta, silk, or a similar fabric which reflects the most light) in a graceful drape. Notice how the curves of the fabric resemble the cone and cylinder shapes you have practiced. Sketch in the major folds of the fabric and tone them as you have the geometric shapes.

Now practice on a simple garment. Select a basic shirt or jacket and lightly draw it on a piece of tracing paper. Shadow the sides of the shirt. Add a shadow line under the placket. When drawing a woman's garment, add a soft shadow under the bustline. Shadow the area under the

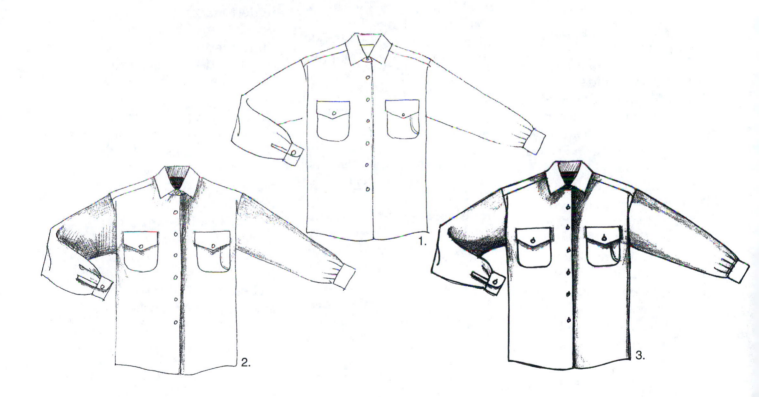

collar to give it a layered look. Shadow the sleeves as if they were a cylinder. These techniques will work on many other types of garments.

Now reinforce the silhouette of your shadowed sketch by outlining it with a bold, dark pencil or marker line. Vary the pressure on the marker, emphasizing the corners of the silhouette for a more interesting drawing. Draw in the smaller parts of the garment (collar, placket, pockets, etc.) with a fine-line felt pen. As you become more confident, practice the shadowing technique on more and more complicated sketches.

ADDING COLOR: PENCILS

Color lends an added dimension to your sketch. Prismacolor pencils are an easy step up from lead pencils. These bold and varied colored pencils are available in sets ranging from a dozen to more than fifty colors. The colors may be blended to create many additional shades by lightly shadowing one color over another. Black Prisma pencils are effectively used to outline a sketch. Purchase several additional black pencils to use as outlining pencils. Flesh tones are also available and make rendering the figure extremely easy.

Purchase a set of at least a dozen Prismacolor pencils. Draw five 1" × 1-1/2" rectangles like those in the first exercise and color the lightest one first with a Prisma pencil to learn how much pressure to place on the pencil. The leads are quite soft when sharpened to a fine point, so save the darker tones for when your pencil point is blunt. Color the five rectangles from the palest tone to a deep, rich color.

Now select a yellow and red Prisma pencil. Lightly shadow a rectangle by diagonally toning it with the yellow pencil. Now color over the first tone, *moving your pencil in the opposite diagonal.* You have created a simple cross hatch tone. Experiment with shadowing by using the red pencil to deepen the tone at the edges of the rectangle. This exercise can be easily translated to rendering a garment.

Again, lightly draw a garment with a #2 lead pencil using the figure croquis. Select at least two colors of Prisma pencils to color and shadow the garment. Shadow the drawing with the boldest color. Outline the silhouette and details with either a black Prisma pencil or a fine-line felt tip pen.

ADDING COLOR: FELT MARKERS

A tremendous variety of felt markers are available. Designers use gray-toned markers for preparing camera-ready illustrations which will be printed for advertisements and style sheets. Gray-toned markers are available in warm grays which have a yellow undertone, and cool grays which have a blue undertone.

Broad-tipped colored markers are excellent tools for coloring and shadowing a sketch because they are easy to use and do not require water or brushes. A sketch can be quickly colored, requiring almost no drying time before the garment can be detailed. Broad-tipped markers are used in combination with pencils, fine-line pens, and paint. The techniques for using colored and gray-toned markers are identical.

Cross hatching

Prisma
Pencil
Outline

2.

1.

Grey Toned Markers

2.

1.

191

Begin practicing marker rendering by drawing a circle. Again imagine it is a shiny, rubber ball with a light focused at the center. Color the ball, leaving an uncolored area where the white paper shows through to represent the part of the ball reflecting the light. Deepen the tone of the ball at the edges by going over the circle with several additional layers of marker tone. Blend the shadow towards the white area on the circle. Experiment by reinforcing the shadowing by using Prisma pencils in a complementary color.

One of the disadvantages of rendering with felt pens is that it is difficult to blend the strokes to form a solid color. When using transparent drawing paper, this problem can be solved by coloring in the back of the sketch with the solid color and adding shadows and outlining to the front of the sketch. To practice this technique, lightly draw a garment on transparent paper and color in the back of the sketch with a broad-tipped felt pen. Analyze the garment and determine if you want to leave a highlight. Apply some shadow areas by reinforcing the tone with additional strokes of your felt pen. Turn the sketch over and shadow and detail the sketch with pencil and fine-point pens.

Designers often use white paint when rendering with felt markers to add highlights and accents after detailing the sketch. This is especially important when using transparent paper which does not have an intense white ground. White paint allows the designer to analyze the effect after the color has been added, instead of using the paper to provide the highlight.

RENDERING PATTERNED FABRICS

Patterned fabrics present an additional challenge. It is important to accurately translate the scale of the fabric's pattern to the size of the figure you are drawing. The Sybil and Sam croquis have basic measurements which relate to an idealized flat figure. Measure the size of the pattern you are rendering to determine the size of the *repeat*. The repeat is how the basic motif is used to create the overall fabric pattern. For example, if the basic motif is a four-inch square, approximately four of these square motifs will equal the waist to collar measurement of a typical bodice.

To practice print rendering, first lightly sketch a basic garment, and lightly block in the major patterned areas of the garment, relating the size of the repeat to the size of the figure. To double check your measurements, hold the fabric up to your own body in front of a mirror and estimate the number of print motifs necessary to cover the garment. Render the fabric carefully, using

one
repeat

3"
repeat

28½"

pencils and felt pens. When sketching patterned fabrics, most artists draw a rather large figure so they can render the print in a convenient size.

Realistic rendering of a print fabric is called a *tight rendering*. The artist makes every attempt to replicate the pattern and textures exactly. Tight renderings are typically used for catalog illustrations, theatrical designs, and textile advertisements. *Loose rendering* does not try to render the fabric or figure exactly but gives the feeling of the fabric without using all the details or only rendering a portion of the pattern. This style is much less time consuming and is often used to quickly illustrate a print garment.

GEOMETRIC PATTERNS

Stripes

Geometric patterns are popular fabric designs. Woven and printed stripes usually run parallel to the warp or selvages of the fabric. Defining areas of the garment, like the yoke, collar, or placket with a stripe pattern which contrasts to the direction of the body of the garment is an effective

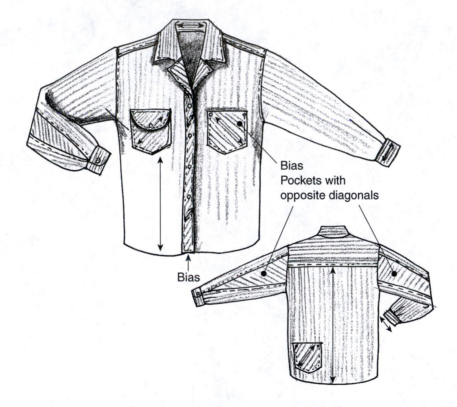

Bias
Pockets with opposite diagonals

Bias

style device. Knit stripes, especially T-shirt and sweater knits, almost always run horizontally. Stripes may also be placed on the diagonal or bias grain for a special effect.

Plan the layout of the striped fabric you are using. Scale the stripes for your drawing in the same way you planned the number of repeats in a patterned fabric. Do not attempt to draw small stripes in exactly the correct amount, but lightly render the lines to approximate scale. Remember that darts may distort the stripe layout.

Any fabric with a linear design should be treated as a stripe. Seersucker and corduroy are good examples of a stripe pattern that is created by texture and contrasting colors.

Checks and Plaids

Checks conform to the rules of geometric placement in the same way stripes do. Straight garments are effective in checks because darts and seams alter the smooth grid of the fabric. Build a check by placing the vertical grid on the sketch as you would a stripe. Fill in the grid with the horizontal pattern, relating the size of the check to the scale of the figure.

Plaids are more complicated geometric patterns than stripes or checks, but the rules governing design placement are similar. Carefully study the plaid swatch before beginning to render your sketch. Analyze the size of the repeat (a single unit of the pattern) and scale the plaid to your figure using light pencil lines.

A plaid is built by the intersections of horizontal and vertical stripes. The blending of yarns and the size of the stripes make a wide variety of color and patterns possible. Consider using a broad felt

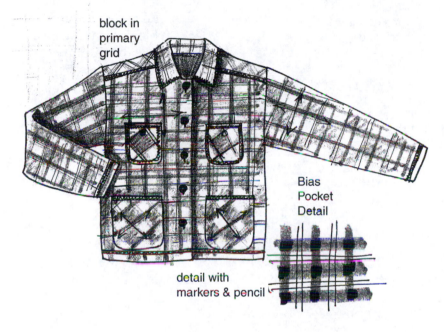

block in primary grid

Bias Pocket Detail

detail with markers & pencil

Tweeds and Herringbone

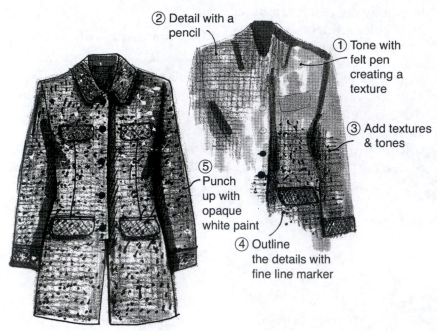

② Detail with a pencil

① Tone with felt pen creating a texture

③ Add textures & tones

⑤ Punch up with opaque white paint

④ Outline the details with fine line marker

Corduroy

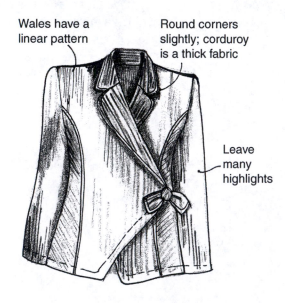

Wales have a linear pattern

Round corners slightly; corduroy is a thick fabric

Leave many highlights

pen for the boldest parts of the plaid and detailing the fine line portions of the pattern with Prisma pencils or a felt pen. Shadow portions of the garment as you did rendering a solid fabric to add the third dimension.

RENDERING TEXTURES

Tweeds and Herringbone

Tweeds are woven from contrasting novelty yarns which often have colored flecks which accent the basic tone of the fabric. Analyze the fabric and isolate the basic tone. Render this with felt pen. Use Prisma pencils and fine-line markers to detail the various colors in the pattern. *Herringbone* is a tweed which has a stripe pattern created from opposing diagonal weaves. Lay out the direction of the stripe first, and tone the pattern using a tweed method but rendering the mini diagonals.

Corduroy

Corduroy is a linear plush fabric that conforms to the layout rules of striped fabrics. Corduroy's pile (called *wales*) gives the fabric a soft luster. Begin the rendering by laying out a linear pattern and lightly tone the fabric with a

soft pencil, blending the toned areas with your finger, which should soften and blend your tones. Shadow darker areas of the edges and hollows of the garment and leave many highlights to illustrate the gloss of the pile.

Linen

Linen and other dramatic woven textures can be rendered by using the cross hatch method you practiced when learning how to use Prisma pencils. The cross hatch direction is governed by how the grain line on the fabric is maintained. Analyze the texture of the fabric. A compact woven is best rendered by using a broad felt pen to lay in the basic tone and lightly coloring in the texture with a Prisma pencil, using two directions to indicate the texture. Top stitching is a popular trim for a flat weave fabric and is best rendered with a fine-line pencil or marking pen.

RENDERING LUSTER FABRICS

Luster fabrics reflect a great deal of light because they are woven with smooth, shiny yarns. *Crepe de chine, satin, taffeta,* and other smooth,

Linen

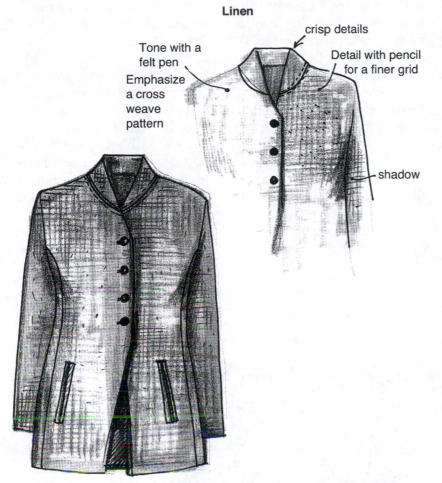

- Tone with a felt pen
- Emphasize a cross weave pattern
- crisp details
- Detail with pencil for a finer grid
- shadow

Luster

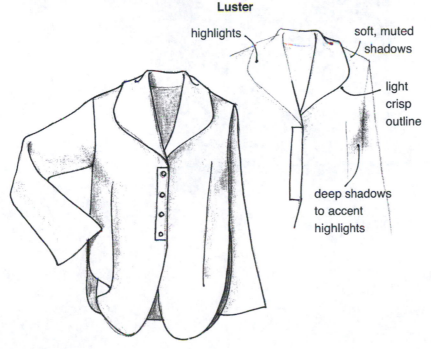

- highlights
- soft, muted shadows
- light crisp outline
- deep shadows to accent highlights

reflective surface fabrics create highlights in broad areas of the garment. Some fabrics, like *lamé*, use metallic yarns interspersed with other yarns to create a "super" highlight. Before beginning your rendering, study the fabric and notice the highly reflective areas occur on the top of the folds, whereas deep shadows are characteristic of the folds.

Begin with lightly coloring in the fabric with felt pen, leaving original paper highlights on the reflective areas of the garment. Build up the color with several layers of color and shadow with smooth, flowing darker tones of the same base color. Keep the silhouette smooth, light, and crisp to indicate the fluid flow of these fabrics. Consider using white painted highlights to add highlights to the rendering.

Very reflective fabrics and trims like sequins, rhinestones, and beading can be rendered in the same way. Contrasting areas of dark and highlights are typical of these trims, but they form a dot pattern of highlights instead of an area highlight.

Velvet, velveteen, and velour all absorb light because of their deep, rich pile. Highlights occur around the edge of the garment. Start by coloring in the base color and build the densest color at the center of the garment. Allow highlights where the fabric is gathered and at the edges of the garment. Light tones are difficult to render because deep contrasts cannot be built up. Render style lines and details in velvets with opaque white and deep black to capture the highlights. Round the corners of collars, pockets, trims, and the general silhouette to capture the bulky nature of these fabrics.

Velveteen/Velvet

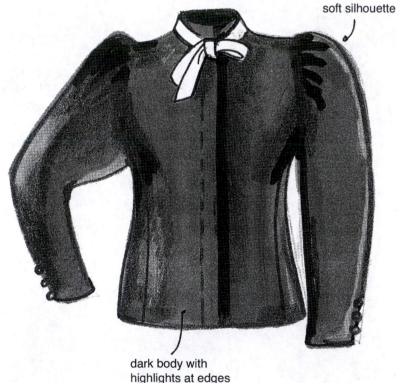

soft silhouette

dark body with highlights at edges

SHEERS

Sheer fabrics are transparent, revealing the body contour or under layers of fabric. Sheers are a natural fabric for evening wear, undergarments, and sleepwear. Chiffons are soft and clingy, whereas organdy, dotted swiss, and eyelet are crisp.

The body shape should be lightly drawn, with the silhouette of the garment sketched over it. As you render the fabric, subtly reinforce the body contours with a flesh tone or darker shade of the fabric color. Render the details and silhouette with a fine light line.

Laces also have a transparent quality and because of the variety of styles, require analyzing before rendering can begin. Use a flesh-toned marker as an underlying tone and render with a fine-line marker or pen when drawing a dark lace. To render white lace, opaque white paint and a fine-line brush are the best media. Illustrators often use a toned paper so the pattern of white lace is contrasted.

Sheers

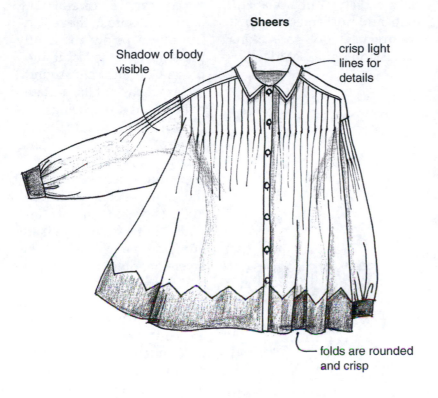

Shadow of body visible

crisp light lines for details

folds are rounded and crisp

Lace

APPLIED PAPERS

Screens are transparent acetate sheets available in a wide variety of colors, patterns, and gray tones. They may be applied over a drawing and reworked with paint, pencils, or marking pens. Screens are also available in dot patterns, which are useful when preparing sketches for black-and-white reproduction. Acetate screen type faces contain a wide variety of sizes and styles of alphabet fonts and numerals, which are practical tools for making professional presentations.

To apply acetate screens, first select the tone or pattern from an art store. Carefully place the full sheet over the illustration and cut a slightly larger piece than the area you are covering. Be careful not to apply pressure to the screen. Cut the shape out and lightly press the sheet to *tack* it into place. Delicately cut around the exact edge of the acetate with a matt knife, being careful not to cut into the illustration paper. Lift off the excess acetate and firmly apply the remaining acetate to the sketch. Detail shadows, highlights, and other features with paint, pen, or pencil after applying the screen. Multiple layers of applied screens give a different look.

At this time screens such as the ones described above are rarely used and are becoming harder to find as computer and laser printing technology have almost rendered them obsolete.

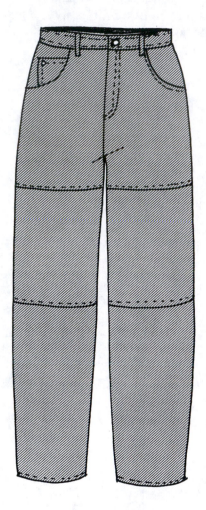

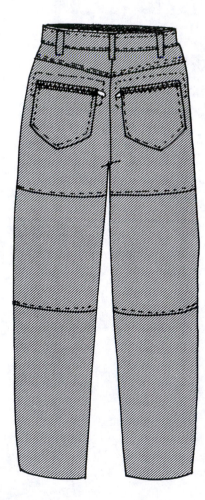

REVIEW

Word Finders

Define the following words from the chapter you have just read:

1. corduroy
2. cross hatch tone
3. geometric patterns
4. herringbone
5. lace
6. lamé
7. loose rendering
8. luster fabrics
9. plaids
10. Prismacolor pencils
11. rendering
12. scale
13. shadowing
14. sheer fabrics
15. tight rendering
16. tweeds

DISCUSSION QUESTIONS

1. Sketch two identical garments to be made in the same fabric. Render one with Prisma pencils and one with markers. Copy each sketch on a copy machine and evaluate the medium which reproduces the best. Reinforce the outline of your sketch and the detail rendering with a stronger line if all portions of your drawing do not reproduce well.

2. Sketch a garment and use markers, Prisma pencils, and applied paper to render the fabric. Highlight the sketch where appropriate with white paint. Mount the sketch on opaque board.

3. Design a coat which will be made from taffeta with a velvet collar and cuffs. Use a swatch of taffeta and velvet to compare the differences in light reflection. Render the fabrics with pencils, white paint, and marking pens.

Additional Sketching Techniques

Illustration Courtesy StyleLens.com

Drawing apparel designs begins with a knowledge of the proportions of the fashion figure. Tracing from the Sybil and Sam croquis provides practice to reinforce the dimensions of the fashion figure. Drawing clothes is the next technique to master. Tracing the many silhouettes and details and combining them to form designs are an excellent foundation for learning how to draw clothing freehand. Finally, rendering the garment requires observation and develops skills in handling diverse art tools and supplies.

The most important way to learn how to draw is to practice. Tracing is only the first step in learning how to draw. Begin to sketch garments you see in stores, on people on the street, and in photographs. Visualize a garment and draw it using the templates. Gradually stop tracing each detail from this book. Take a fashion sketching course and begin to draw from real garments and live models. Invest in books which teach how to move the figure and develop more complicated drawing and rendering skills. *The Complete Book of Fashion Illustration, Third Edition* by Sharon Lee Tate and Mona Shafer Edwards (Prentice Hall, 1995) is designed as an advanced companion text to *Snap Fashion*. Learn the techniques of other illustrators by imitating their work and adapting the style you like the best for your own sketches. Diversify and begin to sketch a variety of fashion types.

To improve your drawing using the tools from this book, begin by sketching garments from photographs you have clipped from fashion magazines and catalogs, using the Sam and Sybil templates as a guide.

Some designers always use a template. Other designers lightly sketch a basic figure, draw a face, and then the garment directly on the page without the use of tracing paper and a template. The fashion figure has become fixed in their minds.

A *light box* is a useful tool which allows tracing more complicated drawings on opaque papers. Art stores sell this lightweight, metal framed box with a frosted glass top over a light for under $100. Consider purchasing a light box if you draw a great deal.

USING THE FASHION TEMPLATE FOR FREEHAND DRAWING

Place the template under a piece of transparent paper. If you are drawing from a photograph, study the garment and determine the changes you want to make. If you are drawing from your imagination, begin by analyzing the hand of the fabric the garment is to be made in and determine the silhouette and styling possibilities for the fabric. Block out the outline of the garment, using a #2 lead pencil and a very light pencil

line. Define the neckline and sleeves and detail the folds of fabric as they flow around the body in the same light stroke. If you wish, draw in the figure from the template, tracing over the head, arms, and legs.

When the garment and figure have been lightly blocked in, determine the media you will use to color in the illustration.

If you are using broad-tipped felt pens, add the large color blocks before you outline with marker because the line will blur if touched by the broad felt tip. Pencil rendering is best added after the outline of the garment has been rendered because the media is more easily controlled.

Detail the garment with a light pencil mark. The goal is to be able to block in the outline and details of the garment using a marker or outlining pencil as soon as possible to save time. Usually a great deal of practice is required to be able to draw the finished detail lines directly on the template. Begin by producing a complete, lightly sketched-in pencil drawing and then outline it with pen or pencil.

Finish your drawing by shadowing the basic color blocks, rendering the face and figure, and cutting out the sketch for mounting on opaque paper or board. Remember, small inaccuracies can be painted out with opaque paint.

DRAWING THE FASHION FACE

The face is a focal point in a picture and establishes the age and type of clothing to be illustrated. Many illustrators are fascinated with the model's face and use it as the starting point for a design. Usually, simple hair style and makeup are most effective for showing off the apparel, but more elaborate hair styles are also appropriate.

Both masculine and feminine fashion faces have the same proportions, but women's features are more delicate than men's. The head is oval shaped, with the fuller end at the forehead. The features are balanced symmetrically on either side of the center line. The eyes fall at the horizontal median and are almond shaped with almost the length of a whole eye between them. Eyebrows begin at the inside corner of the eye, arch over the midpoint of the almond shape, and extend slightly beyond the outer edge.

The nose falls at the lower one-third division of the face and lines up with the

inner corners of the eye. The mouth is centered below the nose. Women's chins are slender and well defined, whereas the masculine chin and jawline is heavier and more pronounced.

Cheekbones accent the oval, defined by shadowing. The tops of the ears align with the eyes and end parallel to the mouth. The natural hair-line curves around the skull above the top part of the forehead.

Drawing the Face, Step by Step

1. Draw a rectangle 6" long and 4" wide on a piece of transparent paper. Measure and mark the 6" on the sides of the rectangle. Fill the rectangle with an oval that touches the bottom, top, and sides of the rectangle.
2. Divide the rectangle into quarters, 2" on either side of the vertical median (center) 3" on either side of the horizontal median.
3. Measure 1–1/2" on either side of the vertical

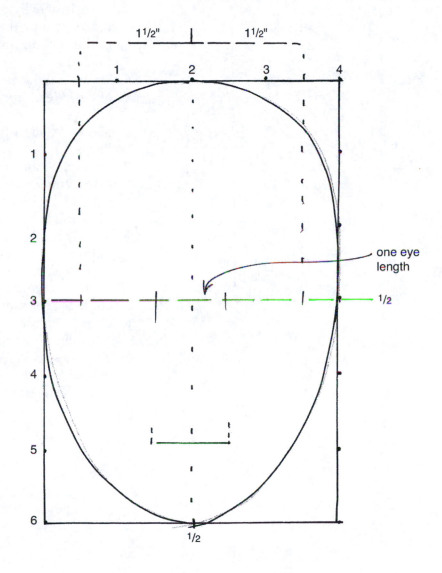

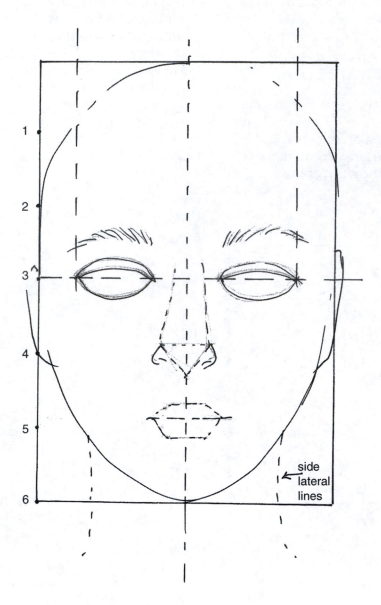

side
← lateral
lines

median and lightly draw the two lateral lines.

4. From the lateral lines inward along the horizontal median, draw two 1" long, almond-shaped eyes. Notice that there is 1" between the eyes.

5. Extend two light guidelines down from the inner corners of the eyes. Indicate the nostrils, which are evenly balanced on either side of the vertical median (line 4).

6. Draw shallow ear shapes at the side of the head between the eyes (line 3) and nose (slightly beyond line 4).

7. Draw the mouth, extending it slightly beyond the inner lateral lines above line 5. The man's mouth is less well defined than a woman's because typically the lips are thinner and not emphasized with lipstick.

8. Curve the side lateral lines slightly inward and draw the neck. A woman's neck is longer and more slender than a

man's. Emphasize a man's jawline with a bolder shadow.

9. Add cheekbone contours inside the ears and shade.

10. Draw eyebrows beginning at the inner corners of the eyes. Arch the brows at the center and extend them slightly beyond the outer edges of the eyes. When drawing women, use light, short lines to imitate the way eyebrow hairs grow. Men's eyebrows are usually fuller and darker.

11. Detail the eyes with lids and pupils. Eye makeup defines a women's eye more boldly than a man's.

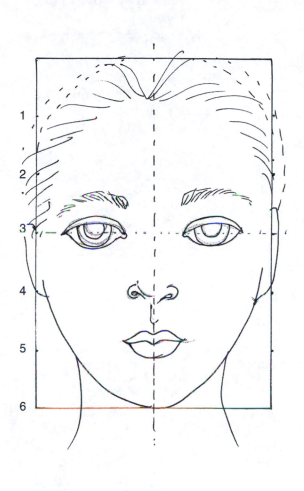

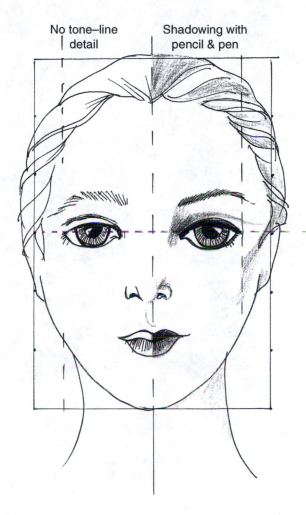

No tone—line detail | Shadowing with pencil & pen

12. Add the hairline above line 1, extending it to the sides of the ears.
13. Shade the eyes and bridge of the nose. Use a bolder definition for a man's nose.

Drawing the Mouth

1. Divide a small rectangle as shown. The top lip is usually smaller than the bottom lip. Men's lips are less well defined and thinner than a woman's.

2. Draw two circles in the top part of the rectangle and a larger oval below this for the feminine mouth.
3. Detail the shape of the mouth, using the ovals as a guide and carrying the lines to the edge of the rectangle.
4. Shade and shape the lips.

Notice the many ways the basic features can be drawn to create unique and exciting faces.

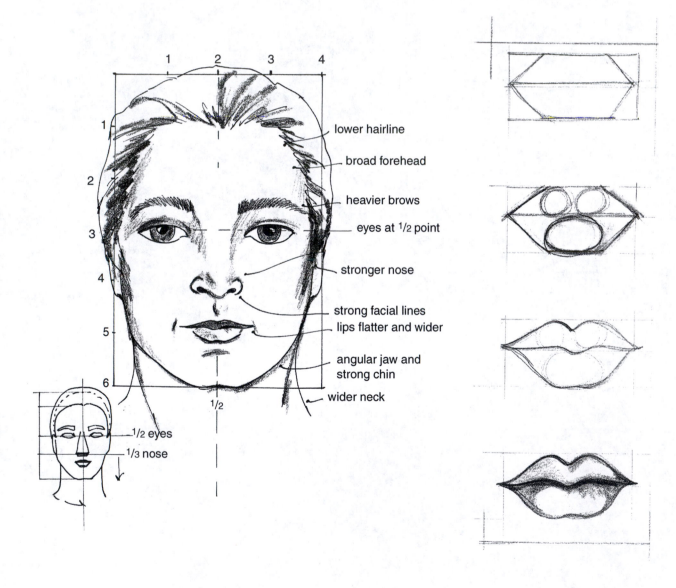

lower hairline

broad forehead

heavier brows

eyes at $^1/_2$ point

stronger nose

strong facial lines

lips flatter and wider

angular jaw and strong chin

wider neck

$^1/_2$

$^1/_2$ eyes

$^1/_3$ nose

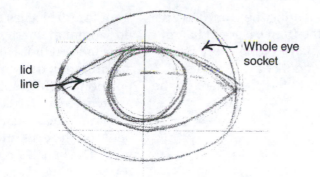

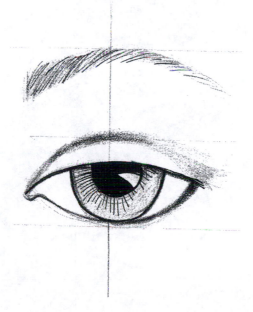

Drawing the Eye

1. Draw an almond shape.
2. Divide the top third of the almond with the curved lid line. Fill in at least one-third of the eye with a round circle for the iris. Notice that the lid covers the top of the iris.
3. Add the pupil to the center of the iris and shape the inner corner of the eye.
4. Detail the eye. For women, add lashes, highlights, and shadows to represent eye makeup. Men's eyes are less defined and have a heavier eyebrow. They are usually not open as wide as the feminine eye.

THE PROFILE FACE

The profile head fills a square. The shape is roughly oval, with a pointed lower corner representing the chin. The face fills the front diagonal half of the square. Notice how the placement of the features relates to the placement on the front face. The eyes fall on the horizontal median, and the nose falls on line 4. The lips are drawn in the same position, slightly above line 5, as on the front face. The placement of the ear is between the eyes and the nose. The hairline conforms roughly to the diagonal line through the square.

Study the differences between the female and male profiles. In the male profile, the nose is bolder and the lips thinner. The eyebrow is heavier and the eye less defined because no makeup accents the lids and lashes. The jawline is defined and the chin is prominent.

The formula for a proportional profile head varies dramatically when drawing from life. The silhouette of the forehead, nose, and chin have an infinite variety of contours and variations. Observation is the key to developing the ability to capture reality and draw portraits from life. The formula will assist in breaking down the components of the profile face so they can be understood.

Drawing the Profile Head, Step by Step

1. Draw a square 6" by 6" and mark a 1" grid in light pencil. Use overlay paper.
2. Draw an oval with the narrow end slanted towards the lower corner of the square.
3. Draw a diagonal guideline from corner to corner, bisecting the square.
4. Divide the square into quarters with light lines.
5. Draw a wedge shape centered on the horizontal median, line 3. Indicate the profile eye shape here.

6. Shape the nose, indenting it at line 3 and drawing the triangular shape ending at line 4.
7. Draw the ear between the eye and the nose on the vertical median of the square.
8. Outline the mouth and chin.
9. Draw the neck coming from behind the diagonal. This should be a graceful curve for women and a stronger, straighter column when drawing a man.

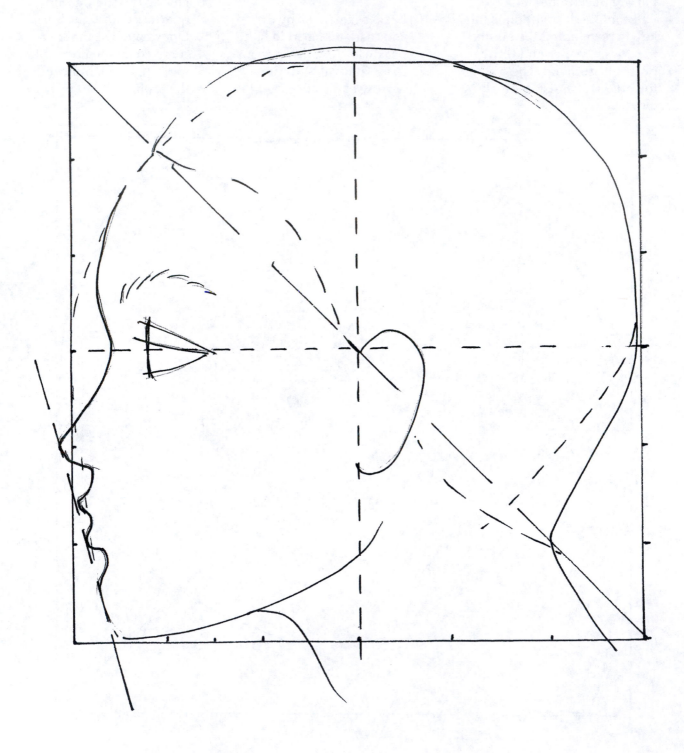

10. Draw the mouth above line 5.
11. Curve the chin. Women's features should not be too weak or too exaggerated. Men should have a bold chin and jawline. The lips should just touch this line.
12. The hairline corresponds roughly to the diagonal. Curve the hair around the ears and at the nape of the neck.
13. Detail the eye. Notice how the eyebrow arches over the front of the eye as it follows the skull's ridge over the eye socket. The male profile has a bold eyebrow.
14. Add the nostril and the outer curve of the nose. Refine the profile of the nose.
15. Detail and shadow the mouth and cheekbones.

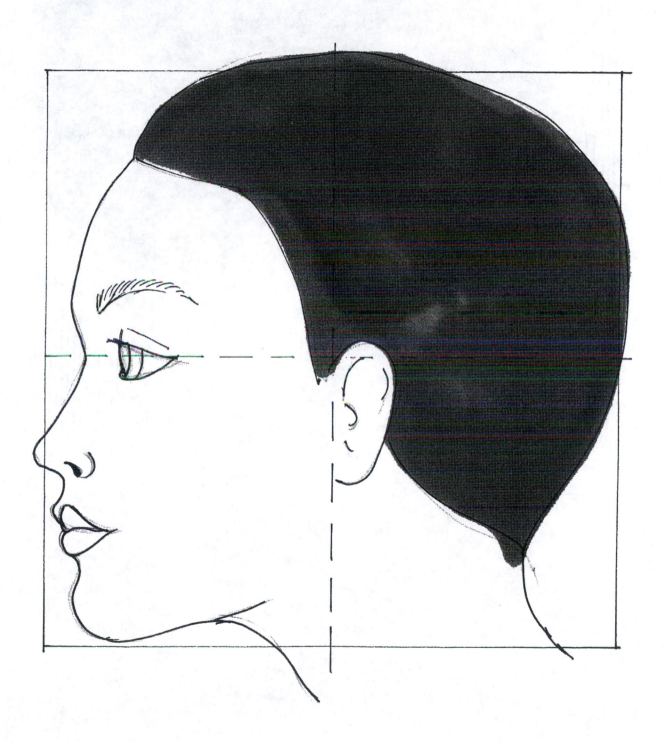

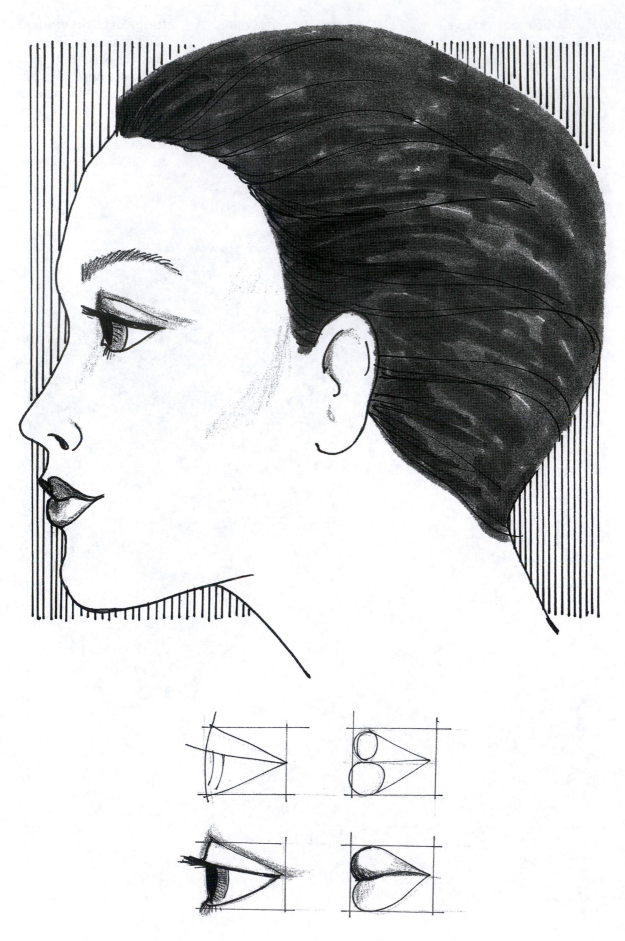

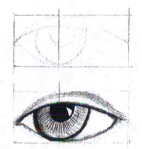

Sketch profiles from life, photographs, and other drawings to practice your new skills. Draw the profiles facing left and right so that you will be able to draw both. Beginners tend to draw a profile facing the direction of their weaker hand.

THE THREE-DIMENSIONAL HEAD

The volume of the head corresponds to a box drawn in one point perspective. The features can be simplified to stylized indications, but a concrete idea of volume and structure is necessary to successfully draw more complicated and realistic faces.

The sketches that follow show the nose in various positions. Sketch several heads using photographs, breaking down the position with guide lines drawn in contrasting color. Analyze the part of the face that is closest to you because it has the truest proportion for the accurate placement of features.

When you have analyzed the feature placement, draw

over the first sketch leaving out the guide lines. Shadow in the part of the face which is turned away from you. Draw the features with a fine-line felt pen or a sharp Prisma color pencil. Remember to use bold felt pens on the back of your transparent paper to tone the basic flesh color without leaving overlap shadows.

Drawing the Three-Dimensional Head, Step by Step

1. Draw an oval with a slant to one side. Establish the vertical median line which indicates where the nose is placed.
2. Lightly indicate the horizontal median, thinking of a round body as you sketch it in to locate the eyes.
3. Add marks for features based on your previous knowledge of how to place the nose and mouth. Keep all feature marks parallel.
4. Add the ear mark by dividing the oval again and lining up the ear with the eye and nose.
5. Block in the basic features, noting that you will not see as much of the far side of the face.

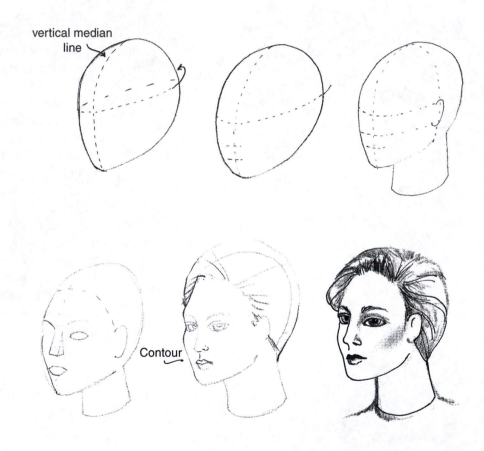

vertical median line

Contour

6. Contour the side of the face. Direct the iris and pupils of the eye to one spot.
7. Clean up the guide lines, add hair, and tone the cheekbones. Use shadowing and highlighting techniques to give added depth to your sketch.

DRAWING HAIR

Hair styles change as rapidly as fashions. It is important to match the hair style to the kind of garment you are illustrating. Study fashion magazines to determine the styles being shown with career apparel, active sportswear, and dramatic evening clothes. Note styles which appeal to young juniors. Collect photographs (scrap) of styles which appeal to you.

Hair grows out of the scalp. Your drawing lines should imitate the natural growth pattern of hair. Draw the direction the hair grows with irregularly spaced lines that simplify and capture the volume of the style. Notice how healthy hair of various colors reflects light and use highlights to give hair a sleek, healthy look. Shadowing emphasizes the profile of the face and gives depth to the hair.

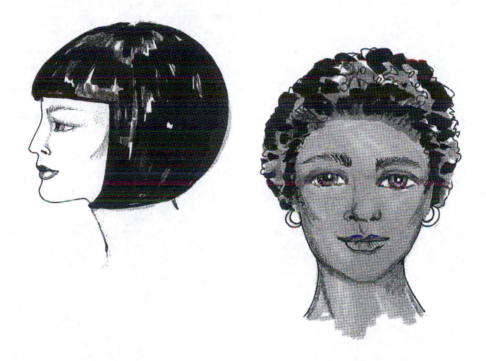

Drawing Hair, Step by Step

1. Draw a face with a light pencil line indicating the features and the skull.
2. Block in the general silhouette of the hair style.
3. Erase the vague indication of the skull.
4. Draw directional lines starting at the hairline and flowing out to meet the edge of the silhouette. Make the lines irregularly spaced. Continue to detail the features as you work on the hair style.
5. Shadow and highlight the hair. Observe live hair styles and photographs, noticing how the highlights occur in various styles and hair colors. A darker area around the face is an effective contrast device.

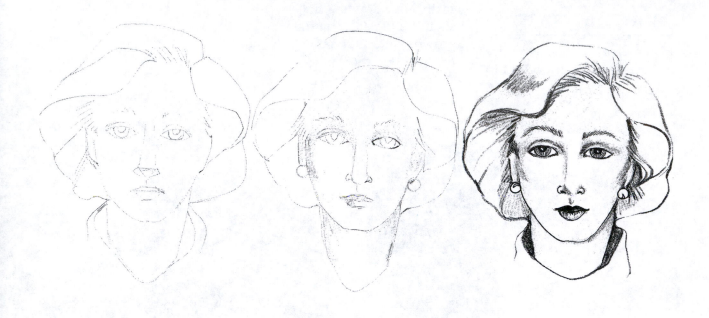

To render blond hair, use more highlight areas and fewer deep shadows. Do not eliminate all tone, however, or the hair style will lack definition. Sketch a series of ten hair styles for both men and women working from magazine photographs. Experiment with felt pens, Prisma pencils, and lead pencils. Try using only line to illustrate some of the hairstyles. Try adding hair accessories such as combs and ribbons to vary the effect.

Art Work

Art must have a crisp well-defined line and tone quality.

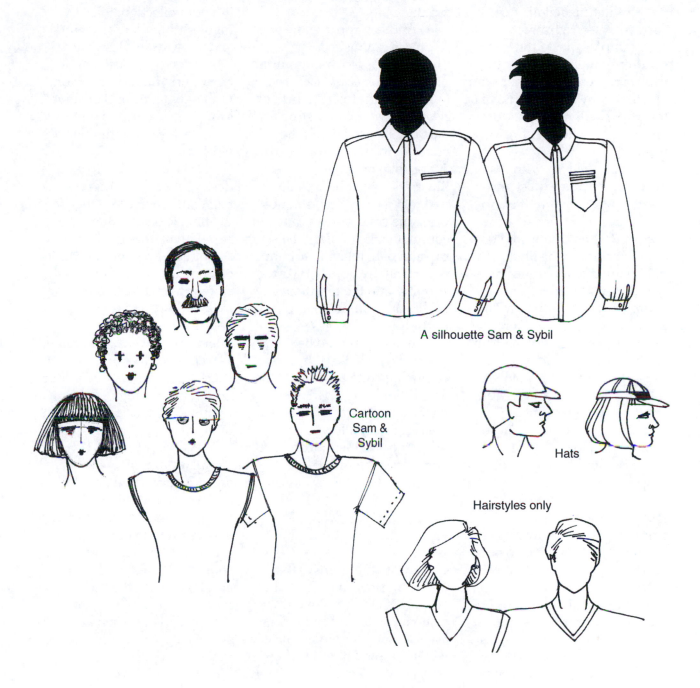

A silhouette Sam & Sybil

Cartoon Sam & Sybil

Hats

Hairstyles only

The artwork may be enlarged or reduced with a computer scanner or copier. Complicated fabric rendering is best done on a large scale to give the artist sufficient room to draw a print.

If the finished art needs correction—a redrawn head, for example—paste the new head over the mistake with rubber cement and either scan or photocopy. The outline of the paper will not reproduce and will save hours of rework time.

A *line drawing* with no gray tones is the easiest and least expensive kind of art to reproduce. This type of art is effective when duplicated on a copy machine if the line is bold enough. Gray tones do add dimension and complexity to an illustration; artwork is usually rendered in black-and-gray tones. When a special color job is desired, the press is inked with a colored ink instead of black ink. More complicated rendering is usually done by an illustrator trained in color printing processes and is beyond the scope of this book.

Evaluate your artwork jobs after they have been printed. Analyze how much darker a gray tone has to be rendered to print well on each kind of paper you use. Remember which wash or line technique is most effective. Save all your printed artwork for reference and include the best pieces in your portfolio.

PRESENTING YOUR ILLUSTRATIONS

A *mat* is a frame cut from illustration board. Mats may be purchased commercially from an art or frame store or cut by hand using a mat knife and guide. A dark mat is most practical because it provides a grip that will not be soiled by dirty finger prints.

Another appropriate way to present a finished illustration is to front mount it on *illustration board, foam core* (a lightweight foam board), or *colored paper.* A contrasting art tape can be used on all the edges of the mounting board. A portfolio or series of illustrations can be visually tied together by mounting on the same color or on a range of complementary colors. This method of displaying artwork is particularly appropriate for slipping into the plastic page covers of a commercial portfolio.

Artwork should be covered with a plain sheet of vellum taped to the back of the illustration and folded over the face of the art. This protects the image and allows the printer to add identification or note changes without damaging the illustration.

INTERVIEWING FOR A JOB

Creative jobs require that an applicant present designs and artwork so the employer can evaluate creative ability. A *portfolio* containing your best work is essential for an interview. Select a professional artwork binder (available at an art supply store) which will keep your drawings protected and well organized. Do not carry a portfolio so large that it is awkward to review. Select your best work and evaluate which pieces to show before each interview. Twelve to fifteen pieces is a good selection. Keep in mind that a potential employer will often remember the weakest piece in your collection. Start by highlighting your best work and show examples which illustrate your consistency next. End your presentation with a dynamic and creative group of sketches so you leave the interviewer with your best work.

It is reasonable to go to a design interview and be asked to create specific sketches for the line. Research the company before the interview so you have a good idea of its customer image. Shop retail stores and evaluate the merchandise so you can relate your experience in the interview (see chapters 13 and 14). Do not leave original sketches with a manufacturer without receiving remuneration or a concrete job offer.

A *resumé* is a brief summary of work experience and education and should be left at each interview. Head the resumé with your name, address, and telephone number. Work experience should be listed by date and employer, with the most recent job listed first. A brief description of the job and specific duties should also be included. The schools attended and the degrees received should follow work experience. A resumé should be neatly typed and fit on one page. Professional resumé services will write and print a resumé for a fee.

The Interview

Prepare carefully for a job interview. The following tips will help:

1. Prepare your resumé and portfolio well ahead of the interview. Shop the manufacturer's line so you know the customer image, the price range, and the competition.

2. The first impression is created by how you are dressed and groomed. Creative people are expected to dress fashionably and usually a bit more formally than would be worn to the job on daily basis. Casual clothes may mark you as a person who is more at home in the workroom.

3. Research the location of the interview and arrive a few minutes early. Allow some time to get lost if you are unfamiliar with the area. Know the interviewer's full name and how to pronounce it.

4. Prepare questions to ask the interviewer. These could include growth potential, training programs, and advancement possibilities at the firm.

5. Be prepared to fill out the employment application neatly (in pen) and completely. Bring two copies of your resumé and attach one to the application. Give the other to the interviewer.

6. Greet the interviewer by name and shake hands firmly. Smile and make eye contact and be as relaxed as possible. Listen to the questions and respond alertly. Do not ramble when answering a question; stick to the subject.

7. Ask about the requirements of the job as early in the interview as possible and relate your experience to the position. Think about your goals and abilities, and show your portfolio to reinforce them.

8. Do not smoke or chew gum.

9. Respond to questions truthfully and do not make derogatory comments about your present or former employers. Be prepared to give the names, phone numbers, and addresses of persons that you have asked to be references.

10. Ask for the job if you are interested in accepting the position and do not be afraid to accept the job offer on the spot if you want it. You may wish to think the offer over or defer making decisions about the details (salary, parking, benefits, etc.) until you meet a second time. Call the interviewer even if you decide not to take the job.

11. Thank the interviewer for his or her time and consideration. Follow up with a note or phone call summarizing your interest in the job.

REVIEW

Word Finders

Define the following words from the chapter you have just read:

1. artwork
2. hand (as it relates to fabric)
3. mat
4. mat knife
5. media
6. portfolio
7. profile
8. resumé

DISCUSSION QUESTIONS AND EXERCISES

1. Select a manufacturer and develop a mock interview process. List the steps to take prior to the interview and fulfill each. Select five designs from your existing collection and create five more which are specifically applicable to the

manufacturer you are studying. Write a resumé and adapt it to the specific job you are seeking. If possible, conduct mock interviews with your instructor, an industry guest, or a fellow student to practice portfolio presentation and interview techniques.

2. Draw a series of women's faces which have the appropriate hair style and makeup for the following garments:

 (a) tennis outfit;

 (b) after-five cocktail dress; and

 (c) a sporty business suit.

3. Sketch a group of junior or missy occasion dresses using details from this book and from your research. Mount these sketches on illustration board or foam core, using rubber cement or mounting tape. Include a swatch of the fabric the group is to be made from, trim samples, and render each garment in the colors you have selected for the garments.

UNIT 4

Now that you have learned the basics of good design illustration, and some industry secrets, we will explore the world of trend research and product development. We will answer the question "How do I know what are the right designs to use for my line?" So in the following two chapters you will learn how to scout fashion trends using your objective eye. You will do this by using a library of fashion items and details in an Adobe Illustrator file found on the CD that comes with this book.

ADVANCED DRAWING SKILLS 2

CHAPTER 13

Designing with Computers

This chapter is about training your fashion eye. Do you have one? Fashion is, among many things, about observation. There is no one in this industry that doesn't have or doesn't want to have a keen eye for details and new ideas that spring from the runways, streets, clubs, magazines, or reports that focus on retail buying trends. Fashion is a never-ending stream of new ideas that change quickly and

Highly visible pop singers such as Madonna are very influential. The grammy and other music award shows are a great source of inspiration and confirmation.

Illustration Courtesy StyleLens.com

often without notice. Changes can come from the great laboratory of new ideas known as *couture* or from the stage of a hot pop or rock n' roll band.

PRIMARY AND SECONDARY TRENDS

Trends can be broken down into two categories: *primary* trends or *secondary* ones. Primary trends would, for the most part, refer to a major silhouette change. For instance, let's say that we are in a primary trend where clothes are worn close to the body as in tight T-shirts, jeans, body-hugging dresses or fitted jackets (see Women's Blazers-Basic row 2 page 71). Now let's imagine that this trend is *morphing* into a new primary trend where clothes move away from the body as in A-line tops, trapeze dresses, full skirts or pouf skirts (see pages 127 and 138, A-line and trapeze tops). Now visualize this new primary trend as an empty box that the rest of fashion (secondary trends) falls into. Primary trends can span many seasons to affect a total change, taking a few years before the average consumer feels comfortable enough to buy it (see chart on page 40).

The trends that fall into that empty box of primary trends are naturally called secondary trends. Secondary trends only require a rumor, a celebrity endorsement, or a top-selling music video to

Cher.

Sketches on wall of studio of designer Christian Lacroix.

become popular. This is the realm of fast fashion. The Italians call it *pronto moda*. Secondary trends might be Asian inspirations, the 1960s, the 1970s, "seasonless" fashion, or ethnic inspirations like references from India, Africa, native American Indians, Mexico, or all of

them. The thing about fast fashion is to remember that although some vendors will jump into a trend immediately making it look old in just one season, it does not mean that it is over. These fast-fashion trends linger and often gain momentum.

A sketch from designer Ferre.

GIANFRANCO
FERRE

**The major "zines" to see what's
happening in the world of fashion
and celebrity.**

Let's track a secondary trend. We will use "super models" to track it. The press reports on their every move—much less today than a few years ago, but the top ones are still in *People* and *Us* magazines or hosting reality shows. The following is an actual example of how a particular trend in an elite group affects the fate of fashion for everyone. A couple of years ago (2003), trend reporting services and astute fashion reporters started seeing models wearing cowboy boots in their off-runway hours. Clever reporters for a *blog* or newspaper started watching very closely for the possibility of other western ideas to surface. Six months after the first cowboy boot was seen, the iconic prairie skirt (also known as a gypsy skirt) started appearing on key celebrities. Next, the boyfriends of these models and celebrities were seen wearing western style belts with large buckles and suede jackets with fringe. It was now a full-fledged secondary trend ready for testing in edgier shops like Barneys, Guess, Lucky Brand, and H & M, and a season (or two, or more) later filtering down to the discount chain stores (see chart on page 40). At present (2005–2006) that tiered prairie skirt has led to the

Asian inspiration (a cheongsam).

acceptance of full skirts, which is part of that primary trend where clothes move away from the body and is the anchor item for a very strong Bohemian Chic trend that has its roots in everything ethnic from Central Europe, North Africa, Central Africa, India, and the Middle East.

It is also very possible that this moving away from the body has lead to the acceptances of bubble, or pouffy shirts and dresses.

Looking at old photos or album covers of bands like the Mamas and the Papas or the Eagles are perfect for information related to this trend.

Cowgirls.

Primary Trend Examples *Left*—clothing that moves away from the body . . . babydolls, A-lines, pouf, or bubble shapes. *Right*—clothing that skims the body or is fitted, slim, lean, or attenuated.

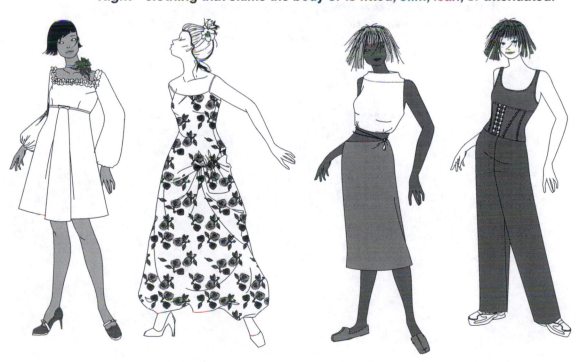

Secondary Trend Examples
Examples of a secondary trend called California Dreamin' which appeared in one of the author's forecast books. Note the use of handicrafts such as macramé, fringe (right out of the 1960s and 1970s), a poncho style, and the slouchy hat.

Prairie skirts were a major item that was a direct result of a trend that happened off the runway. Later on, because of their popularity they became known as gypsy skirts in order to fit in with a folkloric trend that later developed. Other names that these same skirts can go by are peasant or tiered.

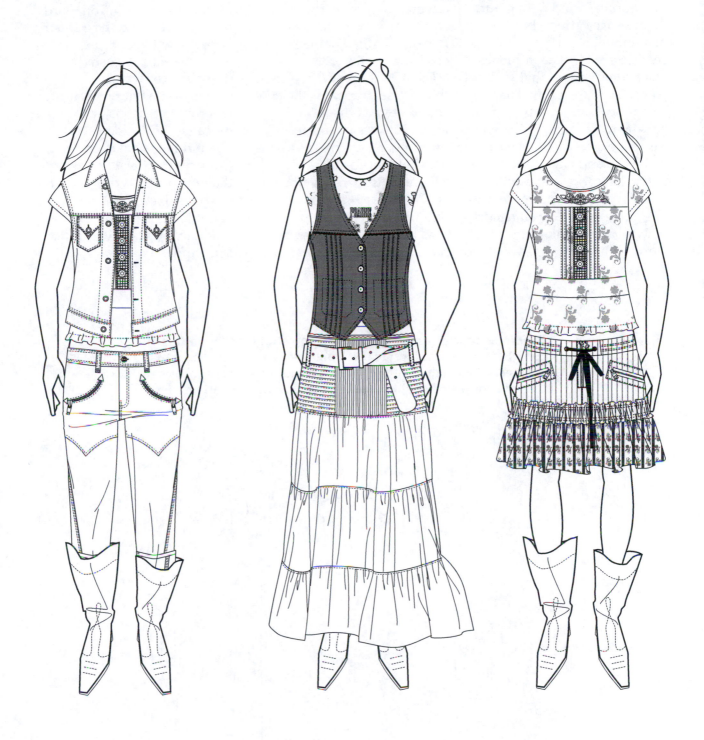

Now let's talk about how the primary and secondary trends influence each other. The following is an example of a secondary trend falling into that primary "trend box" we imagined. Let's say we are currently under the influence of a primary trend that is slim and close to the body. That being the case, we can use a narrow rectangular silhouette (see page 20), which is narrow at the top and narrow at the bottom. It forms a straight line. An example of this would be a somewhat long slim shirt (like a caftan tunic-length top) worn with leggings, drainpipes or skinny pants. Now we spy a new trend on a night out at a trendy club or on any one of the Internet sites devoted to fashion runway shows in New York, London, Paris, and Milan or ones covering retail trends (*see below*). On these sites we learn that A-line/trapeze is the new silhouette that the most influential designers are promoting. That means that the shoulder-to-ankle silhouette is narrow at the top and widens toward the bottom. This could apply to tops, skirts, dresses, and even pants. Also, let's say that there is a particular tendency for Asian influences coming down the runways. In the past, a terrific line from the ex-designer for Gucci, Tom Ford, had the press and the industry hopping with excitement when his models sashayed down the runway in Cheongsam styles in beautiful embroidered satins or brocades, both Asian staples. The influence can even come from international news. At the time of this writing, China is a big subject in the news, and it looks as if Chinese influences will be with us for some time.

Examples of what could be called a long straight silhouette. On the right is a caftan/shirt style. It is slim with what is called a hi-lo hemline . . . short in front and long in back. The other is fuller and more of a long sleeve shirt that is usually worn cinched or belted.

Rectangular silhouette made up of a classic Eisenhower jacket and boxy shorts.

Free internet site home pages (vogue.com, elle.com, mensstyle.com).

Now, what do we do with this information? First, we need to know who our target customer is. Is she 15, 25, 35, 45, or older? Is she a large size customer or petite? Your goal as a designer is to be forward in your design but only to the degree that it suits your customer. Your customer loves fashion, but she may be a working consumer who requires clothes that can take her from the office to a seminar at the convention center to a late night dinner. Our dilemma is at once obvious. It is that Asian silhouettes are not A-line but rather rectangular and fitted, and it is possible that the shopper or the retailer you sell to wants both. You need to come up with a solution regarding the silhouette that will entice customers and not alienate them. For instance, create an A-line or trapeze top or jacket with cheongsam details, like a cheongsam closure, a mandarin collar (also known as a stand collar), wide sleeves, and frog closures. You can also use Asian-inspired prints such as stylized kimono prints, T-shirts with cranes or panda bears, and textiles associated with the Far East such as shantung or brocade. You cannot, at this stage, be expected to know all these things. They will come in time. Hang in there and keep asking questions.

A—Shrug style with kimono style sleeves; **B**—cheongsam closures, mandarin collar (also known as stand collar), and frog closure—when India is in fashion it's called a Nehru collar); **C**—is a perfect example of the crossovers of secondary trends of the 1980s (the overdesigning and ABBA reference) and Asian (the kimono sleeve) within a primary one that moves fabric away from the body.

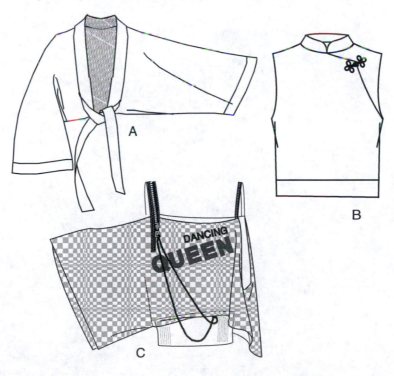

Asian textiles.

Koi or ginza fish. Also look at cranes, dragons, cherry blossoms, chrysanthemums, and traditional kimono prints.

Panda bears on fabric.

Author's two variations of prints with panda bears. First is on black grounds with ikat motif. Second print has been changed to a predominantly pink bear on white grounds with bamboo branches as backdrop.

Satin can easily be associated with the Far East. Also look at shantung, ikat, and embroideries.

Here is another example of a primary and a secondary trend uniting. Let's say the new primary trend is the opposite of the A-line. It is called a wedge silhouette (see page 67). And let us also say that the secondary trends are numerous—remember, there can be a host of secondary trends at the same time. At the time of this writing (spring 2004–2005) there is western, uptown cowgirl, vintage, retro, boho chic, ethnic, deconstructionist (frayed edges and exposed and unfinished seams), feminine (ruffles, flounces), the 1980s (strictly a club trend at the moment), and motocross (just developing). We'll choose the 1980s because this decade was quite full of a number of ideas and saw a major change in silhouette as it relates to volume (as it refers to shape). So what we will be talking about is the primary trend of the wedge mixed with the secondary trend of the 1980s.

The first thing you will note when going through any reference book on the 1980s is that decade's love affair with the BIG shoulder pad. We are not about to, unless forced, going reintroduce the BIG shoulder pad unless you are studying theatre/costume design and intend to work in that industry. There are many other ways to emphasize the shoulder. It can be done by revealing the shoulder with peek-a-boo effects, adding color to it (see page 240—bustier-peasant style), or decorating it with appliqués, embroidery, or a faux corsage. So we will emphasize the shoulder with an off-the-shoulder (both shoulders revealed) or asymmetrical off-the-shoulder (one shoulder revealed) style. *Because of the primary trend being the wedge, with all the attention at the top, we will use big shapes as in wide baggy knit tops that will be teamed with slim pants.* All this creates a lot of attention at the top that tapers toward the bottom, thereby creating the desired wedge shape.

Of course, there is much more to the 1980s than silhouette. There were the prints that included a blend of

1960s and 1980s op and pop art inspirations (see Andy Warhol, Peter Max, Roy Lichtenstein) and influences of rock stars such as Blondie, David Bowie, and Robert Palmer.

AN IMPORTANT NOTE: It must be apparent by now that your ability to be creative and successful in the fashion industry is directly proportional to the amount of interest you have for all facets of life—past, present and future. It's a big job, but then again you will always be learning and that's a good thing.

Wedge silhouette via gathering, dolman sleeves, horizontal stripes, and generous amounts of room create an illusion of a silhouette that is wide at the top and narrow at the bottom.

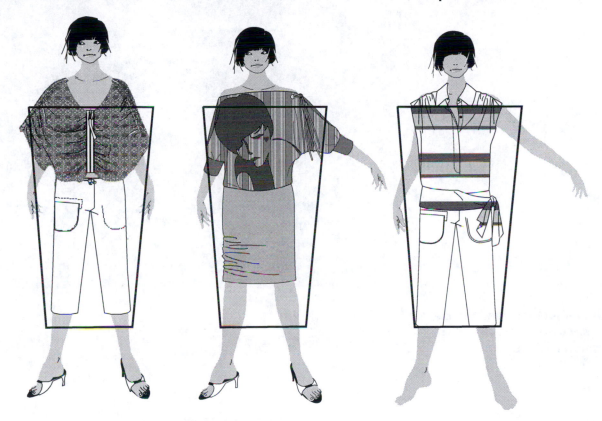

It might be some time or even maybe never (I should know better than to say never in this business) for shoulders of this proportion to emerge once again. Knowledge of this type of 1980s decade novelty is essential for careers in costume design.

Off-the-shoulder treatments are a very successful means to draw attention to the shoulder.

Example of pop art: Lichtenstein's Comic book art.

Source:
Grai St.
Clair Rice

ASSIGNMENT 1

Using the sketches provided on your CD create six garments, of which at least one falls within the primary trend of A-line with a secondary trend of Western (as in cowboy). Watch a Western on TV, reference details at your school library, or ask around. Go to stylopedia.com and look up the names of the details—smile pockets, collar points, bolo ties, Western yoke, etc. Remember, asking a question and getting an answer are always a part of fashion scouting and design.

ASSIGNMENT 2

Your assignment is to go to the sketches on your disk and put together a line of six items that are representative of the future. You will note that this type of look is often based on skiwear and several active sports because of the nylon fabrication, quilting, piping, velcro, and zips. Please create the page in landscape and not portrait. Remember you can add your own futuristic components. Let's see what you can do.

ASSIGNMENT 3

Using the components found on page 2 of the future assignment (#2) create four new ideas using the basic shapes on page 1 of the A-line/Western assignment (#1). You will note, if you want to try, that it is much harder to make Western details work on future wear.

Portrait versus landscape.

Portrait

Landscape

REVIEW

Word Finders

1. attenuated silhouette
2. blog
3. chic
4. deconstructionist
5. drainpipe pant
6. exposed seams
7. frayed edges
8. frog closure
9. horizontal stripes
10. morphing
11. objective
12. peek-a-boo
13. pop art
14. primary trend
15. prints
16. retro
17. seasonless fashion
18. secondary trend
19. stylist
20. vintage

DISCUSSION QUESTIONS

1. Where does the word *Bohemian* come from?

2. Now that you have discussed Bohemian, do you think you are one?

3. Why was Puccini's opera called *La Bohème*?

4. How would you describe a diva? Does it have a positive or negative connotation?

5. What is seasonless fashion?

6. How does pop culture affect the development of trends?

7. Discuss the differences between pop art and pop culture.

8. Who was Andy Warhol and how did he become the most important symbol of pop culture of his time?

9. What artist would you use as inspiration for a print? What would be the inspiration? The color, technique or subject that was used? What exhibits in your area can you go to? Report on what people were wearing at these exhibits in the museum or gallery that you visited.

10. How does celebrity play into the development of trends?

11. How do world affairs and politics affect fashion?

12. Do wars necessarily mean an infatuation with (1) army green or desert tan, (2) military jacket and details, and (3) camouflage prints? Do you own anything that can be said to come from these groups and can you remember what was happening in the world when you bought the item?

13. Is there anything else that you have bought that may have been influenced by a celebrity or a rock group?

14. Can you recommend a film that was about China or Japan that can be used as reference for designing a line?

15. What current film in the theaters do you think could be influential for fashion? There is no right or wrong answer. It is your opinion. Get comfortable with expressing yourself. If you can't find a current film, try a TV show.

16. Why is China in the news and how does this news affect fashion?

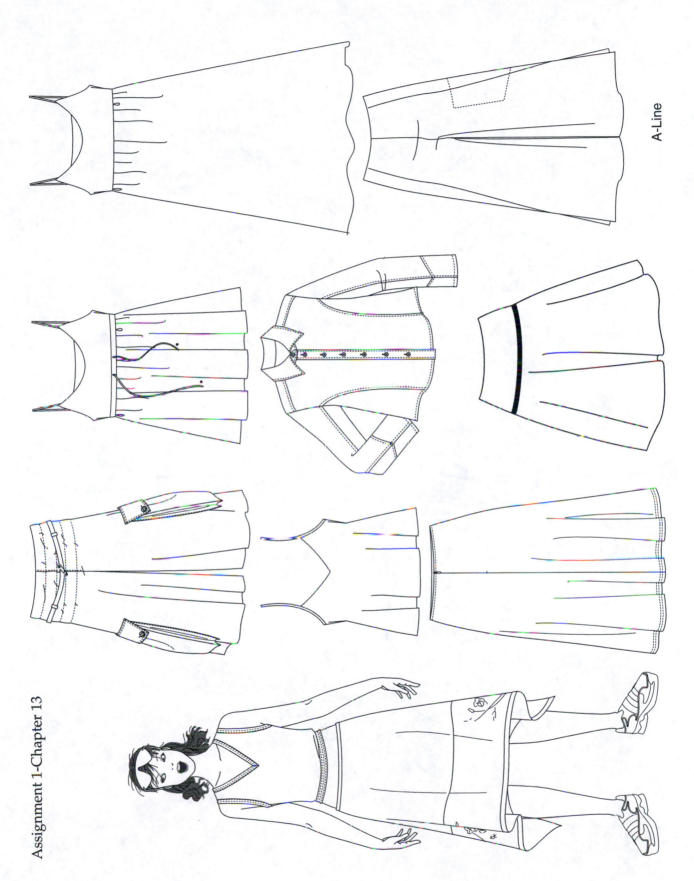

A-Line

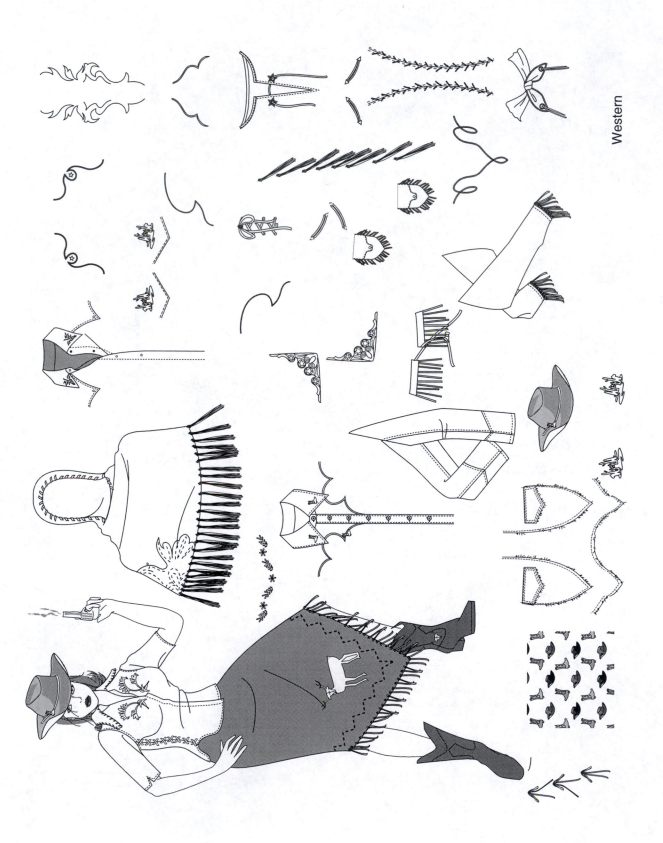

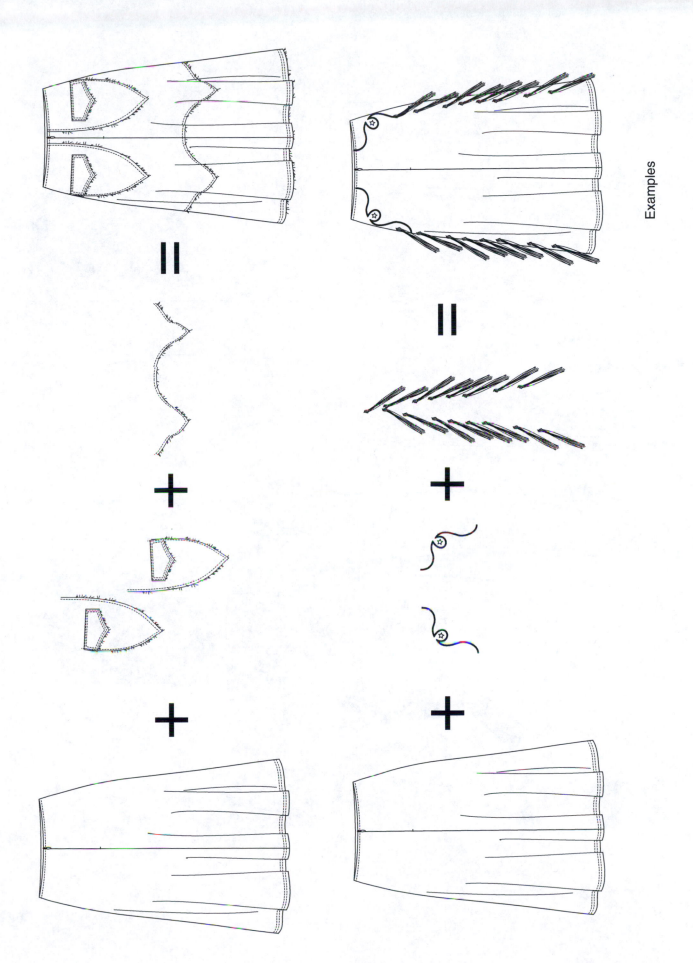

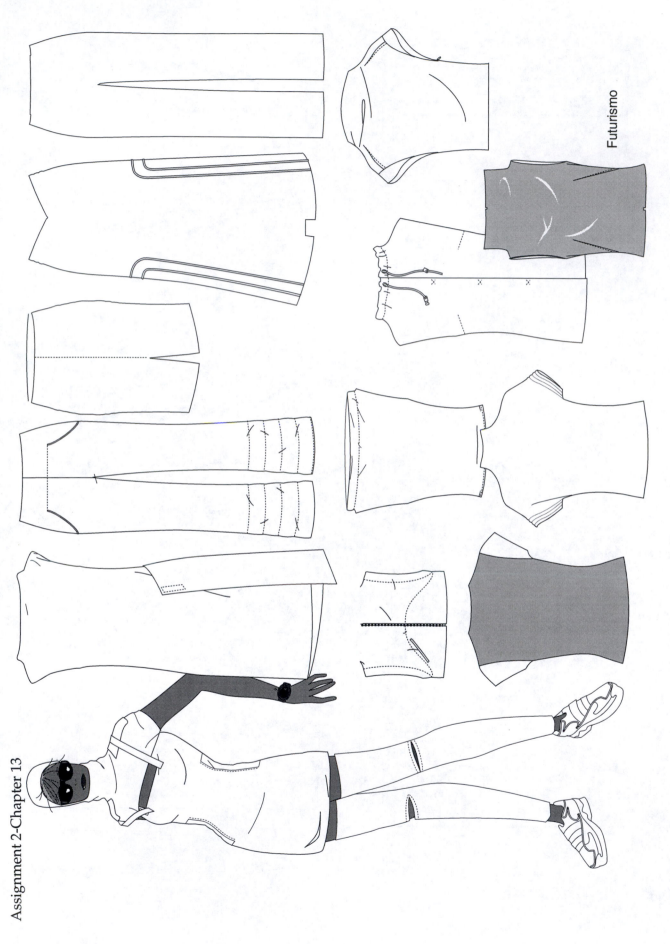

Futurismo

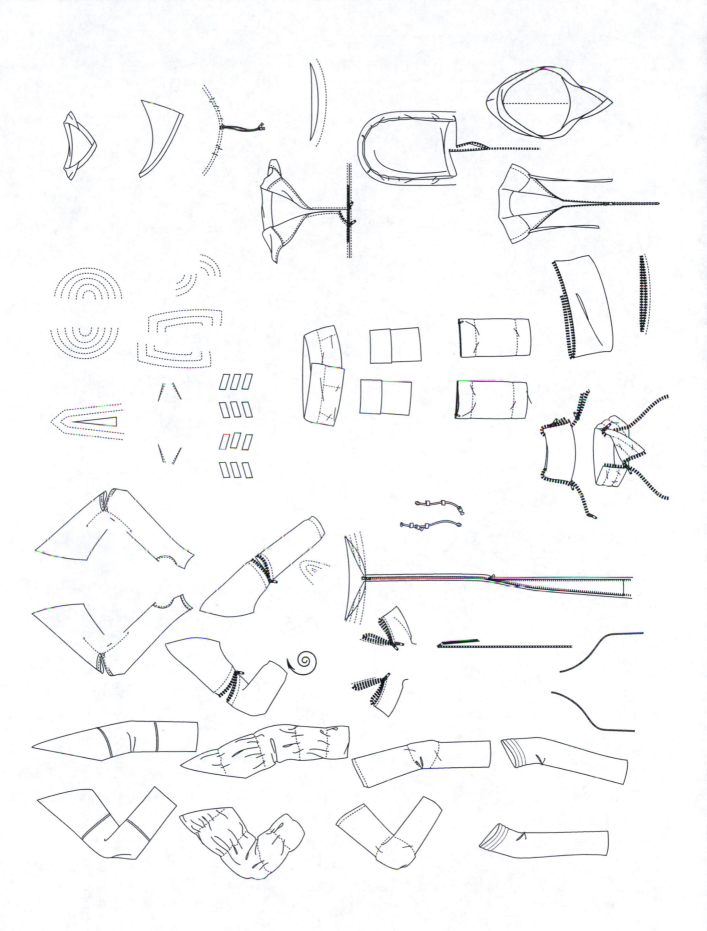

= =

+ +

+ +

+ +

+ +

Examples

Future Checklist: hoods, topstitch details, quilting, nylon, poplins. clean design, peek-a-boo effects, bold zippers, pouffy details, reflective tapes, thumb-catchers, raglan

Observation: Training the "Fashion Eye"

MEET JOE

This chapter is concerned with training your eye through careful observation to track trendy quarry. This is not as easy as it sounds because you will have to give up your personal or subjective judgments, opinions, and evaluations (JOEs) and instead use a somewhat scientific method of collecting data and facts. Doing so will assist you to see things from your companies' or customers' viewpoints, or in other words, it will develop your ability to

be objective and to remain so even in the face of your strong beliefs about aspects of fashion. Only via the collecting of facts that are not shaded by your personality can you begin to style lines for people other than yourself. Of course, we are not throwing out your JOEs altogether. There is plenty of room for them. They are the icing on the cake and make the difference from one designer's or stylist's line to another. First, we need to know the rules in order to break them creatively. Now, a bit more about being objective.

A trendy group.

Illustration Courtesy StyleLens.com

A more conservative group.

FASHION OBSERVATION OR THE "FASHION EYE"

The best way for you to understand the difference between objectivity and subjectivity is your buying an item of clothing for a friend as a gift. You wouldn't buy what you would like to wear but rather what you think your friend might like. How do you do that? You do that by objective observation. You ask yourself, "What does my friend like?" Is his or her favorite color red, blue, or yellow? Does my friend like solids, tropical prints, or stripes? Does he or she dress conservatively or edgy? Does

he or she like fitted things or loose cuts? Your answer to any of these questions is determined by observation. And you did it objectively. Of course, you probably know this person well enough to throw in that extra ingredient called intuition, but at this point you need to set intuition aside. It's a very important element of design, however, and we will call on it a bit later to assist us.

First, we'll take a look at how the *New Merriam Webster Dictionary* defines the word *observe*. It reads: 1—to see or sense esp. through careful attention, or 2—to come to realize especially through consideration of noted facts. The key word here is facts. As

mentioned earlier trend research is, at the very beginning of your career in the fashion industry, a scientific approach that calls on you to make notes of facts that are not too shaded by your JOEs. As I said before, you will always have your JOEs, no matter what you do. Enjoy them. But you need to know the difference between them and the facts. Once you've mastered the art of observation you can start breaking those rules.

TALKING ABOUT TRENDS

One of the key things to know about observation as it relates to fashion trends is whether or not what you observe is new.

At this stage, you can't possibly know what's new because you have no idea what's old. You might know what is old and what is new when it comes to the things you wear or wore during the past two *seasons* (spring/summer and fall/winter), but what about clothing for *juniors, career juniors, young adult, contemporary, or missy customers*? Do you know what is new, what sells, what doesn't sell for these customers? You need to know this information in order to do your job effectively. With the assignments later on in this chapter, you will understand how your love of shopping, perhaps the most useful tool

you already own, can enable you to gather this information.

Clearly, you have to be open to a whole new set of criteria to build a line for a customer who probably does not have your particular likes and dislikes. We are going to address this in the upcoming assignments. You may think that you don't need an investigative mind to understand how a trend will affect your line because you have access to so much information from magazines and the Internet. Because of the incredible amounts of varied information available, however, you will need to develop a sorting technique to

separate the usable from that which is not. The most important criterion to accomplish this is to know your customer. By knowing your customer, you will be able to know immediately what trend, detail, color, fabric, or trim is right for him or her. Remember, there are thousands of ideas that march down the runways as seen online at vogue.com, elle.com, or men.style.com (or in their hard copy magazine versions). You need to be able to pick the ones that best suit your customer. There are also paid subscription websites such as stylelens.com that offer free trend alerts on a regular basis.

Vogue cover.

A few trips to the mall over the length of this course using the techniques outlined in the following paragraphs will give you the tools to differentiate trends that are applicable to various social, ethnic, age-related, and economic groups for which you may need to design, to style, or to merchandise. Before you head into the stores where every designer, stylist, merchandiser or owner—local or international—practically lives in order to stay in touch with his or her customer, we need to cover some things about trends that will prove useful.

Let's begin with fashion cycles. These days the fashion cycle of a trend has been compressed into a shorter period of time. Thirty years ago, fashion cycles appeared and disappeared like clockwork over long periods of time, sometimes as long as seven seasons. There were simple rules. For example, when polka dots appeared, it meant either the end of a print cycle or the beginning of one. So for seven seasons, we had lots of printed fabrics and for seven years we had solids.

Nowadays, forget rules. The market is better attuned to the needs and wants of consumers because they are in charge. The industry does what they say. It does not dictate to them. You have to be quick and flexible in translating trends for your customers. You have POS (point-of-sale) technology in

Website home page of StyleLens.

order to better track what consumers are buying so you can get more of what they want into the store. Of course, there are still cycles, but the timing of their appearance and disappearance is no longer as trustworthy as it once was. Some say a cycle is three seasons, and some say cycles do not exist any longer.

Although the length of fashion cycles is in question today, there are some things you can count on as a general rule. For example, the end of a print cycle inevitably means the introduction of textiles with surface interest (e.g., tweed, crepe, or piqué), shiny surfaces (e.g., satin and

charmeuse), and yarn dyes (e.g., Prince of Wales, tartans, buffalo checks, and an assortment of other plaids). A print cycle can include countless variations of different motifs that include florals, tropicals, borders, geometrics, stripes, conversationals, figuratives, dots, spots, and animal skins. These all supply the necessary surface interest, novelty, and variety for the shopper. So it follows naturally that the decline of prints would lead to textiles with surface interest. In a majority of cases the customer needs something other than color to attract his or her valuable dollar.

Dress in a print and solid fabric.

A plaid.

A lacoste shirt.

A figurative print.

Figurative (faces & human figures)
retro textile design in two way repeat

A conversational print.

Fingers snapping and words in
background inspire conversation, hence
the name conversationals.

Let's talk about one of our newest reoccurring trends, deconstruction, which pops up every few years. The deconstructionist trend of the early-to-mid 1990s that came out of Antwerp was a hit immediately with rock and grunge band members who loved the rebellious feeling that exposed seams, tattered fabrics, and frayed edges gave them. Clothes were even being designed to be worn inside out. During that same season, it was also a hit for the *post–punk/goth* consumer, who was able to buy it for a lot less (knock-offs) from manufacturers that specialize in clothing for that consumer.

The next season, more forward manufacturers started introducing distressed detail on some of their pieces, testing the waters to see if their customers understood the look. There is a lot to understand with some looks, and this was and is one of them. For instance, how can the average shopper be expected to understand or relate to a trend the very first season it appears that is so radical that only a handful of customers would appreciate it? Even a customer's children might need a season or two to understand the look and that will only take place through repeated exposure to videos and zines of their favorite rock and roll bands or film celebrities. Again, it is paramount that you know who your target customer is. You need to ask questions such as the following:

What is the age range? 15–35? 35–55?
What is his or her income level? Affluent? Medium income? Low income?
What level of risk is your customer willing to take? Edgy? Conservative?
What are his or her evenings like? Dressy? Casual? Club? Rave?

A designer or stylist has to ask this question: How can his or her company use any trend for the customer to whom the company caters? Let's go back to the deconstructionists to sort that question out. After the initial introduction of the deconstructionists, which lasted two seasons, they were suddenly gone. As gone as they were, some of their influence lingered with many companies. They never gave up on frayed or tattered edges as part of their design. Years later (2004), this small group of devotees—having made adequate noise at trade fairs and, more importantly, at cash registers, etc.—established the platform for the rips, tears, fraying, slashing, and distressed treatments that are hot for the denim market at this time (2005–2006) as well as for high-end goth or decadent looks in "lux" fabrics such as silk taffeta. Now consider the customer to whom your company caters: a woman in the suburbs who may work at the local bank. She is not going to wear this look. She would probably buy only a jacket or blouse, that has a pin attached that has frayed petals. This simple addition would be seen as decoration by this consumer, giving her just enough to make her outfit (or ensemble) more conversational. Her fellow employees would comment on it, thereby creating a conversation. Distressed dying and finishing techniques that create worn spots on denim or corduroy items might be more acceptable for her leisure or casual clothes. The point here is that you, no matter what level of customer—*budget, moderate, or designer*—you cater to, need to watch for new trends that might be seen on a lead singer who wears short sleeve knit T-shirts over long sleeve woven shirts or a movie star who only wears white shirts with French cuffs. You never know where an influence will come from. There once was a time when a King Tut exhibition in New York created a rave for metallic gold prints with Egyptian motifs.

T-shirt over long sleeve shirt.

T-shirts over long sleeve hoodies, tees or even long sleeve button front shirts were first spotted on band members. Stylists for magazines quickly used the idea for fashion shoots. Within 6 months they were everywhere. It was a perfect candidate for trompe l'oeil (pronounced... trump loy) where the item looks like 2 pieces but is actually 1. Also called a 2-fer.

King tut.

Briefly, let's turn to the relationship between trends and intuition. Intuition is defined as being aware of or knowing something without having to discover, perceive or research it . . . instinctive. Over time you will develop your intuition. You will look at a trend and know intuitively that this is right for your customer. This will become apparent when you've mastered your objectivity.

Distressed Items.

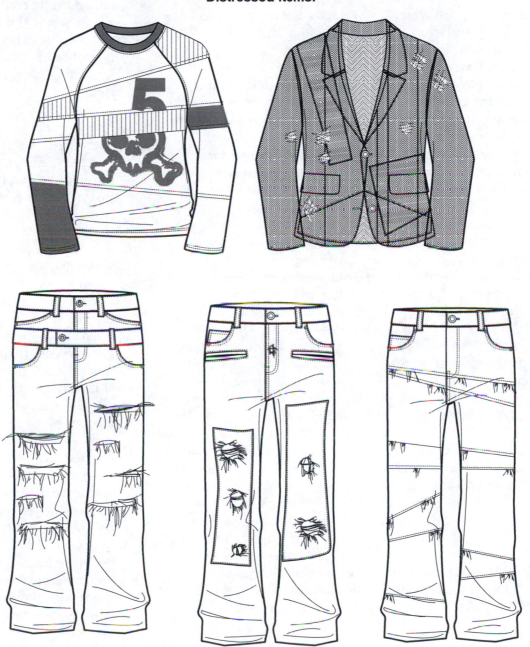

Examples of the aftermath of Antwerps deconstructionist period. Here we have what I call interrupted graphics (a modern version of patchworking), a tattered tailored jacket with actual patches, and lastly the distressed jean with rips and tears creating an instant history for their owners.

In Chapters 13 and 14 along with Chapters 1–12, you have been given some of the necessary tools you need for uncovering information as it relates to generating a line. You can, when you are on the job, buy or subscribe to fashion services and magazines, both for color and silhouette. Even if you were able to buy each and every one of them that is currently on the market, it would be difficult for you to come up with any one trend that was common to any two or three of the services and magazines. That is why your own personal observation is best. Nothing will ever take its place.

For additional sources of information regarding trends, see the report EyeSpyUSA/LA, which is included on your CD. The report includes trends from the United States and Europe. Enjoy. You may also want to visit snapfashun.com for more information on what is happening in Europe and Los Angeles. It is updated all the time.

So with these additional sources in mind, we will end this book with various assignments. We are going to begin at ground level to begin our journey into mastering observation and uncovering trends that are right for your own company or a company that employs you.

ASSIGNMENT 1

The following exercise was created to assist you in developing your powers of observation. You are going to shop not to find what you like but rather to fulfill the requirements of the assignment. This exercise will not only test your powers of observation but will assist you on your road to objectivity. It is a very valuable lesson for you to learn if you are ever going to work and play in the fashion industry.

Your assignment is to visit a local department store and shop these three departments: junior, contemporary, and designer. You may want to divide the three categories by store, for instance, junior—A & F, contemporary—Banana Republic or BeBe, and missy—Chico's. On two pages create four columns each. In the first column, from top to bottom, list the areas you are going to observe in the order listed below. At the top of the other columns, running across the page, write title in junior, contemporary, and missy or designer (it's your choice). (See example of shopping assignment on page 267 or on your CD in Chapter 14 folder.) Now from these three departments find the similarities and differences in the following order:

Ask yourself the following:

1. *Color:* What color predominates in each department? Black, white, chartreuse, antique rose? If you don't know the name of a color ask the salesperson. Don't be surprised that she doesn't know. You will find the salespeople in better departments more knowledgeable. **HINT:** To describe a color think of colors as they relate to fruit (banana yellow, cherry red), vegetables (eggplant, carrot, squash, pumpkin), flowers and trees (rose, daffodil, iris, bark, spruce), the sky (blue, overcast gray), the sea (azure, aquamarine, seafoam), the earth (moss green, peat), branded colors (Tiffany blue, Campbell's soup red, Cheerios yellow), and gems, precious and semiprecious (ruby, emerald, turquoise). You can also use descriptions for groupings of color such as an art movement or artist (pop art movement, the artists Matisse and Mondrian). You get the idea. Describe the color carefully as you can because the human eye is not known for remembering exact shades of color, so some point of reference is necessary.

1. Color referencing

Matisse collage.

An eggplant.

A gem.

Spruce trees.

2. *Prints*: Were there any prints? What ratio did you see compared to solids: 50 percent of the department, 25 percent? Of the prints you saw, were they small flowers, large flowers, were they on white grounds, on black grounds, were there spaced flowers, checks, plaids, impressionists, conversationals, figuratives, Pucci, ethnic inspirations, etc.

A printed dress.

A solid suit.

A black ground print.

Ethnic influences: Tonga islands, tapa cloth.

Cambodian yarn died textile.

Panama, mola design, cuna indians.

3. *Fabric:* Was it lightweight? Did it have texture like a tweed, boucle, waffle, or crepe? Was it matte or shiny? How did the fabric feel? Was it season-appropriate or seasonless?

Seersucker swatch.

Satin.

4. *Details:* What kind of pockets were similar (square or rounded)? Did they have flaps? Were they military? Utilitarian? Were they cargo pockets?

Different pockets.

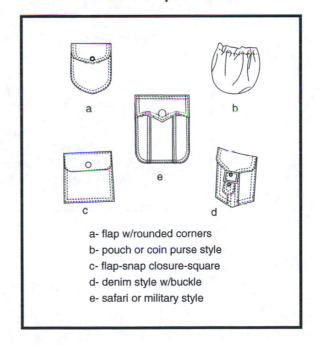

a- flap w/rounded corners
b- pouch or coin purse style
c- flap-snap closure-square
d- denim style w/buckle
e- safari or military style

5. *Closures:* What kind of closures were they? Zippers, velcro, lace-ups, buttons, snaps?

6. *Necklines:* Were they scoop, square, or sweetheart? If you don't know the name, you should ask the salesperson, draw it, and look it up later in this book or go to stylopedia.com.

Different necklines.

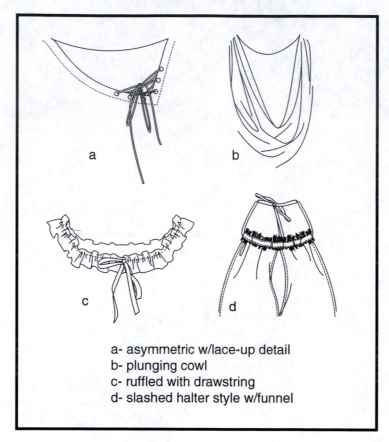

a- asymmetric w/lace-up detail
b- plunging cowl
c- ruffled with drawstring
d- slashed halter style w/funnel

7. *Merchandising:* Were there more pants than skirts in the departments? Were they narrow skirts, wide, long, or short? Observe.

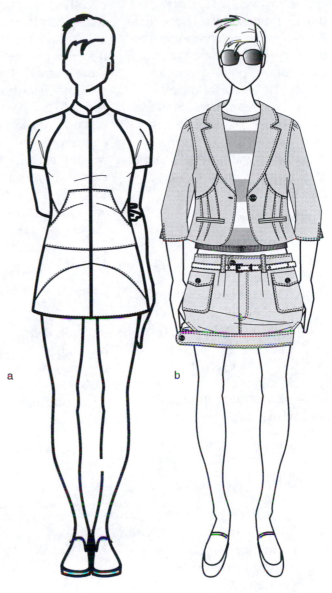

a-ergonomic design gives this sporty ensemble a futuristic look that is just ripe for innovative textiles

b-shrunken items play off of the newer primary trend of volume.

a

b

8. *Price points:* **What was the** average price for one particular type of item. Select a pant, jacket, blouse, or T-shirt.

Come back to class ready to share.

Important Note: If you are not familiar with the descriptive name of a fabric or how to describe a color (chartreuse, lavender, lilac, etc.) that you might come across in the following assignment, feel free to ask the salesperson. She will be of assistance. Salespersons, if they are not too busy, are friendly as long as you are. So wait for the right time. Asking for information is part of this assignment.

Your Introduction

Hello, my name is _____ and I am studying design at _____. Would you be so kind, if you have a moment to spare, to answer some (two or three) questions in regard to fabric and color?

ASSIGNMENT 2

Let's assume that the current trend is a retro one, and by visiting stores and looking online at the most recent runway shows, you observe that designers are using various retro/vintage details such as peter pan collars, pintucks, etc.

Your assignment is to create new bodies using the details found on the CD. Create three new items with Peter Pan collars: a jacket, a shirt with a button front placket, and a dress. The blouse and dress should have pintucks. Feel free to use other retro details to add more design to your item. Remember, more details are not mandatory. Sometimes less is more.

Further Research:

vogue.com (free)
elle.com (free)
men.style.com (free)
firstview.com (subscription)
stylelens.com (subscription)
snapfashun.com (free)

ASSIGNMENT 3

Browse a shopping website and while there sign up for a catalog. Catalogs are an excellent way of learning what sells because it is not customary for retailers to put items in catalogs that only have a small chance of selling. Usually items are selected for past performance but now updated with newer colors or prints. After all catalog returns are high enough. Your assignment is to give a brief description of who the customer is that these sites cater to and why you came to the conclusion you did.

Some Websites to Consider:

bebe.com
topshop.com
hm.com
chicos.com
zara.com
urbanoutfitters.com

ASSIGNMENT 4

This assignment is to further drive home the point that every primary trend can incorporate secondary trends. This assignment asks you to combine the primary trend of volume with a secondary trend of military. Remember, primary trends take a long time to develop whereas secondary ones are almost instant, or as the Italians say, they are *pronto moda*.

ASSIGNMENT 5

The last assignment is just for fun. Here you will learn various names for an Asian-inspired secondary trend.

REVIEW

Word Finders

1. Customer, type of: junior, contemporary, young contemporary, missy
2. Flashdance top
3. grunge
4. intuition
5. POS
6. stylist
7. subjective

DISCUSSION QUESTIONS

1. How would you describe the following: florals, tropicals, borders, geometrics, stripes, conversationals, figuratives, dots, spots, and animal skins? How many different types of florals are there? Name animal skins that are popular in fashion.

2. What are the differences among a stylist, a merchandiser, a product developer, and a designer? Probably you might want to find out what an IT or a CIO is since these people play a more and more important role in companies.

3. Can deconstructionist be applied to literature, painting, and architecture? Can you name some deconstructionists in these other disciplines?

4. What are folkloric references? Describe some folkloric garment and how you would reinterpret it for junior, missy, contemporary.

5. Is clothing, in the final analysis, costume?

6. Is fashion design considered art?

SCOUTING TRIP date: Feb. store: XYZ Season: Spring	Junior	Contemporary	Missy
Color	bright colors main emphasis on the blues shown with yellow	blues are less strong merchandised with gray	less bright and more dark teamed with a very strong brown story
Prints	mostly small ditsy florals for emerging western look. big flowers for dresses tie dye and ombre were popular	medium sized florals, mostly roses on white grounds. Tiffany blue grounds looked new	large spaced flowers .,...yellow daisies on white or light brown/cafe au lait grounds.
Fabric	eyelet white lace baby wale corduroy cotton sheeting lacoste knits	eyelet white lace lt.wt. knits summer weight wools lacoste knits	cotton pique waffle or lacoste knits
Detail	cargo pockets were everywhere	mostly patch pockets	lots of cargo pockets...could signal a return
Closures	zips velcro	zips large metal buttons	zips velcro
Necklines	deep V boatneck (or bateau)	scoop boatneck sweetheart modest V	boatneck polo placket
Merchandising	jackets over flat-front trouser shorts tight t's with PJ bottoms sandals with prairie skirts	oversized lt.wt. cotton knits and pleated trouser or tailored shorts cropped sweater knits with prairie skirts	not enough merchandise... still lots of sales
Price Points	dresses: 45-60 separates 25-75	dresses:50-110 separates 45-100	mostly sale merchandise

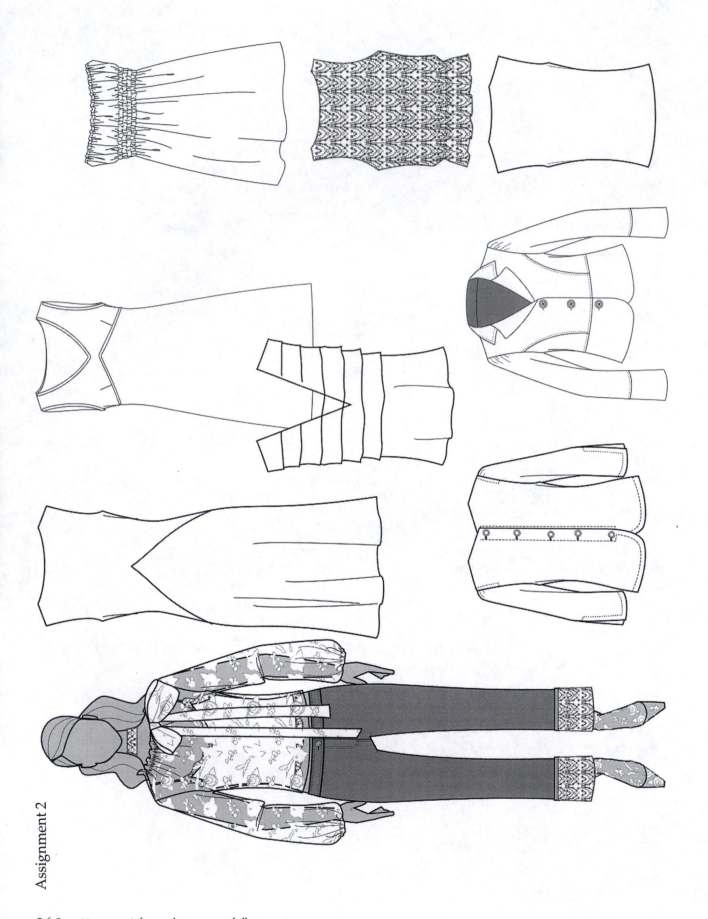

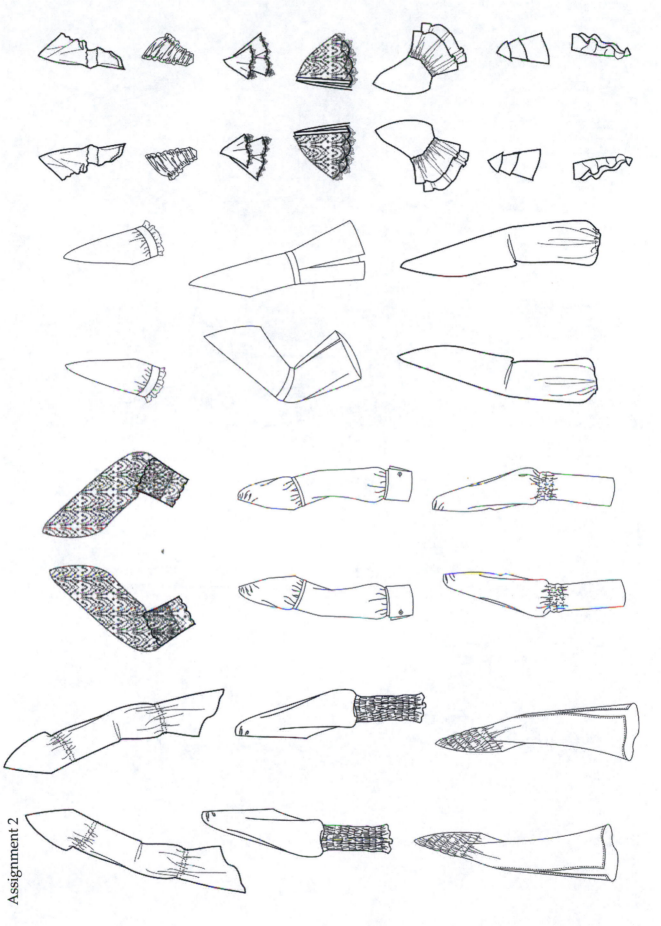

Assignment 2

Assignment 4

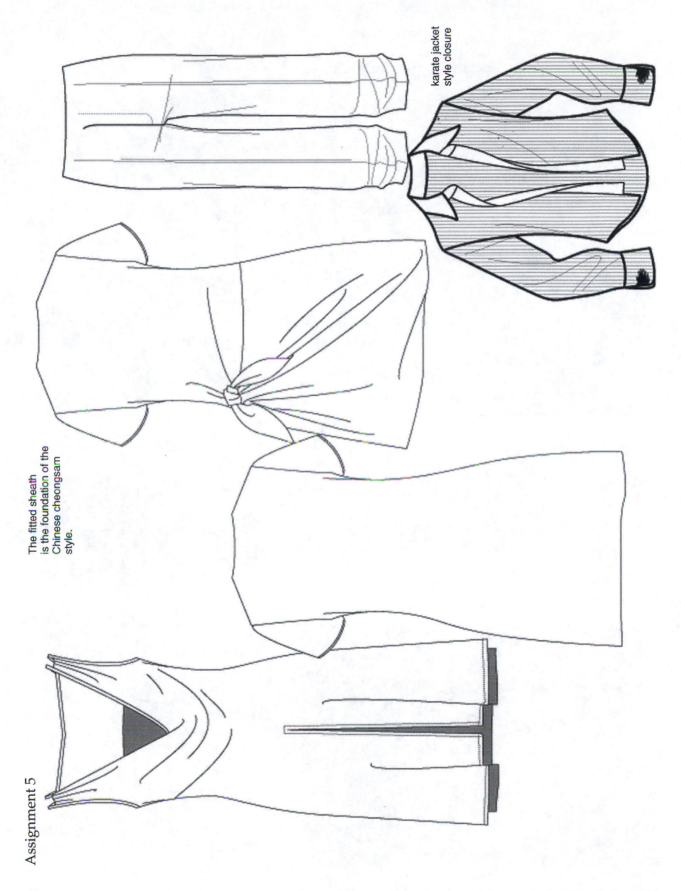

karate jacket
style closure

The fitted sheath
is the foundation of the
Chinese cheongsam
style.

Assignment 5

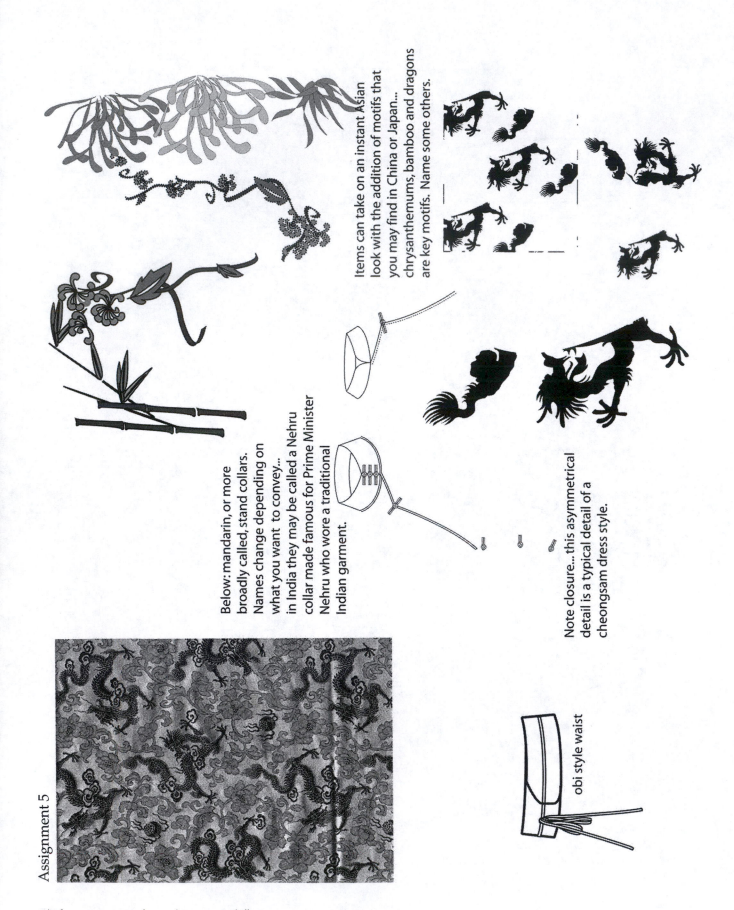

Items can take on an instant Asian look with the addition of motifs that you may find in China or Japan... chrysanthemums, bamboo and dragons are key motifs. Name some others.

Below: mandarin, or more broadly called, stand collars. Names change depending on what you want to convey... in India they may be called a Nehru collar made famous for Prime Minister Nehru who wore a traditional Indian garment.

Note closure... this asymmetrical detail is a typical detail of a cheongsam dress style.

obi style waist

INDEX

H

Hair, 217–219
Half-circle skirts, 123
Half peplum over skirt shorts, 149
Halter necklines, 109
Halter style vest, 79
Halter-wrap neck leotard, 151
Hand, 16
Hand-knit sweaters, 176
Handkerchief hemline, 169
Handloomed sweaters, 175
Harem-basic pant, 145
Head. *See also* Face
 profile, 211–214
 3-D, 215–217
Head lengths, 5
Heart buttons, 167
Herringbone, 196
Hi-lo hemline, 232
Hidden placket, 103
Hidden placket - stitch detail shirt, 82
High-pleat & tab waist, 173
High rise pants, 141
High waist, 173, 174
High waist-bound pockets pants, 155
High waist-flap pocket pant, 146
High waist-hot pants styling shorts, 150
High waist-scalloped hem skirt, 128
High-waist-side tab trim pants, 155
High waist-side zipper pant, 146
High waist-vest styling pant, 145
Highlighting pencil and marker illustrations, 187
Hip-chanel chain (trim), 166
Hip details, 164–165, 173–174
Hip hugger, 141, 144
Hip hugger-hot pants shorts, 150
Hood, 102, 108
Hooded necklines, 108
Horizontal balance, 34
Horizontal patterns, 28
Horizontal stripes, 239
Hourglass silhouette, 19

I

Ikat, 238
Illustration board, 49
Informal balance, 33
Innovative style, 44
Innovator, 40
Insert pocket-inverted pleat pants, 155
Insert pocket-one pleat pants, 155
Inside Fashion Design (Tate), 43
Intarsia, 175–176
Internet web pages, 233–234

Interviewing for a job, 220–221
Intuition, 257
Inverness cloak, 176
Irish fisherman's sweater, 176
Irregular gathers-fly (waistband), 173
Italian cut suit, 59
Item line, 46–47

J

Jacket
 men, 59, 86
 outerwear, 176, 180–182
 women, 57–58, 71–76
Jacquard patterns, 175
Jamaicas, 141
Jean(s), 140
Jean jacket, 76
Jean jacket pockets, 172
Jean jackets, 181
Jean shorts, 148
Jean style-flap yoke shirt, 83
Jean style-long-sleeveless dress, 135
Jean style-men's shorts, 157
Jean style-rivets pockets, 172
Jean style-slit pocket shirt, 83
Jean style-stitch detail shirt, 83
Jean w/pocket inset-back, 144
Jeans, 140
Jewel buttons, 167
Job interview, 221
Job search, 220–221
Jodhpur pants, 146
JOEs, 249
Juliette - basic sleeve, 95
Jumper, 124
Jumpshirt-shirt style, 152
Jumpsuits, 140, 152–154. *See also* Pants and
 jumpsuits
Junior apparel, 43
Junior dresses, 124

K

Kangaroo-buttoned pockets, 172
Kangaroo pockets, 172
Kilt style-asymmetric style skirt, 130
Kilt style-pin & tabs skirt, 130
Kimono sleeves, 88–89, 97
King Tut exhibition, 255, 256
Kneaded erasers, 6
Knife pleats, 170
Knife pleats - shorts, 170
Knife pleats-drop yoke skirt, 130

Raised turtleneck basics collar, 114
Raised wrap & shawl style collar, 114
Raised yoke zipper neckline, 109
Rectangle, 18
Rectangular silhouette, 233
Reefer, 178
Rehearsal shorts, 141
Rejection phase, 41
Rendering. *See* Basic fabric rendering
Report West, 1
Research, 45–46
Resource, 41
Resumé, 220
Revere collar, 101
Reversal darts at neck (bodice), 62
Rhythm, 37
Rib-basics collar, 114
Rib with stripes cuff, 98
Ribbon lacing placket, 120
Ribbon trim-loops placket, 120
Roll line, 101
Roses, 167
Round-buckle open (trim), 166
Round necklines, 111
Rounded edge lapel, 118
Ruffle trimmed neckline, 101
Ruffled lace tie-unisex placket, 119
Ruffled-unisex placket, 119
Ruffles, 161–162, 169
Rugby shirt, 84
Running shorts (men), 157

S

S/B novelty lapel, 117
S/B shawl-notched lapel, 117
S/B stitch trim lapel, 117
S/B wing style lapel, 117
Safari jacket, 76
Safari style jacket - cargo pockets, 180
Sailor collar, 101, 113
Sarong, 123, 131
Sarong-side tie skirt, 126
Sash knotted at side (trim), 166
Sash-tied in knot (trim), 166
Satin, 197, 238
Scalloped placket, 120
Scarf collar, 113
Scoop neck leotard, 151
Scoop neck-long sleeve zippered top, 69
Scoop necklines, 110
Scoop with bow neckline, 111
Screen printing, 160
Screens, 200
Sculptured necklines, 108

Seam, 21
Seasonal colors, 25
Seasonal timing, 41
Secondary trend, 226. *See also* Designing with computers
Secondary trend examples, 230
Self-ties, 158
Semi-fitted dropped waist, 139
Separates, 142
Set-in sleeves, 87–88, 91–95
Set in - long basic sleeve, 91
Set in - long-pushed up at cuff (sleeve), 91
Set in - long-tab & button sleeve, 91
Set in - narrow - flounced cuff sleeve, 92
Set in - trench style sleeve, 92
Set-in sleeves, 87–88, 91–95
Shadow, 175
Shadowing the garment, 188–190
Shantung, 238
Shawl collar, 101
Shawl collars, 112, 113
Sheath-4 dart-below knee skirt, 126
Sheers, 199
Shift, chemise, or cocoon dress library, 137
Shiny fabric, 28
Shirt
 men, 58–59, 81–83
 women, 56–57, 64–65
Shirt-basic unisex sleeve, 92
Shirt-basic-with placket - unisex sleeve, 92
Shirt button, 104
Shirt collar, 101, 112
Shirt-convertible collar, 112
Shirt dress, 57, 124
Shirt edged collar, 112
Shirt-flounce trim cuff, 98
Shirt-flounced cuffs, 92
Shirt-lace trimmed cuff sleeve, 92
Shirt-lapel style collar, 112
Shirt-panelled cuff, 98
Shirt placket, 103
Shirt-rolled up cuff, 98
Shirt-round edged-basic collar, 112
Shirt-ruffled collar, 112
Shirt-side cuff links, 99
Shirt-stitched placket cuff, 99
Shirt-style dress, 134
Shirt style leotard, 151
Shirt-tab closure cuff, 99
Shirt-tab styling cuff, 99
Shirt tails, 82
Shirt 2 buttons cuff, 99
Shirt-Western yoke-stitch detail, 66
Shirt w/over skirt shorts, 149
Shirt-wide-cuff - 4 buttons, 99
Shirt with stitch detail, 66

CREDITS

Page 225: Iain McKell/Retna Ltd.

Page 226 (top): Images, Peter Gould/Getty Images Inc.—Hulton Archive Photos

Page 226 (bottom): Abbas/Magnum/Magnum Photos, Inc.

Page 227 (top): Gianfranco Ferre

Page 228: Getty Images Inc.—Hulton Archive Photos

Page 229 (left): Regan James/Getty Images—Digital Vision

Page 229 (right): Nancy R. Cohen/Getty Images, Inc.—Photodisc

Page 236 (top): Grant V. Faint/Getty Images Inc.—Image Bank

Page 236 (bottom): Japan Press Illustrating Service/Getty Images Inc.—Hulton Archive Photos

Page 237 (top): Barbara Beckmann Designs, Inc.

Page 237 (bottom): Drug Enforcement Administration

Page 238: Cary Wolinksy/Aurora & Quanta Productions Inc.

Page 240: Laima Druskis/Pearson Education/PH College

Page 249: Steve Moore/Index Stock Imagery, Inc.

Page 250: Getty Images—Stockbyte

Page 251: © Judith Miller/Dorling Kindersley/VinMagCo

Page 253 (top): Photolibrary.Com

Page 253 (bottom): Nicolas Russell/Getty Images Inc.—Image Bank

Page 254: Getty Images Inc.—Hulton Archive Photos

Page 256 (bottom): Alan Keohane © Dorling Kindersley

Page 259 (left): Matisse, Henri. Beasts of the Sea. National Gallery of Art, Washington, D.C. Image © Board of Trustees, National Gallery of Art, Washington.

Page 259 (top right): Getty Images—Stockbyte

Page 259 (middle right): Colin Keates © Dorling Kindersley, Courtesy of the Natural History Museum, London

Page 259 (bottom): Yva Momatiuk & John Eastcott/Photo Researchers, Inc.

Page 260 (left): © Judith Miller/Dorling Kindersley/Cloud Cuckoo Land

Page 260 (right): Photolibrary.Com

Page 260 (bottom): © Judith Miller/Dorling Kindersley/Steinberg and Tolkien

Page 261 (top): © Wolfgang Kaehler [2002] www.wkaehlerphoto.com

Page 261 (bottom): Tim Hall/Robert Harding World Imagery

Page 262 (top): Will & Deni McIntyre/Getty Images Inc.—Stone Allstock

Page 262 (bottom): © Dorling Kindersley

Page 263: Siede Preis/Getty Images, Inc.—Photodisc